# She Can Find Her Way

✎

## WOMEN TRAVELERS
## AT THEIR BEST

*Essays by Independent
Women Travelers*

# She Can Find Her Way

## WOMEN TRAVELERS
## AT THEIR BEST

*Essays by Independent
Women Travelers*

### EDITED BY
# ANN STARR

Upper Hand
**PRESS**

Excerpt from NOMAD'S HOTEL by Cees Nooteboom,
translated from the Dutch by Ann Kelland.
Copyright © 2006 by Cees Nooteboom.
English translation copyright © by Ann Kelland.
Reprinted by permission of Houghton Mifflin Harcourt
Publishing Company. All rights reserved

Cover and box design by Myeong Sik Ryu
Interior design by David Moratto

Upper Hand Press
P. O. Box 91179
Bexley, Ohio 43209
U. S. A.
www.upperhandpress.com

Printed by Häingraph

ISBN: 978-0-692-36867-1

*I am the way.*

*Straight as an arrow*
*aimed at the distance,*
*but in the distance*
*I am*
*far away.*

*If you follow me,*
*Here, there, everywhere*
*You will arrive,*
*Anyway.*

*A way is away.*

— CEES NOOTEBOOM,
*Nomad's Hotel*

෴

# Contents

## VOLUME 2

〜

## VOLUME 3

〜

## VOLUME 4

# Foreword: Postcards

*by*

## ANN STARR

Come along. Twenty women narrate their solo journeys — domestic and foreign, adventurous and contemplative — in these five volumes of memoirs. If these are postcards, were they having fun? Do we wish we'd been there?

Our authors have covered a lot of ground. Teenagers and retirees alike, they have sped across East African deserts, and waited out East Indian monsoons. They've accepted rides from bad men; they've followed their Peace Corps training to perplexing ends. Many discovered new landscapes. Some discovered, and some lost themselves. All returned to tell about it.

For whatever reasons these women set out, most have in some way stood up to bullies, bad luck, and to cultures that don't like women to be visible, brave, and free. These women used intelligence, ingenuity, instinct, and courage to go where they wanted.

Still, it's worth asking if all of them *reached their destinations*? A destination is where a person set out for; but as these stories richly illustrate, a destination's value and meaning — and sometimes its very location — can change en route. The countries of awareness discovered by our travelers are even more generously represented in these volumes than the many map points listed in the contents.

Traveling isn't all about the map. For the solo traveler it's about accepting an experience — brief or extended — of balancing risks with goals; information with desire; fears with action. It's about deciding where you're really going when a second ago you were a minute from arrival.

Imagine — or remember — yourself in these stories. Put yourself where *you* had to make a decision to continue or turn back; to trust or be wary. Think of losing your way, your money, or your identity.

Reader, when you travel light, slip one of these little volumes in your briefcase, backpack, or purse. If you're off on a longer trip, pack the whole set in your luggage and extend your mental travels with these entertaining, beautiful, inspiring, eye-opening, exciting, and always thoughtful stories by women who travel alone. You will wish you were there when these writers tell you where they've gone.

— *Ann Starr, Editor*

# She Can Find Her Way

### Women Travelers at Their Best

*Essays by Independent Women Travelers*

# VOLUME 1

# On Getting Lost

*by*

## MARGARET HAWKINS

*To travel hopefully is a better thing than to arrive.*
— ROBERT LOUIS STEVENSON

WHEN I WAS a child one of my favorite books was Alice's Adventures in Wonderland, about a girl who follows a rabbit down a hole and discovers a new world. My brother gave me the book, along with the suggestion that if I looked hard enough I might find a similar rabbit hole in our suburban backyard. That prospect — me disappearing down a hole — was an idea we both liked, if for different reasons, and I still harbor a small belief I might find that hole, somewhere. Without it, a trip feels over before it's begun.

Maybe that's why I don't mind getting lost.

I almost always do. I used to feel ashamed, arriving at someone's house an hour late, with my platter of wilted appetizers, but I've come to accept it's how I roll. When GPS came on the scene, friends rushed to tell me about it. They expected me to change, and I thought I might,

but I never got around to buying one, or, later, to getting the kind of phone that would do the job even better. I knew that politeness demanded I try harder, but these devices made me feel bossed around and hemmed in. To me, they were like crossword puzzle answer books. If someone was going to solve it for me, I figured, what was the point of doing it at all? That's around the time I began to realize my expectations of travel were different from other people's. *They* wanted to *arrive*.

Driving alone, I take back roads. I stop to buy gourds from old men at makeshift stands who pet my dog. I don't want to obey some disembodied voice, urging me to get back on the highway. I don't want to walk streets in unfamiliar cities staring at a small screen, enclosed in that bubble of universal at-home-ness that is life online.

So I get lost. Denied the opportunity, I even miss it. Waterlogged maps and missed exits, or even just getting off an elevator on the wrong floor, which I do regularly often to surprisingly agreeable results, are just the grossest manifestation of what is mostly a state of mind. Even at home, I'm always a little dislocated.

Quiz: Are you the kind of person who likes to get *a.* there, or *b.* lost?

Twenty-some years ago, I signed up for an ill-considered bicycle trip through Baja, Mexico. My intention

was to lose myself in a foreign land while benefiting from the logistical advantages of group travel and partaking in wholesome exercise. Now, it seems like a dreadful plan. Then, I'd lost my way.

Though it was a tour, I was very much alone. My idea of bicycle riding was formed in childhood, pedaling meditatively to and from the library with a basket full of books. Now, among athletes, I daily lagged behind the pack, pushing my rented pedals in solitude while the skin boiled off my bones.

I was in no danger of getting physically lost. There was only one terrible road, flanked by a murderous-looking ocean on my right and sere scrubland to the left. My options were simple: keep going or give up, and wait for the "slag wagon" to come scrape me from the pavement like a dead dog. Still, lost I was.

On the third miserable day, lightheaded from heat and boredom, I spoke to a bull. He stood in a field, as I slowly pedaled past. I was lonely by then, and struck by the animal's gravitas and beauty. When he raised his head and looked at me, I asked if he was a Taurus.

Now, I love animals. I never meant to tease him. But perhaps there was a misunderstanding. He began to toss his head. Snort and paw the ground. I remember the sound of his breath, his hooves on the dry dirt,

as he trotted in my direction, picking up speed as he came. I don't remember a fence.

I found out that day I was more of an athlete than I thought, though people who know these things tell me I wasn't fast but lucky. If the bull had wanted to do more than chase me off, he would have, easily.

Recently, I asked my husband what the moral was. "Isn't it obvious?" he said, seeming a little annoyed with my denseness. "Stay with the group." I'd expected him to say don't talk to bulls. Even if he'd said stay home I wouldn't have disagreed. But *stay with the group*? Never!

People say the key to a good trip is planning. They get mad when I quote the David Whyte poem: "What you can plan is too small for you to live." They want me to get with the program. Follow the itinerary (syllabus, recipe). I understand. It's why I like to travel alone. Though even I will acknowledge that sometimes surprise is just a nice word for disaster.

Over thirty years ago, I drove my Ford Pinto from North Carolina to Chicago, with a load of paintings and a can of turpentine in the trunk, heading home after graduate school. Somewhere in the mountains, my rear tire blew.

Cell phones didn't exist. The protocol then was to put up your hood and stand by the side of the road look-

ing hopeful. Sure enough, almost immediately, a pickup truck stopped and out spilled a gang of teenaged boys. They seemed deeply pleased, unloading my trunk to get at my jack, to find a pile of nudes there. Respectfully, they lined the paintings alongside the road, modestly facing away from traffic, then changed my tire. *Trust*, I thought smugly, *and the universe will deliver.*

Spare tire in place, I drove west and crossed the Tennessee border late that night, feeling tired but lucky. I suppose you'd say my guard was down. When I saw a neon motel sign ahead, on a deserted service road, I pulled in.

Waiting alone in the cool mountain air for the night clerk to answer the bell, I felt someone approach from behind. A woman now stood close to me at the outdoor check-in window, though just a moment before the road and the parking lot had been empty. The motel clerk appeared. There was one room left, he said. The woman suggested we share, and offered to pay.

Reader, I almost said yes. I was about to — fatigue short circuiting my brain and my father's thrifty voice ringing encouragingly in my ear — when a strong, clear feeling came over me: get out of there.

Back in my car, wide awake now and driving fast, trying to figure out what had happened, certain physical

details began to register — coarse dark hair on thick wrists that stuck out of the too-short sleeves of a long-sleeved blouse, the wig-like coiffure that was maybe just a wig, the deep whispery voice. I wasn't raised to trust my gut, but that night I learned to.

Riddle: When do you travel alone but you're not alone?

Answer: When you take your dog.

Sometimes you're not the one in danger. One July I packed up Max along with a few provisions and a small tent and drove us to a picturesque campground in the Kettle Moraine, in southern Wisconsin. I looked forward to the kind of bolstering silent companionship that only a dog like Max can offer. His full measure cannot be taken here but suffice to say he was superb company. And he loved my convertible.

I planned to spend two nights.

I'd bought a cheap one-man tent for the occasion, one I could easily pitch myself. The guy who sold it to me said it would fit one adult and one child. I suppose he'd sized me up, when I told him what I wanted, and figured I must be somebody's mother, off on a Girl Scout trip. Perfect, I'd said. I didn't tell him my prospective tent-mate was a Rottweiler.

Cell phone reception ended abruptly at the park

entrance. At first, Max was cautious. He stayed in the car while I unpacked, pitched the tent, built a fire, opened a bottle of wine, only venturing out, finally, to eat. I looped his leash to the picnic table but I didn't really need to. He stayed close, seemingly spooked by things I could only guess at. After supper he assumed his guardian lion pose, surveying the woods while I read the newspaper by the light of a full moon.

Max always did have a thing for the moon — when his time finally came he left the earth on the eve of the longest eclipse of the twenty-first century. That night, in the tent, it wasn't long before caution turned to curiosity and he'd figured out how to poke through the flimsy fabric and break free. By the time I was up and after him, he was out of sight, gone exploring.

It's a terrible thing to lose your dog, even for an hour, to squander all that trust and put him in danger through your own hare-brained idea of adventure. Imagine the campground, quiet as a graveyard, lit by a full moon. I was sure someone would wake and shoot him on sight. (With his stub of a tail, he resembled a small bear.) When he returned, as mysteriously as he'd left, I lay awake all night, clutching his leash, listening to him snore.

I should have left at first light. Instead, I was determined to hike. It was early, still cool when we set out.

Then the sun climbed the sky. A half hour in, ragged from no sleep, I realized I'd forgotten water. Heat bore down, a gaseous predator intent on killing something. Pretty soon, Max quit walking and flattened himself in the grass. His black coat shone in the baking sun, and he locked his eyes with mine as if to say *please. Can we leave now?*

But we couldn't. The marked trail had disappeared, or I couldn't see it. I could hardly think. The sun grew hotter by the minute. I peeled off layers of clothing. Max remained encased in his black fur coat.

That was the hour of guilt. Loyally, my dog had followed me and here is where I'd led him. He weighed over ninety pounds. Even on a good day I couldn't carry him and this was not that.

Max, ever stalwart, must have known it was up to him to save the day and after a while he stood up. Eventually we found the faint trail and our way out. I sped back to Chicago feeling foolish and, once again, lucky. Max ended up living an unusually long and healthy life, but I could have lost him that weekend, several times. What's the moral? Carry water, for sure. Leave your loved ones at home? Maybe. But, never risk getting lost?

Ever notice how the word worms through our language, suggesting a universe of possible dislocations?

Get lost, we say, in insult. We lose ourselves in thought, rue a forgotten skill as a lost art. We lose our way, our inhibitions, our minds. Patti Smith believes in a Valley of Lost Things that lures away what we love, which we then seek at that saddest and most hopeful of places, The Lost and Found. Finding is its own reward, after all, and you can't be found until you're lost. That hint of old-timey redemption gets me every time. I want to be the 100th sheep. Note as well, the delicious paradox: you *get* lost — losing and getting rolled into one.

When I was a freshman in college I took a train from Champaign, Illinois, to Chicago, where I planned to transfer to another train. I was on my way to visit a friend at a college in the western suburbs. It didn't seem like a particularly risky venture. As a younger teenager I'd commuted into the city hundreds of times, sometimes for classes at the Art Institute, but often just to wander. I thought I knew the city pretty well. I liked to hang out at the train station, to people-watch and, frankly, to experience the frisson of mild danger given off by the haunted stares of shaggy old men.

It never occurred to me there was *another* station, let alone that I was on a different train line and had gotten off one stop too early. But there was and I had and now I was on the south side of Chicago looking for a

nonexistent connection, with little cash (I'm not sure I'd even heard of credit cards), the only pale person in a sea of brown faces. I wasn't in danger, exactly, but it was nighttime and I was eighteen and I must have stood out. Safety, in such situations, depends entirely upon whom happens by.

You could stop right here and say the moral is Get a Grip. Be sensible for God's sake. Study your schedule, instead of looking out the window. Memorize your stop. *Pay attention.* (I'm channeling my father here.) Stop Being Such an Irresponsible Moron and, if you can't do that, Just Stay Home.

Fair enough, point taken. I'd like to posit an alternative conclusion though, which is that if I had been that sensible girl and done all those things I'd never have gotten the second part of the moral, which is that, occasionally, if you're open to it and very lucky, when the near future seems like an opaque, toxic sludge that's going to crawl down your throat and choke you, and only when you don't expect it, a high school boy on his way to his night job at the post office but possibly an actual angel appears out of nowhere and notices your uncomprehending stare as the woman in the information booth bombards you with complicated directions, and steps in to interpret the timetable, walk you to a

train, explain where to transfer, keep you company, entertain you with stories of his life plan until your departure time, and generally set you on the right path. Then, just before disappearing, as a way of revealing its true identity (for beneath the hoodie or the housekeeping uniform or the food worker's hairnet, this person is beyond gender), said angel will bestow upon you a dazzling angelic kiss, and by that you will know it, and know that everything will be all right, if not in the exact way you intended, a fact you may not figure out until almost twenty years later, *when it happens again*.

I was at Newark Airport, on my way home from some ill-advised, ill-conceived business trip. I had too much baggage in every way, starting with a load of samples that would never become products. (Gem-studded silver collectors' plates from Nepal featuring dancing Hindu deities, anyone?) Meetings in New York hadn't gone well. Things weren't going very well at home, either. I looked forward to being airborne, hoped, in fact, that my plane would orbit the earth for the rest of my natural life, allowing me to read magazines and eat freeze dried pasta until I died peacefully from old age, buckled into my aisle seat.

All I wanted was to set down my bags. First though, I had to get to the gate.

But, danger? You say. Oh, none really, unless you count the possibility of self-annihilation, or at least of losing my mind, and maybe a little recreational self-harm in an airport bathroom. Just to take the edge off, you understand.

To make matters worse, I'd missed my plane. My alarm hadn't gone off and, due to strange circumstances outside my airless hotel room the night before, involving banging on my door and undecipherable mumbling in the hall, I had not slept much.

Waking groggy and disoriented, I could tell I was hours late by looking at my wristwatch. When I'd reached for my alarm clock, though — why hadn't it gone off? — it wasn't there. I found it on the floor across the room. Had I thrown it? Wouldn't I remember that? Did that have something to do with the strange sounds I'd heard? Nothing made sense. And didn't the name of my hotel, The Warwick, sound kind of like warlock?

Spooked, I got myself and my pile of ridiculous stuff into a cab and to the airport, then on a waiting list for a later flight. But I still had to get to the gate.

I was feeling low, inching the useless pile along the waxed floor when out of nowhere a tiny woman, not young and dressed in a blue housekeeping uniform, rushed toward me as if I were a fire to be extinguished. Speaking

a staccato language I didn't recognize, she glanced at my ticket, grabbed most of my bags and marched ahead, fast in her rubber-soled shoes. Briefly, I lost sight of her. Maybe she was a thief, I thought, hopefully. But when I got to my gate, there she was, guarding my stuff. Before I could thank her, she'd disappeared into the crowd.

This sudden kindness was strange, but so was everything that day. I fell asleep against a pile of metal Shivas and didn't wake until my flight was boarding. I ducked into the ladies room. There she was again, the woman in the blue housekeeping uniform.

The next part is embarrassing — I tried to give her money. (I wanted to thank her! Words weren't working, and surely she could use it, I reasoned. Hadn't she been cleaning toilets?) But at the sight of my cash she raised both palms as if to ward off evil. Then, maybe to shut me up, she grabbed my face and kissed me on the mouth.

One night, years later, after a few glasses of wine, I told this story to a friend. I stopped there, at the kiss, and topped off our glasses. To me, that was the end of the story, the natural climax of one of the strangest days of my life. My friend looked expectant. She waited, and when I didn't continue, she asked, reasonably, "So, then what?"

I had to think, try to remember what happened

next. "I think I burst into tears," I said, surprised to retrieve that detail.

"Sure," she said. "But after that?"

I can see now the story cries out for denouement. If I'd written it as fiction, I would have made up something good — the front-page headline on the newsstand at O'Hare, after I landed, announcing the plane crash my mysterious delay had allowed me to miss. Or my subsequent conversion to Krishna consciousness, or the Catholic Church. My first day at the nunnery, my airport angel would reappear, and turn out to be the Mother Superior. As it was, the day devolved into routine, as most days do. But the memory hung there for years, leaving me to wonder occasionally what, if anything, it meant. Then one day I remembered the boy in the train station. Which led me back to the moral, which sank in this time. See above.

A long time ago I struck up a collegial friendship with a fusty, semi-retired humanities professor who taught where I taught. We talked about books and movies and I thought we were buddies, until the day he casually referred to me as "a bit of a lost soul."

I was mortified, not just insulted but hurt, and after that I avoided him. He was pompous, fatuous, I decided. It took me a long time to admit to myself he was also a little bit right. It took me even longer not to care.

Now, I let my freak flag fly. I don't just get lost. I *am* lost. It may be the very thing that makes me a writer. Certainly it's what makes my life interesting, to me at least. And those sure people? The ones who are always right, who always know where they're going and where I should go? The tour guides and correctors of the universe who would march me past my rabbit hole every time? The ones I used to cross the street to avoid (who'd usually follow me, and escort me back)? I used to kind of hate them. Until I realized: I need them. I like to think we need each other. Someone has to remind the sure people to keep an eye out for holes. ✍

# On the Train

*by*

**MAGGIE KAST**

*This essay is sponsored by the kind
generosity of Laurel Richardson*

*I*'M ON THE wrong train. No, I'm on the right train, but my bags are on the other train. Three minutes to go. I've run in flopping Birkenstock sandals the length of the track and down the stairs to change my ticket from Zell am See — that's Zell on the Lake — to Zell am Moos — that's Zell on the Moos River, or something — and I've run back. Panting, I've climbed into one of the two trains on adjacent tracks, and my mental wires cross. Is this the 2:26 train on track 14 with my bags in it or the 2:40 train on track 13 with my bags mistakenly transferred? Sweat drips into my eyes, and suddenly the familiar appears strange, each object standing outlined against its background, like words in quotation marks.

"I've changed my ticket, but I have to get my bags," I tell the conductor in German. "OK," he says. "But hurry." I race through the train, throwing my weight

against the heavy doors between the cars, searching frantically, finding nothing. Passengers see my agitation and ask helpful questions, but I don't have time to explain. I see the lady with whom I believe I left my bags when I began this mad exchange.

"Did I leave my bags with you?"

"No," she says, making me wonder if I might have moved them to the other train before I ran downstairs. My heart is pounding.

"Did you get your refund?" asks the conductor, very concerned that I have paid too much for my trip, ignorant of my confusion.

"*Ja, alles in Ordnung.*" Everything's OK. Of course it's not. I jump off the train and glance at my hand. I've not even had time to put the change back in my wallet. I'm all alone, and I don't know what to do.

It's hard to explain how I got the wrong ticket in the first place. I planned this bike trip from Warsaw to Prague in the late nineties, when people still used travel agents. It had been almost ten years since my Austrian husband, Eric's death, and I'd never been to Europe by myself nor done a cross-country bike ride. Travel to Europe was still a hesitant approach to an unhealed

wound, tempting me to seek traces of Eric in the moun-
tain air we'd breathed together or the new wine we'd
shared, the street names he liked me to read aloud to
him or the cobblestones that took him back to child-
hood. He had been Europe to me, with its millennia
of culture and conflict, and I approached the continent
this time with both desire and trepidation. I would not
revisit Vienna, Eric's birthplace, where we had so often
been together, but skirt it carefully, joining members
of the Bicycle Adventure Club from all over the U.S.

I'd been riding locally to improve my strength and
stamina and also took a German class, raising my level
to a solid intermediate. The ride turned out to be good
and hard, the kind of trip that bonds a group in mu-
tual support. Often the maps seemed designed to con-
fuse the enemy rather than guide the visitor. We missed
turn-offs, took detours and asked directions in mime,
looking out for each other. One day I rode with Ed, a
big man in a loud stars-and-stripes outfit, and we were
lost for three hours looking for the Wieliczka salt mines,
famous for underground palaces and statues made en-
tirely of salt. My embarrassment at Ed's clothing soon
gave way to gratitude for his six-foot presence and

friendly companionship. As we rode, I discovered the steadfast man who'd married young, then lost his wife and raised his five-year-old son alone.

"Gdzie jest Wieliczka?" I'd ask a passerby each time we came to a cross road, trying to remember that "w" was pronounced "v" and some "l's" were pronounced "w."

"We're doing great," Ed would say. "We're almost there." We arrived at the mines just as the group was finishing the tour, but we had no regrets. We'd been found.

Besides studying German, I'd taken a bike repair class before the trip and learned to take my bike apart for shipping and put it back together, but this knowledge had just glanced off my brain. So when I felt a loss of traction on my pedals one day in Poland, I wasn't sure what to do. With the bike off the road and laid on its side, my focus narrowed to its uselessly spinning wheels and dangling derailleur. The links that had fit so neatly when in place now seemed too short to work back in. My fingers got black and sticky as I struggled. When finally I succeeded, stood up and looked around, the group was long gone. There was nothing to do but continue, taking what I hoped was the right way. I rode

past the fruit display stands and tobacco stores of a town center, and then past homes with flower-filled gardens, storks nesting on the roofs. The summer day was warm and the air thick with humidity despite the cloudless sky. Houses gave way to a yellow field where a young woman in a bikini pitched hay onto a truck. She waved, I waved. Everyone in Poland greeted us with "*Dzein dobry*," good day, and we replied in kind.

Soon I found myself alone, deep woods on either side of the paved but narrow road. I began to feel like the last person on earth, endlessly pedaling. I wasn't frightened of the present but worried about the future. Would I just keep riding on and on? The road felt like a path without context, a track with neither start nor finish, unrolling before me into the distance.

Sometime later, I heard a voice behind me. "Does your mother know where you are?" Larry, the group leader and a strong rider, must have circled back to the town, then quickly caught up with me. I laughed with relief first to hear and then to see him.

After the bike ride I planned to meet up with old friends of both Eric's and mine and attend a performance of the *Salzburger Festspiele*. My confidence buoyed by the

successful ride, I thought I was on my way, but more than mental wires had been crossed in the planning of this trip. My Austrian friends made a habit of staying at the *Gasthof Seewirt* in the *Salzkammergut* at the time of the *Festspiele*, where they knew the owner and ate the same delicious fish each year. They always hiked around the lake, the men in *Lederhosen*. With their guidance I'd made a reservation at this guesthouse and bought a ticket to the *Salzburger Festspiele's* most famous production, Hugo von Hoffmannsthal's *Jederman*, Everyman. I'd told my travel agent I wanted to take a train from Salzburg to Oberhofen-Zell. I had a brochure with a map of the town and picture of the guesthouse, but she could find no evidence that the town existed, much less train information.

At the German language table where I practiced speaking I announced that I would be visiting Zell, in the Salzkammergut near Salzburg. "Oh, Zell am See," said a native of Vienna. "*Sehr schön*. Nice place." So I gradually slipped into calling my destination Zell am See and assumed it was another name for the same place. After all, it was on a lake. The guesthouse brochure showed this clearly, so why not "*am See*," on the lake? Before I left home I received precise train instructions from my friends: "Take the train *Richtung: Attnang-*

*Puchheim* at 2:26, arrive in Zell at 3:10 and arrange for the *Gasthof Seewirt* to pick you up." I loved the precise note from my friends and relished the taste of *Attnang-Puchheim* exploding in my mouth like grapes.

I arrived in Salzburg and went to buy a ticket for Zell am See, surprised by how expensive it was for such a short distance. Then I looked at the list of trains posted on a high board and saw that mine is not the *Richtung: Attnang-Puchheim*. I showed the ticket agent the letter from my friend. Should I not be on another train? "No," they assured me. "You have a ticket for the right train to go to Zell am See." I went up to the platforms and loaded myself and my stuff onto the 2:40 train.

On the train I meet a communicative woman who has spent the day trying to get to her true destination after taking a wrong train. Suddenly reality begins to percolate through my brain, and I ask her if Zell am See and Zell am Moos are the same place. She does not know, so I run outside, thinking my bags safe with her, and ask the conductor.

"Certainly not," he says, outraged for me. "You've

paid far too much for Zell am Moos. Hurry downstairs and change your ticket." I have only a few minutes before the earlier train is scheduled to leave, and I drag my bags out of the train and throw them onto the neighboring one, leaving them with a young man who gives no sign of recognition or understanding. This is the moment and the action that are lost to memory when I return from exchanging the ticket. Thus I wind up rampaging though the train to Zell am See in desperate search before I finally jump on the train for Zell am Moos, just as it pulls out.

The train gains speed. The problem is now out of my hands. My breathing slows, and my brain lets go. I amble through the moving cars, surveying their contents. Quotation marks fade, and objects subside into their context, the world regaining continuity. I will probably find my things, but if I don't, there is nothing I can do until I get to Zell. For now, I am in a state of unknowing, and I accept it completely. I walk on air, dreamlike, through the unfamiliar cars. The lost chunk of memory slowly filters in and finds its place in my head. Finally I come to the uncommunicative young man. Of course, my bags are there.

Today, almost twenty years later, I see my confusion as a miniature reenactment of recovery from deep loss. In a few seconds, I went from panic to acceptance, an experience I would repeat, much more slowly, from the day my husband died, through years of therapy, to the present. I've taken bike trips through the San Juan Islands, the flat country of Holland and the jungles of Yucatan. Four years ago I made a long-wished for hike along the Camino de Santiago de Campostela, Spain's medieval pilgrimage route.

Moments of confusion are rare for me now, and I look at the uncertainties of youth — What will I do? Who will I be? — replaced by the narrowing options of old age. I will be whoever I am right now. Acceptance is a choice, if a difficult one, perhaps easier when there is no choice. I hope I will face the certainty of life's end with the same relief I felt when my brain released its grasp and I wandered through the train cars, luxuriating in my dreamlike pace, knowing my bags would either turn up or not. When neither Polish phrases nor pedaling legs can save me, perhaps the unknown will begin to look like home. I am on the train, and it is moving. There is nothing more that I can do. ❧

# Marry Me

*by*

ANNA SEQUOIA

⁓

IT WAS THE year I finally lost 60 pounds and began to realize I was beautiful. I was 21 years old.

I had a plane ticket and tuition for one term, a summer session, provided by an aunt who had lived in Europe and thought it was important for one's development as a human being to spend time there. I had some cash, not much, from the year I worked at Bloomingdale's after dropping out of college the first time; my parents contributed the cost of my *pensione*, the *Locanda Beccatini*.

I'd studied Italian for two years. Despite having devoted at least two hours a day to the language in class and during interminable subway trips to and from Washington Square College, my accent was horrible and I could barely sustain a conversation. That did not stop me. Two other students from Professore Benno

Weiss' class had signed up for the *Facoltá pergli Stranieri* at the *Universitá di Firenze*, and so did I.

I prepared for the trip by buying, on sale, a red bikini with a shelf bra and hand-painted parrot on the bottom that had tail feathers trailing down into the crotch. A neighbor, a widow who sewed for money, used a Vogue pattern to make dresses for me of fabric that wouldn't wrinkle.

My mother, my father and brother, plus three cousins on my mother's side came to the airport to see me off. I couldn't wait to get away from them.

~

The Italian language class was held in a high-ceilinged, fluorescent-lit room full of earnest female American students with midwestern accents. I found it remarkably boring. So instead of going to class, I went to museums, I walked, and I encountered people.

At the *Piazza dei Ciompi*, as we both were rooting through a box of old *latticino* marbles, I met a British expat who told me he had gone to school with Prince Charles. He confided, as I am sure he had many times before, that the future king wasn't particularly bright. He said he and a few friends were invited to the *Palazzo Pucci* the following evening, did I want to join them.

I said I would, but instead spent the next evening with a Greek architecture student, Theo, I met at the Brancacci Chapel.

I need to interject here: during the time I was supposedly a student in Florence, during the summer of 1966, I met exactly one school-age Italian — an earnest young woman from Montecatini who was living at my *pensione* and cramming for entrance to medical school. We saw each other at the main meal of the day, which she ate with her head down and in silence, speaking only to the *Signora*, with her hand partly over her mouth. It seemed as though every other young Italian had left the city.

The Greek contingent from the *Facoltà di Architettura* was still in Florence. Theo told me, in his mash-up of Italian, English and Greek, that the architecture school was full of Greeks because it was inexpensive, and also one of the best in Europe. He was handsome and charming, but very difficult to understand. It was a relief when his rowdy, laughing crowd of friends joined us. Three of them spoke English.

Costas looked a little older than the others. He joked less. He seemed serious and earnest. I noticed that while everyone else was guzzling wine, he sipped his; it didn't seem to interest him. But it was obvious to all of us that I did. When we crowded into his beat-up

Volkswagen bug, Theo behind us on his Vespa, Costas asked me to sit in front.

We drove to *Piazzale Michelangelo*, parked and climbed to a spot where there were benches and low stone walls to lean against. The sun was just setting and the city looked bathed in gold.

"*Guarda il bel spettacolo!*" someone exclaimed with an exaggerated British accent. "*Guarda il bel spettacolo!*" they kept repeating, laughing.

"The English have the worst accents," Costas explained. It made me both self-conscious about my own exorable accent, and relieved that I wasn't a Brit.

~

They were all on vacation from the university and had time to play. With Theo and Stelios, and Stelios' wife Ersi, we drove to see Michelucci's new *Chiesa dell'autostrada*. Costas and I drove alone to Pisa, and then to the beach at Viareggio.

Costas showed me his architectural drawings: buildings that to me looked strangely old-fashioned, with prominent carved wood rafter tails. They were very different from the stark linear sketches I would see later from his friends.

He taught me to count in Greek, to curse, and lascivious slang for parts of the reproductive system. He said he was disappointed that I wasn't a virgin. When he turned me over, he said at least I was "a virgin from the back."

I had never experienced the kind of voluptuous erotic pleasure he gave me. I was besotted by it. When he suggested that I leave the *pensione* and move out to Scandicci, to the apartment he shared with Theo and another student, I went. I knew it was selfish: I saw that the *Signora* was stricken when I told her. She supported herself by renting rooms to students; she had been counting on the money from me. How could I go with that man, she said to me. "*É un' brutto*," she said, he's ugly, and I knew she was talking about something other than his looks. I didn't listen.

When he asked me to pose for him without my clothes, I resisted. "No one will ever see them," he said. "Only me." He kept bringing it up. He would wait until I was lying sated beside him, and then ask. I finally relented. He set up a tripod, posed me sitting in a chair, and lying down. I was surprised when he lay on top of me and photographed us together.

I always knew he was going to back to Greece to see his mother.

"Come with me," he said one morning as we stood at the local bar in Scandicci having coffee. "Theo is coming with me, and Stelios and Ersi. We'll be crowded, but it will be a good trip." Then he lightly moved his hand along the back of my neck, in a way he knew would arouse me, and smiled.

"Marry me," he said.

"Sure," I said.

It was my way out; that was the way I saw it. My mother's older sister had done it; she had married a Czech diplomat and lived what seemed to me then a life of adventure. She'd escaped from her family's blue-collar roots in upstate New York, and I was trying to escape from mine. "I am in love with a Greek," I wrote to her. "An architect."

He didn't bring up money until we were about to leave. "I need to borrow money for the trip back," he said. "I'll pay you back."

"That's fine," I said. I didn't care about the money. We were getting married. There was a part of me that wanted to be taken care of. Besides, I felt flush. An uncle of mine, my father's younger brother, had just been vacationing in Italy with his wife and had given me a gift of cash.

~

There were five of us in the Volkswagen bug. Because of the luggage, Ersi sat almost all the way to Athens on her husband's lap. Everyone sang and told stories, mostly in Greek, up the coast of the Adriatic and down through Yugoslavia. Costas, Theo and Stelios took turns driving. We stopped for food and to relieve ourselves, but they kept on driving. Finally, in Thessaloniki, where Costas had cousins who could put us all up, we stopped.

Costas introduced me to the cousins. Both were older women in black dresses with black stockings rolled into a knot beneath each knee. They were sitting on folding chairs in front of the house and gestured for me to sit with them.

"*Kaliméra*," I said. They nodded, intuiting that was the extent of my conversational skill. Costas hugged me and with everyone else went inside.

After a long pause, one of the cousins said to the other in Greek, which by then I had begun to understand. "Don't worry, the same plane that brought her will take her away."

~

"Will you love my God?" Costas said to me, lying next to me in the hotel in Athens. I thought it was one of the most ridiculous questions I had ever heard, so I didn't reply. He knew I was Jewish. There was not one chance I was going to convert.

I did not like the hotel. It was too far from the center of the city and being there made me uneasy. The place was strangely quiet; I never saw another guest. The evening Costas installed me there and made love to me, after he left I had decided to read. When I turned on the light above the bed, the bulb was red.

"Why would you put me in this kind of hotel?" I asked him the next day.

"It's not easy to find a hotel where I can be upstairs with you," he said.

By day, alone, I walked around Athens or went to look at the ancient jewelry at the National Archeological Museum. I found Athens hot and crowded and frenetic. In the neighborhood where I was staying, I discovered a restaurant where I could go into the kitchen and point to what I wanted to eat. But I didn't like eating alone in restaurants, and I was lonely. I didn't see Costas for days.

Finally, he invited me to have dinner at his mother's house.

His mother was very polite to me. She was a short, stocky, somber woman dressed entirely in black. She spoke no English, but I immediately intuited that I was there as a school friend, not a fiancé. She pointed me toward the low-ceilinged, tight dining room that I suspected also served as a living room. Costas told me where to sit. On the wall directly across from me was a huge, hand-colored photograph of a man with extravagant mustachios dressed in Greek military uniform. The top of the heavy frame jutted out from the wall and loomed over the table.

"My brother," Costas said when his mother was out of the room. "Killed in the Civil War."

His mother brought in a large, heavy platter of *keftedes*, lamb meatballs, and then left again.

"We're waiting for someone," Costas said. "Have some of these. They're delicious."

A few minutes later another woman joined us. She was younger than his mother, although by no means young, and also entirely dressed in black.

"She was engaged to my brother," Costas told me in English. "She comes to dinner every Thursday."

"She's wearing black for him?" I said. I felt stupid asking it, but I wanted to be sure.

"Yes," he said.

"They never married?"

"No," he said.

Dinner was awkward. Costas translated a few bits of conversation. Mostly I praised his mother's cooking, which was exceptional. The brother's "widow" barely spoke.

Eventually, I excused myself and asked for the lavatory. Costas got up and led me outside, into an unlit paved courtyard. The bathroom was in a separate, small building with a cement floor with a drain in the center. The shower consisted of a pipe that stuck out of the wall, with an encrusted showerhead and no curtain. I had the uncomfortable feeling that the room needed a good scrubbing.

After the meal, after I thanked his mother with the words he had taught me, after we went back to the hotel and had sex, Costas said, in a mix of English and Italian, "When we are married, no more *cosmetici*, no more *minigonna*." No more cosmetics, no more mini-skirt.

Then he informed me that we would move into the house with his mother.

*Not on your life buster*, I said to myself. Absolutely not. I was not escaping the Bronx to go live in Patissia, Athens, in that depressing house with his mother and the "widow" of his brother coming to dinner every Thurs-

day evening. Not in that house with the portrait of his brother leaning over ever meal. Not with that bathroom across the courtyard with the weird toilet I still wasn't sure would even flush. And I was not going to convert. I was not giving up cosmetics. I was not going to stop dressing any way I wanted to dress. I was not going to efface who I was, or what I thought, to fit into some outdated ideal of an old-fashioned Greek's idea of what a woman should be or act like.

That was it. It was the end of the erotic torpor. It was the end of my own passivity. Done. The next morning I went to Piraeus with my suitcase and got on a ferry to the Cyclades. I wasn't even positive where I would go, but I remembered that when I once again ran into the pretentious Brit who had mentioned Prince Charles, he had talked about the Greek island of Ios. He'd said it was beautiful, inexpensive, and it was easy to rent a room there.

I stopped in Santorini. I'd been a wimp and had left a note at the hotel for Costas. I felt guilty, but then I realized that in a way I was running for my life. I stayed overnight then got another ferry to Ios. And as the ferry was pulling near the dock I saw them, my friends from the University of Florence School of Architecture: Theo and Stelios and Ersi, and other people I knew,

waving as they recognized me on the bow. They had been there seeing off some friends from Athens.

When I told Stelios later, as we sat at a long table with Ersi and Theo and the others, eating fresh-caught grilled fish and drinking retsina, that I had had enough, I was done with Costas, Stelios said "Good. You know, he has no money. This is how he manages. Every year he finds some good-looking woman to seduce and pay his way. I'm a little surprised it took you this long; you seemed like the smartest of the bunch. I'm glad you left. But I will say you looked great in those photographs he took. I liked the ones without him in them." ⁓

# Road block

*by*

## LAURA GREENE

◌ↄⱷↄ◌

*I WASN'T SURE IF our truck was slowing down, or time was. As we closed the distance to the road block, I thought maybe we could speed up and drive around them. The ground was flat and our truck was sturdy. Couldn't we just make a huge arc like the ostrich, and go back the other way?*

*Then I saw them.*

*Guns.*

*The men were casually taking rifles off their shoulders, with smiles as big and white as the great salt pan around us.*

*I'd be lying if I said I wasn't scared. My fear was as hot as the sun, but at the same time, I relaxed. I knew this was coming, and there was relief in that. Because once you're caught, you don't have to run anymore. And I was tired. So tired...*

### 15 MINUTES EARLIER

It was dazzling white as far as the eye could see, over the dashboard and in the rear view mirror. The flat, bleached, dusty plain stretched from Namibia's Skeleton Coast behind us, almost all the way to Windhoek, 250 miles to the east. Juda was asleep in the passenger seat, or at least appeared to be, her forehead creased from years of suspicion. She always had one eye open, getting up in the middle of the night to check the locks, or mutter about Angolan drug dealers, baboons, or tigers, even though there weren't any tigers in Africa.

I picked her up a week ago, at the backpacker's hostel in Windhoek, along with two Korean girls and a Japanese guy. We drove to Soussuvlei, a desert of red sand with the tallest dune in the world, then west to the coast and north to Swakopmund, a low slung, white walled city that hugged a strip of beach between the desert and the dazzling cold sea. The landscapes and wildlife had hypnotized four of us into a deep, silent, wonder but Juda's face never lost it's cynical scowl. I was hoping she would stay behind with the others in Swakopmund, but she stuck to me like glue, always asking where I was going, and then finding an excuse to go there. While the other passengers had paid for their share

of expenses in a lump of cash, said their farewells in the universal language of nodding heads and smiles, and disappeared into a backpackers hostel, Juda remained in the car, head swiveling anxiously, asking me to hurry. She grated on my nerves, but instead of speaking up, I just got quieter. I wasn't in the mood for conflicts.

The two of us left Swakopmund an hour ago, and once Juda calmed down, I could start thinking again. It was February 5th, ten months now, since my mom died, and my cat died, and I had died too, in a way. I held it together for a long time, but life started to unravel anyway, in the way it does, slowly, then quickly. One day I walked in the bar to see my boyfriend kissing another woman, his dirty dishes still in my sink, his beer in my refrigerator.

"Why?" was all I could utter through a clenched throat.

"Why not?" he smoothly replied, eyes as emotionless as the blue desert sky.

After that I stopped caring about anything. I packed a bag and left. Life became simple and clean, like this Namibian desert. I could see things clearly now. It was all just sun and sand. Salt and light. Bones and ghosts.

I took a deep breath and felt something loosen in my gut. Only a few more hours to Windhoek and I

would be saying goodbye to Juda, returning the expensive rental truck, and hopping a bus to the next country. Maybe I'll swim with sharks off Cape Town, or climb Mt. Kilimanjaro. All that mattered was that I kept moving. I could stretch my inheritance a few more months. After that, who knows? But I didn't have to deal with that yet.

Something caught my eye off to the right of the road. A form wavered in the heat waves and with nothing else on the horizon, its height was impossible to gauge. The ghostly white figure was moving fast though, and on an interception course with us. I dropped my sunglasses over my eyes and squinted. It was an ostrich, running at top speed, skinny legs pumping like a sprinter, leaving puffs of white dust in its wake.

When my foot came off of the gas, Juda jerked awake. "What's happening?" she hissed in a panic.

I pointed, smiling.

The ostrich was clearly bearing down on us, so I slowed further. The ostrich slowed too. Then it turned in a great arc and ran the opposite direction away from us, as if it had all been a huge mistake. I drove on, watching the giant bird disappear back into white oblivion.

"Strange." I muttered.

One day a biologist would tell me that the eyesight of ostriches is notoriously bad. Our white truck with black wheels probably appeared as a competitor from a distance. The great flightless bird was running towards us until he realized we were bigger than him, then ran away. So it is in Africa, one must always be ready to fight or run.

Juda settled back into her corner of the passenger seat like a spider, staring out the side window. There had been no other signs of life for an hour. The white road was barely distinguishable from the landscape, making my eyelids grow heavy.

I closed my eyes for a long moment. When I opened them, there was more dust ahead. Something was moving towards us on the road at high speed. Another ostrich? No, another vehicle. The first I'd seen since we left the city behind. A moment later Juda jerked up, her beady brown eyes peering out of a weathered face that had seen way more sun than an Englishwoman should.

I slowed down.

"Don't slow down!" she barked.

I rolled my eyes and maintained a casual 45 miles per hour as an old pick-up truck approached. Sunlight reflected blindingly off the windshield and it was only

when they passed that I got a glimpse of three black men sandwiched across the bench seat, staring at us intently. Juda stiffened and sucked air through her teeth as I waved and gave them a big smile.

"Don't do that!"

I jumped at her tone.

"Jesus. Relax!" I snapped.

She ignored me and stared into the side mirror as they retreated in the distance. I looked in the rearview, irritated at Juda. She had startled me and now my heart was racing. Or was it something about the look of the men? I chastised myself for feeling fear at the sight of black men and checked my stereotype radar. If they had been white, would I be nervous? I looked ahead at the great salt plain. It's emptiness no longer comforting but exposing. I realized the source of my discomfort was not because they were black, but because I was white, in a remote region of Africa, and naive enough to think that nobody would care or notice. Furthermore, we were at least 50 miles away from even a gas station, and there was no cell phone service. The men had looked like they wanted something too, and besides a bottle of water and some biltong, I had thousands of Namibian dollars in my wallet. I wanted to be alone right now, alone, but not vulnerable.

I looked again in the rearview mirror, the car was hidden in the dust of its wake. Then I looked ahead. Another vehicle.

"Look. Here comes another car. It's fine." Was I trying to calm Juda or myself?

She snapped her head up, looked ahead, then in the side mirror again, while raising her hands slowly from her lap to start clawing the air. *Oh here we go*, I thought. She's calling her 'cats' again. When Juda gets nervous, she summons two invisible tigers to protect her. Evidently, they have saved her life several times. However, the cats are also the reason she is in Namibia trying to sneak across the Angolan border and supposedly reclaim an inherited fortune from a drug cartel. This was all she had revealed to me during five straight days in the car. I stopped asking questions when her answers made me more nervous than her silence. Her spirit animals seemed a bit lacking when it came to common sense.

It became apparent that the car ahead of us was stopped. I took my foot off of the gas again. Juda's hands were still clawing the air slowly, methodically, like she was prowling through the brush. "Cats...Cats..." she whispered. Her eyes had a far away look now.

Ahead the dust was settling around the vehicle, a white van blocking the road, with figures moving

around it. Their dark skin shimmered in the sun like Pharaohs as they looked towards us expectantly.

In the rearview mirror, another truck appeared out of the dust, the same one as before, coming up behind us, bumping madly over the uneven road. We were being penned in. As I closed the last 100 feet, the men fanned out and waved as if being friendly, their smiles flashing like hyaenas. I counted five of them. Eight men, including the three coming up behind us. Juda sucked in more air and continued whispering for her cats like a mantra.

I slowed down, time slowed down, and the crunch of the wheels over the gravel softened and slowed, leaving an ominous quiet as I pulled to the side of the road. Juda stopped clawing the air.

The leader of the men stood in front of the group, tall and fearless, somehow knowing I wouldn't run him over. When our large Toyota truck stopped six feet in front of him, he looked it up and down as if appraising its condition, eyeing the plates, the grill, the wheels. His dusty button-down shirt and faded brown khakis looked like something that could have passed for a uniform, but without any distinguishing marks. His aviator sunglasses reflected the truck back at me as he ambled towards the driver's side window. The rest of

the men hung back with their rifles draped casually over their shoulders or pointing at the ground, eyes flicking back and forth between the three of us. I stared towards the leader's eyes like I had learned to do with both animals and people these last few months in the African bush.

As my finger pressed the window button, it lowered with a sigh that blended with Juda's whispered, "Bloody Hell."

He smiled a big smile, his comfort almost putting me at ease. I smiled back by squinting my eyes, Clint Eastwood style, keeping my foot on the gas pedal.

"Good morning, Miss." he announced in a smooth baritone voice.

"Mornin'."

Then he looked past me at Juda, who was frozen in her seat.

"And how are you?"

Juda said nothing.

He paused for a moment, raised his eyebrows, then looked back at me.

"Driver's license please."

My wallet was in my purse, in the back seat, filled with the 5000+ Namibian dollars that the former passengers had given me, along with two credit cards,

and a debit card from my quaint little credit union back home. All were impossible to replace in this country. My passport, however, was next to me, sitting in the cubbyhole of the driver's side door, so if I lost my wallet at least I wouldn't lose my passport. Surely all they wanted was money, right? My eyes flicked across the men. They were no longer staring at the truck, they were staring me.

"Juda, hand me my purse." I said in my Eastwood voice.

Juda didn't move.

The leader leaned down to give her another look. Only then did she move, slowly, reaching back to get my purse, and handing it to me without taking her eyes off of the man. I dropped the canvas bag at my feet, leaned down, and felt around for my wallet without dropping my gaze, my fingers recognizing the familiar feel of leather and plastic cards. A moment later, I handed him my Oregon driver's license, folded, faded, and with the lamination peeling off at the corners. It was seven years old. He looked at it quizzically and then mumbled something in another language to the men nearby. Their expressions didn't change. He looked up and waved the license in the air.

"This is no good. You cannot drive with this here."

I paused, the wind was starting to blow white dust into the truck.

"Really? I was told it was fine back in Windhoek."

"Who told you this?"

"The car rental agency."

"This is a rental car?" his eyebrows raised.

Before I could answer, he laughed and said something else to the men. They smiled. That didn't seem good for us.

He looked at my license again still smiling, but when he looked back at me, his face dropped.

"Why don't you step out of the truck".

The words fell like rocks.

I knew if I got out of the truck, I might never get back in. My hand was still on the stick shift, one foot on the gas, and the other on the clutch. My muscles ached to put the car in gear, but instead I stared at his head, fascinated by the spectrum of grey hairs mixed in to the black. Then I lowered my gaze back down to his mirrored aviator glasses, reflecting my image back at me, a white woman, looking out from the shadows. Maybe I should step out of the truck? I could just hand him the keys and walk out into the desert, where the sun could burn away the darkness that weighed me down.

He slid his sunglasses to the top of his head revealing

brown, bloodshot, unblinking eyes. They had the look of many I had seen on this continent, slightly supernatural, untouched by fear, unclouded by depression, and hardened by a life of sun and toil. They were everything most Americans' are not, the eyes of someone who survives everything, until they don't.

He said again, slower, quieter. "Get out of the truck".

Feeling the pressure of his gaze, I looked away, ahead, and then over to Juda. Her eyes were closed, hands clasped. She appeared to be imitating a corpse, and was obviously not going to be any help.

My instincts urged me to keep talking and stall the man outside my window, so I forced myself to look back at him, gave him my bravest smile, and reached down to grab my passport. "Well, I also have this…" I said, leaning back slowly, and extending the blue leather-bound document out the window. The gold embossed eagle and lettering reflected the sun.

*United States of America.*

He stared at it for a moment as recognition flooded his face, quickly followed by something I hadn't seen yet. Surprise.

"America?"

I nodded and pursed my lips. This was not always a good thing to admit to people.

He eyed the passport, turned it over, then slowly

opened it, chattering to his men in another language. One of them swung a rifle over his shoulder and stepped to the leader's side. They flipped through the pages filled with visas and stamps, paused to look at me, and then back at the passport again, mumbling to each other. The leader looked up.

"You are not Afrikaner? You look Afrikaner." He said skeptically, referring to the tall, white, minority population whom I bore a striking resemblance to. The history of apartheid and income disparity among the white and black populations of Africa is still a tense, unresolved conflict in this part of the world.

"I am not Afrikaner. I'm American."

He weighed my response for a long moment then looked past me.

"And you?" he asked towards Juda.

She was still playing dead.

"She's from England," I said, as if that explained her behavior as much as her presence.

He paused again, gazing at my passport.

"Why didn't you tell us you are American?" he said. I shrugged.

"How did you get here? What are you doing in the middle of Namibia?" He waved his arms at the white void around us.

*I don't know,* I wanted to say.

"I'm volunteering with the Cheetah Conservation Society, up by Otjiwarongo. We rented this truck to see the red dunes of Soussuvlei."

Unfazed he continued, pointing at my drivers license.

"And this...What is this place?"

"Oregon? That's the state I'm from."

He consulted briefly with his men, then turned back to me.

"Is it like California?" he said.

I paused. Something was happening here.

"Sort of, it is right next to California, on the Pacific Ocean." I led, encouraging his interest.

"What about Los Angeles, do you live near Los Angeles?"

"Well...yes," I replied tentatively. Compared to Namibia, I guess Oregon was pretty close to Los Angeles.

The men were crowding towards my window now, jostling each other for the best view. They suddenly looked younger, one couldn't have been more than 15 years old, wearing a faded Los Angeles Lakers cap that might have been yellow in another lifetime.

I looked from his hat to his wide eyes, when he caught my look he blurted out "Hello!" then quickly ducked behind his friend, peeking out a moment later.

The leader stepped forward and said quietly, "And Barack Obama? Have you ever met Barack Obama?"

At the president's name, everyone stopped talking and stared at me, the whole group holding their breath.

Nodding slowly, I said reverently, "Yes. Yes, I have seen Barack Obama."

The men exhaled in wonder at the same time and a din of questions in a language I didn't understand surrounded the leader and me.

Should I clarify that I was only one of a million people at a public rally? It didn't seem that important.

The leader remained quiet despite the others excitement, looking me in the eyes, then at my hair and faded cotton tee-shirt, around the truck and again down to the passport, as if seeing them all for the first time.

"And this, is this your name?" he said, pointing to it in the passport.

"Yes. My name is Laura."

He said it once or twice to himself before announcing it to the men, then turned to me and introduced himself by a hand on his chest.

"Dawid."

"Nice to meet you, Dawid," I replied.

He went on to introduce the other men, all of whom waved, or smiled, or looked down at the ground in response.

Then he looked past me at Juda, "And you, what is your name?"

I looked back at her. She still hadn't moved, but her shrewd eyes were now open, peering out from under stormy brows with something between terror and rage, hands gripping both sides of her seat as if expecting to be ejected at any moment.

"We need to go," she said tightly, quietly, like an overwound guitar string.

I widened my eyes and turned quickly back to Dawid, ready to apologize, my foot moving back to the gas pedal. Dawid only nodded and looked back at me.

"Yes! Yes! Of course. Sorry."

He handed me back my passport, slowly, staring at the eagle on the cover, then looked up at me, leaned in, and whispered, "You should be fine back to Windhoek, but if someone stops you again, make sure you tell them you are from America right away."

*"Right away,"* he repeated, emphasizing the syllables as he handed me back my identification.

"Will do." I replied, slipping my license and passport back in the side of the driver's door.

He stepped away from the truck and shooed the boys back, who were now giddy and giggling, guns swinging off their smooth arms like toys.

I finally allowed my foot and hands to put the truck in first gear. The tires crunched the gravel with a sigh

as I edged the truck around the van and back onto the road. When I passed the last of the boys, one raised his fist in the air and yelled triumphantly, "OBAMA!"

I waved and smiled and accelerated.

Juda and I watched their waving figures disappear in the rearview mirror, breathing as if we had both been underwater. Her hands slowly unclenched the linoleum seats.

"Will you put my purse back please?" It was still sitting where I had left it under my feet. She snatched it up and threw it in the back seat, far away from me, then retreated into her corner.

Ahead, the white desert stretched ahead, like nothing had happened, clear and open as another fresh start. In the mirror, only a faint reflection of the vehicles was visible. I looked back and forth between the road behind and the road ahead, until it was only empty desert again. When the last hint of the trucks disappeared I started shaking, great heaving spasms like hypothermia.

Juda stared at me, saying nothing, even when I pulled over. I opened the door and hung out to vomit, but nothing came out, heaving once, twice, and on the third time, something more like a sob emerged. For a moment, I thought this was it. I was finally going to cry, after a year. I wanted to, and waited for it, but the urge retreated

like a bad idea, replaced with the thought of the drive ahead. I stared at the ground for a few more long seconds until the heat and the fumes drove me to shut the door.

When I pulled back onto the road Juda finally stopped staring at me and returned her gaze to the horizon. She said nothing. I said nothing. The hum and rumble of the truck flying over the miles filled all the space in between the coast behind and the city ahead. The people of my past and the people of the future were ghosts again. There were no more ostriches before the flat white landscape loosened to sage-hued, rolling hills dotted with scraggly brush. Puffy clouds were building in the east, hinting at the approaching wet season. I started to wonder if the men were as threatening as they looked. Maybe those guns weren't even loaded?

*What are you doing in the middle of Namibia?* Dawid's words echoed in my head over and over.

Juda was mercifully quiet the whole ride back, only speaking up when I pulled into a gas station a few miles from our destination.

"Why are you stopping here?"

When her voice broke the silence I jumped. I had almost forgotten I was traveling with another human being.

"I need to fill the tank up with gas before I return the truck."

She considered this for a moment, and without looking at me said, "I'll get the gas."

I was struck by her gesture. It would cost almost $100 to fill up the large tank, and she had already given me money at the beginning of the trip.

"Well, okay. Thanks," I said, then smiled at her, probably for the first time since I had met her.

She looked down at her hands. "It's the least I can do," she said.

I slouched in my seat, embarrassed at my own foul mood.

"I'm sorry I haven't been much company. I just have a lot on my mind."

"It's no trouble," she said.

I resisted the urge to give her a hug. What was she doing out here, all alone anyway? *What are you doing in the middle of Namibia?* I wanted to ask her the same question, knowing she didn't want to answer it either. Maybe there was a kind and generous woman underneath all of those defenses. Maybe she was also looking for answers in the desert, drawn to the bright sunlight of the Skeleton Coast, the red sand dunes, and the mirages.

I was still feeling warm and grateful when I dropped her off at the bus station in Windhoek.

"That was quite an adventure," I said. "I'm glad you were with me for that drive. Thanks for everything." Not quite sure what I was thanking her for.

But a shadow had crossed her face and she was back to her regular self by then.

"Yes, well, I think you'll be fine," she said. It was such an odd thing to say.

"Ok. You too. Take care." I said sincerely, knowing I would never see her again, or send a message to the email address she had scribbled on a piece of paper.

"I will," she replied, looking behind me before quickly walking away.

By the time I realized she had taken my wallet it was too late. She was long gone. ⁓

# Lemmings

*by*

## MARIA LISELLA

*I* WASN'T EXACTLY ALONE. I would be joining a press group, eventually. That Friday the weather was cold, damp — Düsseldorf in Spring — and of course, this having been a transatlantic journey, the hotel room was not ready.

Rather than be organized about my approach to the city, like the museums are closed on Mondays so maybe I should see one or two now, I decided to wander. I meandered into what I think is the Altstadt, the Old Town.

I was so jet-lagged; I missed the Altstadt and walked along Düsseldorf's Fifth Avenue instead. And I got a look at the Japanese community in the city, the largest Japanese community in Europe but, hey, having jet lag is like being drugged. I can be face-to-face with the largest Buddhist temple in Europe and still not *see* it. Likewise, my judgment is a bit clouded.

But I knew Cologne was maybe twenty minutes away — I did not have a free transport card yet — so I found my way to the Hauptbahnhof, the main train station, and was struggling with the ticket machine.

In the screen's reflection, I noticed a tall, young man, bespectacled, in a long black wool coat. For a minute, I thought he looked like a Talmudic student. I'm from New York: We are hyper-tuned in to ethnicity no matter where we find it.

A minute later I heard a voice over my shoulder:

"You are wanting to go to Cologne?"

"Yes, how did you know?"

But I already knew how he knew but I was stalling for time; stalling enough to make an intuitive leap about this stranger looming over me.

"I saw the word Cologne pass on the screen...I have a ticket for just eight euros."

Already I knew it would cost eleven ...but I am always on the lookout for a "deal."

"I have a *group* ticket, and if we are six, we can travel for eight euros each, but one person dropped out, the train leaves in two minutes, want to come?"

"Okay. What kind of *group*?"

Notice I said yes first, then asked about the *group*.

"I will tell you on the train; but right now you have to run up those steps and get on the train to the left."

I bound up the stairs to the *group* train...it is still not clicking: Where am I going with this total stranger who seems nice, but a tad nervous himself? I am also thinking, I am a New Yorker for Chrissakes. We don't follow strangers to trains in foreign countries without asking a lot of questions, do we?

Just as I race along the platform to the train with the handsome German conductors holding doors and helping women on board, I think to myself: Hey, no one, but no one knows where I am. I left no word at the hotel desk. I did not contact my husband...I break into a bit of a sweat now. No one — as in *No One* —knows exactly where I am at this moment, including maybe me.

He points to a seat on the train. I take it. He announces to four young men: "We have our *group*, she is our fifth person."

They look at me, I at them. Nothing is clicking. "What kind of *group* is this?" I address to no one in particular.

The handsome Indian in Calvin Klein jeans smiles..." I don't know exactly but we are, in fact, a *group*."

I look at the others. The Bulgarians are smiling, but no English emerges, ditto the Russian guy; no one else speaks the same language. But we are all headed to Cologne, no?

I am still not following yet, am moving forward

with blanks before my eyes until I fasten on the love locks latched to the Hohenzollern Bridge that spans the Rhine River to Cologne. I trip out on this practice I have seen all over the world: Germany, Poland, China and even the Brooklyn Bridge: young lovers swear enduring devotion, lock lips and lock locks — of all kinds: ordinary brass locks, decorative locks on chain link fences, then throw the keys away to symbolize their everlasting love.

I trip out again: love locks on bridges originate from an Italian love story written by Federico Moccia that became an international bestseller and then a movie, *Three Meters Above Heaven*. In the most famous scene, a young couple places a lock with their names on the Milvio Bridge in Rome, renamed later as Bridge of the Lovers, throwing the key into the Tiber River.

I snap to attention as I catch myself mentally vacating time, space and my seat on the train, the *group*, the nice young man, now the nice young men. I sit up, hoping the train will indeed stop in Cologne. I am also hoping I have not made an ass of myself, in spite of my New York pride.

In the distance, I see what must be the Cologne Cathedral. We arrive in the cavernous Hauptbahnhof and we each run our separate ways.

I am struck by the seedy atmosphere around the foot of the Cologne Cathedral — the buskers, the homeless, the miracle workers, the hawkers — before I step inside. It is colder inside than out; I take in the odd Gerhard Richter window that of course does not really fit into the rest of the lovely stained glass; and I am too tired to keep walking and negotiating another city.

I stray not at all. I was so nervous at this moment; I walked a bit but made sure to keep the Cologne Cathedral firmly in my sight.

Back to the Hauptbahnhof, in fact. Once again I fiddle with the ticket machine.

Out of the side of my eye, guess who shows up? Yes, the nice young man who looks like a Talmudic student.

"You are turning around so quickly," pleased of course, that he has found me and possibly, two more members of the "new *group*."

"So let me get this." I ask him, "All you do all day is ride on the train back and forth. You make money on this one ticket you paid forty-one euros for, is that right?"

"Yes, this is true but only on weekends and off-peak hours."

"You must be making a lot reselling that one-day ticket over and over all day, eh, and it is not exactly illegal, is it?"

"No, not really...I suppose not... illegal, that is."

"What do you do for a living?"

He shrugs, "Not so much, really..."

"You do only this?"

"Well, yes. Now let's get another *group*, look to see who is going to Düsseldorf or the Airport."

"Wait a minute. I might enable you to do this, but I'm not going to collect your new *group*." I surprise myself with my indignant voice. I mean really, was I not benefitting from this sleight of hand with little to no risk-taking? In the end I could play dumb (or dumb as a fox, as my mother would say).

I back off and bump into a couple with thick Spanish accents. They ask me, "Are you with the *group*?"

Oh my God, now I am thinking, what is this, a cult? Do I have *group* emblazoned on my brow? How does she know about the *group*? Is this *group* illegal? Is she undercover and not a Spanish tourist at all? How much time would we be spending in a German jail? Or what would the fine be at the very least? I would hate to have to explain to my press group the very next day that I am missing because I was detained, in jail, paying off fines. This is not good. Too many people know about the *group*.

"Yes I suppose I am," I admit. "... and you are also in for the eight euros?"

Yes, again.

She asks, "Is this a crime?"

"I'm not sure," I say, and am amazed at how quickly I graduate to, "I don't think so."

All of a sudden I am the expert on rail regulations in Germany. Now I am assuring the Spanish tourists that this is not illegal. I think to myself, "Typical know-it-all New Yorker."

We board. The conductor comes by. This time I have no ticket. I simply say in English, "I am with the *group*."

"Oh, the *group*, okay," says the conductor, and he moves on.

I return to Düsseldorf Hauptbahnhof leaving the nervous Spanish couple behind as they ostensibly continue to the airport.

I half considered not forking over the eight euros to the mastermind, because what is his recourse?

But hey, am I going to get moral on this guy after I traveled both ways and saved six euros? After all, it was a win-win...I hate that expression, don't you? ⟞

# The Prodigal Daughter: Saturn Returns

*by*

## DIANE DOBRY

⳿⳾

*I*T'S EARLY MAY 2015, and I'm sitting on the floor in front of my bedroom closet, going through all my clothes, scanning the room to see what I can keep and what I should give away. It is the third time in six years that I've been laid off. I'm almost fifty-nine, and I first faced a two-year layoff six years before this. Since then, I have begun to plan for that possibility every time I find another job.

*Astrologers say that at around age fifty-nine, Jupiter and Saturn return to the place in the sky where they were at the moment of our birth. Saturn returns to its original place once every twenty-nine to thirty years; Jupiter, once every twelve years. Age fifty-nine is the only time after our birth that they do it in the same year. When I turned fifty-nine, I too, returned to where I was when I was born — my parents' home.* I moved into this apartment in

August. A sudden call came while I was traveling, inquiring whether I was still available to begin teaching at a college in Poughkeepsie within a week. Of course I could, I said, and got into high gear looking for place as soon as possible. What I found seemed too luxurious for me because, after all, it was a "luxury" apartment complex: washer, dryer, dishwasher, central air and heat, a balcony, wall-to-wall carpeting, a full walk-in closet just for me, and a remote-control garage. I calculated in my head whether I could save enough money to float through yet another job loss and still enjoy this lifestyle. I deserved it, and I wanted it. Especially the garage.

*At the first Saturn return, around age thirty, the foundation has been laid, and now it's show time. By fifty-nine, we pass the baton to the next generation — some of us rest on our laurels, some still fight the good fight. Others are reinventing themselves and the late bloomers or mid-life crisis sufferers are facing the reality that time actually **does** fly, and it won't last forever. Now's the time to do or die: Be that artist, make that journey across some ocean, leave a legacy, follow the dream.*

At twenty, I dreamed of many different lives: a stay-at-home mom, a commuter working in New York City, an expat and traveler in Europe — I'd become a local, in France, I imagined. A teacher, a writer, a TV host,

an astrologer. But I'd been taught that predictable and safe was the way to go. So I went with the security and predictability of marriage, kids, and a house in the suburbs. Still, adventure beckoned — travel, living alone, working in New York — discovering the world in ways my suburban life would never allow me to do.

*After Saturn's first return at age thirty, when it is one-quarter of the way around the birth chart at ages thirty-five to thirty-seven, we start to test the boundaries as we did before reaching puberty. When it arrives at the point opposite its place at our birth, by around age forty-two, "second puberty," the mid-life crisis, begins, and we may feel a sense of rebellion against life's limitations — the need to break free.*

My day of reckoning grew more insistent. What if I get to my deathbed and have never lived in Europe? What if I could have published a book or been a reporter, but missed my shot? Dreams, however, were not the main reason I jumped that ship. My contentious, disagreeable life exerted a stranglehold on me. The appearance of secure home and traditional family lacked the real, substantial connection upon which a strong relationship thrives. Inside myself, a battle raged. I tried to make myself appreciate what I had, struggling against the rebellious self that cried for what might never be

possible.

Journeys of liberation begin in the mind. By the middle of our first decade, my marriage began to unravel, though we held on for twenty-eight years. When it ended, we sold the house we had purchased the year after we married. I sobbed as I emptied each closet and cabinet. Leaving the place where my sons (both in their mid-twenties) felt they belonged meant that now, whether they liked it or not, our life as a family was finished. They were on their own. And so was I.

But that first tiny apartment in New York City, at age fifty, was a dream come true: My own place, filled with new and repurposed furniture pieces, half a block from Central Park with well-known actors as neighbors. My high-five-figure job allowed me to be there, to finally enjoy my independence and the freedom to build a new life. In the back of my mind, though, I was nervous. Was it too good to be true? *God, I am so grateful to live in this place,* I whispered as I unpacked boxes.

This was 2007, at the beginning of the economic downturn. A series of changes at the college where I had been working for the prior decade confirmed my fears. High-level people were leaving. Suddenly I had to prove myself worthy of staying there. My secure life was behind me, and I had just signed a lease that cost more

than my former mortgage and taxes combined. I was tasting the flip-side of liberation.

*By age fifty, Saturn has moved three-quarters of the way back to its origin at our birth. We begin to re-evaluate and either focus strongly on sticking to our ideal existence or we backslide to more familiar social expectations.*

My entire department was laid off the morning after Commencement in May, eighteen months later. The first morning you don't have to get up for work you want to enjoy not having to rush out the door, but the reality of bills to be paid as time ticks down and the money runs out encloses such little pleasures with barbed-wire fences.

I was one of the lucky ones. My severance pay got me through the summer, so I wasn't worried in spite of reports about the growing numbers of long-term un-employed. I had ten years of experience at a top uni-versity, a master's degree and was midway toward com-pleting my doctorate. I would simply apply for jobs at the many colleges in the area and continue my studies until either a job or a degree was in hand. So I moved to a cheaper sublet across town and decided to enjoy my forced sabbatical.

Two years later, my doctorate was completed, and there was still no job on the horizon. It was time to

take the show on the road.

The "road" took me to Europe for a year, teaching English to college students — that story, for another day. Too soon I was back in New York, living in a succession of guest rooms until hosts began to tire of wondering when I would get a job. "Just take anything," they said. You have to be offered "anything" in order to take it.

It was December, four long months after my return, when a job at another college brought me to a three-story Victorian rental home in a rural upstate New York snow-belt town. The first year, the winter of my discontent, I knew no one. It was dark when I woke up and dark when I got home. By summer, however, the beauty of the area charmed me. But the next winter saw me shoveling snow from the driveway and digging out my little red car again, challenging my mid-fifty-year-old body. I did it, though, because I was determined to be independent.

That job ended a couple of years later, and I got the sudden call to teach for a year in Poughkeepsie. The thought of moving into that "luxury" apartment with its remote-control garage meant I'd have no more snow on the car in the morning: there'd be a maintenance crew to clear the driveway for me. It's funny how luxury means different things to different people.

Nine months later, the Poughkeepsie job ended

too, and I lay on the wall-to-wall carpet of my now empty luxury living room, after all my furniture was removed and wondered out loud, "Why? Now what?"

With every move, I left bits and pieces of my life behind, along with the dreams that went with them. I was willing to part with most, but now, I had purged, packed, stored, and relocated so often that there was barely anything left to store.

With no job prospects, why keep paying anyway to store my unused and unneeded belongings? I donated almost everything I still owned to charity. Forget about decluttering based on "what brings you joy" — how about keeping what you really need that you can drag around from place to place!

What remained revealed my current priorities — a few sets of books, chef's knives, small appliances, my computer, audiotapes, and lots of diaries. Eventually, even some of those would go. The culmination of this long, arduous process, and the second return of Saturn to its original place in my chart, was return to Florida to live again with my parents.

*When Saturn returns, the chickens come home to roost and it's time to pay the piper.*

The trip began with what was to have been a brief stop at my sons' homes on Long Island to celebrate my grandsons' birthdays. That visit turned into four months

of babysitting—enjoying being "Mimi" with the shrinking hope of re-employment ever on my mind.

Finally, I left a few valuables in the hands of my sons and packed up my little red Suzuki hatchback with whatever would fit while still allowing me to see out the back window. I was headed south. I had never driven so far by myself. A palm reader I stopped at along the way down predicted I would not be heading back north, at least for a while.

Each day on the road, I'd drive no more than two hours down the East Coast until I stopped in with one of four friends. First stop, Philadelphia. It was a deliberate choice to set out early on Thanksgiving morning on what I called my Farewell Tour. Few people would be driving the normally manic Parkway, cutting down on the number of distractions (and dangers) as I navigated its curves, pot holes, narrow lanes, and unfamiliar path to a bridge I had not crossed since childhood. Every little section of the drive was another victory.

Though there was virtually no one on the road, my shoulders were shrugged up to my earlobes and my arms felt like tension rods connected to the steering wheel. My brain chattered to me the entire ride, and, in an effort to counteract the effects of all that, I sang along with the radio, and arrived safely on time to

enjoy a relaxing holiday weekend with my best friend and her husband. It was much needed after months of babysitting grandkids.

The remainder of my farewell tour took me on a route that went into Dover, Delaware, to visit a former co-worker, Maggie, now retired, who was also let go with me in my first layoff. Then to Rockville, Maryland, where the grown children of my father's best friend are settled. I stayed with Patrice, the older of two daughters, who, like her brothers, is a small business owner, her success evidenced by her spacious four-story townhouse.

I left Patrice the next day, on a rainy afternoon in early December, white-knuckling it around the Beltway to meet my first-ever childhood friend, Maria, at a large, crowded mall south of D.C. Fearing not only for my sanity and life, I worried about my overflowing car and my ability to shift gears well enough in speeding traffic to get it off the confusing, fast-paced Beltway intact. After arriving at the mall in the cold, wet darkness, I found a parking spot and exhaled. We met inside for dinner, caught up on the latest turns of events in each other's lives, and then headed out onto the unlit, wet, winding, wooded country road, to her house — a compound, actually. Her wooded five acres have evolved over the years into a multiplex of structures, driveways,

pools, ponds and entertainment areas, in addition to the "big house."

Each friend's home along the way was more beautifully decorated, more spacious, and each life more abundant than the last. At every stop I felt even more deficient. But I persisted and continued on my way. *Enjoy the journey,* I thought.

For the rest of the trip, my "auto" and I would relax and ride to Florida from the Lorton Auto Train station in Virginia. Dropping my packed car off at the entrance, leaving my keys and most of my possessions, I entered the huge glass-walled waiting area inside. Row after row of metal seats were filled with senior citizens and a few backpacking college-age kids.

Flying across the Atlantic several times has accustomed me to sleeping in tight spaces, so I saved money and booked a coach seat rather than a sleeper car. I was lucky enough to score two empty adjacent seats for the nineteen-hour overnight trip. Climbing the stairs to the upper level and glancing around my seats, I noticed several passengers reading, scrolling, or talking on their smart phones, and others holding actual newspapers, puzzle books, and paperback novels. I, of course, brought a little bit of everything — my computer, my diary, and a book that I brought along in case I needed an escape

or had no plug to use. Waiters in the dining car served dinner and breakfast at booths with linen-covered tables shared among strangers. With my double reclining seats for a bed, it was the closest I had come to fulfilling my dream of traveling on the Orient Express. I repeat: Luxury is different things to different people.

In spite of the extra seat to spread out on, I slept fitfully, with visions of the challenges that lay ahead, not to mention the morning's two-hour drive from the Sanford train station north of Orlando to the town on Florida's west coast that would be my next home.

We arrived in Sanford before ten a.m. and stood — a sleepy, disheveled group — outside in the warmth and humidity of a Florida December, watching as our vehicles emerged from the train. Mine was one of the last to be driven down the ramp.

The final two-hour leg of the trip left me tired and wanting to cry. I felt I was on the precipice of a cliff and the next step was over the edge into a cloud-covered abyss.

*When we're born, the planets crisscross over the earth in streaks, and sprinkle their stardust on the best places for us to settle down — and the worst. Astrologers look for the lines on a map that show where, at the moment we drew our first breath, Venus and Mars flew over the earth.*

*Those are the best places for us to live. Venus is love and happiness and money. Mars is action, determination, and energy...and sex. When I was born, the planet Venus crossed over the length of Florida. The prognosis was good. It should be a happy, peaceful place. I'm still trying to find out where Mars was.*

I've lived my adult life in constant change, and the people who know me just assume I'm a nomad who wants to keep moving. But enjoying a life of adventure does not mean one longs for constant change. Now I've returned to the place in my life where change is rare and unwelcome — in my parents' safe, secure home, where a predictable life is a good thing. On the one hand, you always know what your have and where it is, with enough time to accumulate everything you could possibly need. A life with little change is a dance memorized decades ago that can still be executed perfectly. But life is the same, day after day, nothing too exciting and nothing much to look forward to except the same tomorrow. There's no opportunity to be part of something new and different.

My father is a rule maker. Some rules aren't even realistic or reasonable. Don't open the fridge, even when looking for something. ("Know what you want before you open the door.") When my light bulb blows, he

tells me, "Next time, let me know ahead of time if you're going to need a new bulb."

It works well because my mother is a rule follower. She wants to be told what to do. If you give her rules to follow, she is as happy as a German Shepard with a yard to guard. She'll crawl out of a sick bed to stick to the schedule because *that's her job*.

Me, I am, by every cell in my body it seems, a rule breaker. Not exactly a rule *breaker* but rather a rule *bender*. If the hostess at a restaurant shows me to a table, I ask to sit at another table. I just do not like being told what to do.

I am a grandmother, living with my parents who would erase my entire adulthood. I think I'd like to cook on their barbecue grill, but in my mind I hear my father saying, "No, you'll break it."

Once change grinds to a halt, you begin to wonder if this is how you want life to be for the rest of your time on earth. For my parents, it is. But, no matter how predictable my parents' existence may be, my presence in their day-to-day lives is enough to tip the scales. And theirs is enough to put the brakes on in mine. For me, that halt offers time to pause and catch my breath, and reflect on what I have had in my life, what I could have had and who I have been versus who I *could* have been.

How that is working for me? Can I hope to have another shot at something more?

*It takes eighty-four years for the planet Uranus to travel around the sun and return to the place where it was when we were born. A few months after I arrived in Florida, we celebrated my father's eighty-fourth birthday. Uranus has returned to its origins in his life and soon will for my mother, as well.*

*Uranus is the planet of surprise, unexpected change, and movement in order to birth a new future. Now in fiery Aries, Uranus ushers in the **need** for something unexpected to happen. For me, Saturn has returned, bringing with it structure, delay, challenges, stopping to consider the consequences, rebuilding. I am Aquarius — ruled by both Saturn and Uranus — I am both the structure and the change personified.*

Though change for my parents will happen with or without me, I expect I'll take the hit for leading it in. Perhaps I'm the one to birth it, while their life of defined structure and caution is meant to be passed along to me, whether either side wants what the other offers or not.

~

Two hundred. That's the number of jobs that I've ap-

plied for since the last layoff. I am either ignored or rejected, even after the hope offered by a phone interview. I've bought a soapstone pendulum from the local metaphysical shop. Like the Magic 8-Ball of my childhood, I ask it yes-and-no questions, and it swings front-to-back or side-to-side. Tell me something good, magic pendulum.

The something good about being here is a break that has branched out to multiple opportunities. Perhaps it wasn't really a break. I sort of nagged my way into a stringer position at the local newspaper office. Finally getting to write one article about a local beekeeper, I guess I wrote well enough to convince them I could cover some stories. If I didn't have to drive around western Florida to write about people, places and events, I'd likely be morphing into a senior citizen rather quickly. I've also begun teaching about astrology, making presentations and giving readings — making like-minded friends.

I look longingly now at mini campers and camper vans as a solution to my need for independence, and I stop at dealers to see my dream mansions on wheels. This emotional roller coaster — the excitement of a new life liberated from being chained to a desk, free to try my hand at freelance writing versus the fear of having

not nearly enough money to live on scares me. Occasionally I still cry by myself in my room and yell at God that this is not how it was supposed to turn out. Silence. I imagine him saying, "Wait for it..."

While researching a story, I came across a quote from Anaïs Nin who wrote, "Life is a process of becoming, a combination of states we have to go through. Where people fail is that they wish to elect a state and remain in it. This is a kind of death."

If I hadn't broken free and begun wandering the world filling different roles, I'm sure I would have been climbing the walls to see what was on the other side. In just five years, I have spent a year in Europe, twenty months in the rural mountains of New York State, another nine months in the Hudson Valley, and now, almost a year in Florida. People told me I was "brave" to do all that I've done. Brave? It was really just life unfolding — having no other choice on the one hand, and living the dream on the other. Looking back, I realize I have actually filled the many roles I had fantasized about while I yearned to escape my safety net.

Which gets me thinking — before I head out for another adventure, maybe I should just start dreaming dreams again and go back to enjoying the journey so life can fulfill them, instead of letting worries get the

best of me and wondering how and when the journey will end. I could ask the pendulum or check the planets, to be sure. Or maybe not this time. ✒

# About the Authors

∼

**MARGARET HAWKINS**, *"On Getting Lost."*
Margaret Hawkins is a well-traveled writer and former columnist for the Chicago *Sun-Times* who teaches at the School of the Art Institute of Chicago. Her books include three novels (*A Year of Cats and Dogs, How to Survive a Natural Disaster,* and *Lydia's Party*) and one memoir, *How We Got Barb Back.* Her next trip is an artist residency in Krems, Austria.

**MAGGIE KAST**, *"On the Train."* Maggie Kast is the author of *A Free, Unsullied Land,* a novel, and *The Crack Between the Worlds: A Dancer's Memoir of Loss, Faith and Family.* She has published short fiction in *The Sun, Nimrod, Paper Street, Rosebud* and others, and essays in *America, Image, Writer's Chronicle* and elsewhere.

**ANNA SEQUOIA**, "*Marry Me.*" Anna Sequoia is the author of ten books, including the best selling humor book, *The Official J.A.P. Handbook* (N.A.L.) and the animal rights cult classic, *67 Ways to Save the Animals* (HarperCollins). An eager traveler, Anna's most recent "big" trip was to Singapore, Bangkok, Ho Chi Minh City and Hong Kong.

**LAURA GREENE**, "*Road Block.*" Laura Greene, Portland Oregon, writes creative non-fiction drawn from her experiences living and traveling five continents as a musician, volunteer, Wwoofer, and backpacker. She has summited Mt. Kilimanjaro, fought forest fires, and walked across Spain twice. When not writing, she runs a music studio and practices her Spanish.

**MARIA LISELLA**, "*Lemmings.*" Maria Lisella is Queens Poet Laureate, 2015-2018. Her work appears in *Thieves in the Family* (NYQ Books), *Amore on Hope Street* and *Two Naked Feet*. She co-curates the Italian American Writers Association readings, and is a charter member of *Brevitas*. Her work will appear in the forthcoming anthology, The *Traveler's Vade Mecum* (Red Hen Press); her essay, *Shades, Colors and Internal Dialogues* appears

in the new anthology, *What Does It Mean to Be White in America?* (2LeafPress).

A travel writer and editor, Maria Lisella has visited 62 countries and is now a New York Expert for *USA TODAY.*

**DIANE DOBRY,** *The Prodigal Daughter: Saturn Returns.* Diane Dobry received her doctorate from Columbia following a life as a stay-at-home mom, a P.R. professional, and an international wine importer. After a half-century in suburbia, she broke out and headed to NYC, Europe, rural New York State and now, sunny Florida, writing her story one inadvertent adventure at a time.

# She Can Find Her Way

WOMEN TRAVELERS
AT THEIR BEST

*Essays by Independent
Women Travelers*

# She Can Find Her Way

## Her Way

## WOMEN TRAVELERS AT THEIR BEST

*Essays by Independent Women Travelers*

**EDITED BY**

# ANN STARR

Upper Hand
PRESS

Cover and box design by Myeong Sik Ryu
Interior design by David Moratto

Upper Hand Press
P. O. Box 91179
Bexley, Ohio 43209
U. S. A.
www.upperhandpress.com

Printed by Häingraph

ISBN: 978-0-692-36867-1

*He only is a useful traveller,*
*who brings home something*
*by which his country might*
*be benefitted; who procures*
*some supply of want, or some*
*mitigation of evil, which may*
*enable his readers to compare*
*their condition with that of*
*others, to improve it whenever*
*it is worse, and whenever*
*it is better to enjoy it.*

—SAMUEL JOHNSON

# Contents

# VOLUME 2

‿

# VOLUME 3

‿

## VOLUME 4

# VOLUME 2

# Writing Home

*by*

## MAGGIE SWEENEY

⁓

*J*ULY 13, 1973
*Hotel Beauséjour, Ain Draham, Tunisia*
*Dear Mom and Dad,*

*I just today got your first letter, written*
*July 1. It probably sat in Tunis a few days*
*before being brought to Ain Draham, but still,*
*that's a long time. Anyway, it was good to*
*hear from you... A virus is making the rounds*
*among both volunteers and teachers this week,*
*but I'm hoping I'll be immune since I was*
*laid low with stomach problems most of last*
*week. For the moment I'm feeling quite chipper*
*and have every intention of staying that way.*
*We're quite high up in the Atlas Mountains*
*in a charming little hotel... I have a double*
*room complete with sink, bidet and WC down*

> *the hall. We have the whole hotel to ourselves,*
> *for all practical purposes, and are served meals*
> *family style in the hotel dining room...*

I can see the Hotel Beauséjour as vividly today as if I had been there a week ago. For our pre-assignment training, the Peace Corps found us a quaint, slightly down-at-the-heels hotel in northern Tunisia, near Mediterranean beaches and sheltered from the brutal North African summer sun by cork forests and mountain breezes. Perched on the side of a wooded hill, the rambling two-story wooden structure with peeling white paint could have been lifted right out of a village in the Swiss Alps, which may have been part of the plan to ease our transition between worlds. I was one of a cohort of thirty-two TEFLS, Teachers of English as a Foreign Language, recruited to work in high schools and adult night schools until the Tunisian government had trained enough English teachers to meet their needs. But before being deployed to towns and cities throughout the country, we were given two months to adjust to the new culture, learn Tunisian Arabic and master the art of teaching English using the direct method.

The decision to join the Peace Corps had been an easy one. The invitation came at the end of a bewildering

final college semester interviewing for jobs I didn't want and wasn't qualified for while all my classmates were getting into the top graduate programs in their fields. The prospect of leaving was made even more alluring by the wanderlust I had suffered since the age of nine, when I spent a year with my family in Paris attending a French school and experiencing the alchemy of foreign language acquisition by total immersion. At age twenty-one I was craving excitement and stimulation.

But the same parents who had introduced me to the magic of international travel at a young age had also instilled in me from an even earlier age an acute uneasiness with raw emotion of any kind, whether in me or in those around me. So I was "chipper...with every intention of staying that way" because chipper was the only setting that my emotional thermostat had ever registered. Two weeks after graduating I cheerfully said goodbye to family and college boyfriend and took off for the adventure of my life. I needed to set out on my own not only to satisfy a thirst for adventure and exoticism; I had to cross the Atlantic Ocean to discover the equally foreign medium of intense, undisguised, in-my-face emotional turmoil. The admission that I had diarrhea — but hey, no problem, I'll be fine — that confession was as close as I came to admitting during

the early months, either to my family or to myself, how hard this would be. Learning to cope with loneliness and hardship and emerge in one piece, triumphant, was by far the most important challenge of not only the summer of training but also the two years that followed.

> *Sep. 14, 1973*
> *Dear Kevin,*
> *...As far as I can figure, I'll be going to Kasserine on the 22nd or 23rd. Though I know settling in will be very hectic and the first few days of school very hard, and though I'm sure to get incredibly lonely, I feel quite ready to go. I'd like to have my own classes right now and see if I really am capable of teaching. It's strange, now that I think about it, that I chose Kasserine, it being one of the smaller and more isolated towns on the list. Maybe that goes along with the attitude I've had toward things all along in Tunisia, of not wanting to do things halfway. I'm very likely in Kasserine to be really submerged in the culture, to learn Arabic, to maybe have harder and more troubling experiences, but maybe to learn more by the end. Maybe even coming*

*into the Peace Corps was a foolhardy thing to do, but now that I'm here I want to make the most of it..."*

What I didn't say, ever, in any of my weekly letters to Kevin, was that I did double-takes for two years every time a medium-built blue-jeaned young man with sandy hair and mustache crossed my path. I missed him more than I could have imagined possible. Our relationship had blossomed during my last year and a half of college, and although he accused me at one point of "running away to the Peace Corps," he had been nice about it — probably as much in denial as I was about how hard the separation would be. But I was young, he was my first boyfriend, and I wasn't ready to settle down. He also surely understood that if I needed to spend two years in a foreign country, I had better get it over with. We both knew that roaming the world was not anything he was excited to do.

My plunge into the culture began when I moved into the "Peace Corps house" in Kasserine. A traditional Arab house on the town common often rented by Peace Corps volunteers, it consisted of four cement-walled rooms set around two courtyards. In the center of the first courtyard stood a wooden structure cleverly painted to

resemble a phone booth but in fact housing a Turkish toilet, a humble hole in the ground with spigot and pail for flushing. Adding to the house's eccentric charm, an abundance of lush flowering vines, rose bushes and lemon trees bloomed in the North African sun that flooded the courtyards all year long.

The kitchen was identifiable as such only by the wooden breakfast nook on one side, whose wall an earlier renter had adorned with a large red and yellow Kellogg rooster perched on a bowl emblazoned with the Arabic equivalent of "the best to you each morning". On the other side of the room, a two-burner gas hot plate provided the only means of cooking. It would be eight months before I splurged on a dorm-sized fridge. In the meanwhile, Kasserine winters were cool enough that meat, milk and yoghurt (when we could get them from Tunis) kept for several days without refrigeration.

The other rooms were square, bright white and absolutely empty. I chose the first one on the right as my bedroom. Soltane, our affable landlord who enjoyed showing off the English he had picked up when U.S. soldiers came through during World War II, brought in a rusty twin bed frame with coil springs and a plastic-coated mattress about as thick and plush as a stale hamburger bun. "Sister Maggie good very good," he assured

me. "Brother Soltane bring bed, no pay, Peace Corps good very good." The family heirloom footlocker that had transported my possessions from the U.S. provided a raised surface next to the bed for my travel alarm clock and paperback book. At the flea market, I found a metal straight-backed chair that looked like a cast-off from the classrooms of my youth, useful mostly for hanging the clothing items I wasn't ready to wash, fold and return to the footlocker. I did eventually order from the carpentry shop next door a very basic but (because wood was a great luxury) very expensive armoire. Completion of this one self-indulgence was promised for late October and realized a month after that.

In the meanwhile, I came to see my bedroom as another iteration of the cabins and tents I had lived in during my summers of camp counseling; the bare light bulb on the ceiling was not bright enough to read by but did keep me from cracking my shins on the foot locker when I stumbled in from the "kitchen" after nightfall. Since the only sheets I could find at the Kasserine dry goods store had the shape and consistency of a cheap table cloth, I slept in the same mud brown sleeping bag from L.L.Bean that had served me so well during those camp jobs, hoping each night that my tossing and turning wouldn't send the whole bundle

sliding off the slick surface of the mattress onto the concrete floor. Soon enough the mountain air turned so cold that, even with an extra blanket, my cocoon proved unsatisfactory for reasons of warmth as well as comfort. I eventually asked my parents to send sheets and an electric blanket from the U.S. I also returned the ancient bed frame to Soltane, preferring the stability of the very cold floor under that slippery mattress.

Even after I'd found an acceptable sleeping arrangement, the walls remained bare and sterile. The comfort and aesthetic appeal of that room made my bleakest college dorm room seem luxurious by comparison That bedroom was the perfect embodiment of my attitude toward my time in Tunisia: I was on loan to the Peace Corps. I was there to do a job with my teeth gritted, and any creative energy I could access would be devoted to measurable successes: learning Arabic, understanding the culture and honing my teaching skills. As my parents had taught me to do with every fiber of my being, I was reacting to pain by staying busy and looking in a different direction. "Life is hard," I can hear my mother saying even now, with an ironic half smile — so move on, and whatever you do, don't wallow in it. My anguish at being separated from the people and places

I was missing was consuming me, and the only recourse I knew was to push that pain even deeper inside. It seemed a betrayal to make myself comfortable, or even minimally settled. My preferred pastime when I wasn't preparing lessons or studying Arabic was to fill Tunisian aerograms to my loved ones with chatty, upbeat reports of all my exciting activities. There were weekly missives to Kevin and the same number to my family, as well as a daily pilgrimage across the town common to check my postal box for lifelines from home. My lifestyle was screaming, "I don't want to be here," even as I exuded good cheer in my letters and threw myself into succeeding at every quantifiable aspect of being a Tunisian TEFL teacher.

> *Sep. 26, 1973*
> *Dear Kevin,*
>
> *I'm most of all eager to establish myself in a routine, to get to know people and become familiar with the life style. Everything is new now, even getting a meal is a chore, and it can be discouraging. School starts on Monday, and I guess it will be better then — at least I'll have a daily routine to fall back on.*

And what a daily routine it was. I was assigned to the *Lycée de Jeunes Filles*, which means "high school for girls" despite a student body that was not only coed but skewed heavily toward boys since adolescent girls were often kept at home to help with housework. The sprawling one-story complex included classrooms, offices and a dormitory for the poorest children who traveled for hours by bus once each term from the tents or hovels where their families lived. The school was on the very outskirts of town, at the base of Chaambi, the highest summit in Tunisia. The town bus that did the two-mile circuit every hour or so left from the bus station right outside our front door. On the first day of school I showed up for the 7:45 bus along with every other teacher and schoolchild in Kasserine. Even with North African bus-cramming techniques, no more than half the people who were waiting could squeeze onto that bus. I was not among those who kicked, nudged and elbowed their way on board. When the other folks who were left on the platform began walking, I understood that I had no other option. Grateful that I had decided against wearing high-heeled shoes to show my sophistication, I hefted my American book bag to my shoulder and joined the parade of pupils beginning the first school day with a two-mile hike.

When I staggered into my classroom twenty minutes late, only a few students were at their desks. "*Les autres sont partis?*" I asked. No, they assured me, the others had not given up on me and left. They had not yet arrived. It was Ramadhan, the month of abstaining during daylight hours, so everyone had stayed up much of the night breaking their fast and celebrating with their families. Like the majority of the town's population, those who were missing would get up and start their day when they were ready. It was a valuable lesson in some crucial elements of Tunisian culture that our training had overlooked: the importance of religious ritual, meals, and time spent with loved ones. That day also launched a two-year process of loosening my American grip on punctuality and easing into a much more relaxed relationship with the clock.

My work at the *Lycée* was overseen by the Tunisian Ministry of Education, the same bureaucratic entity that had provided our teacher training, written all of our textbooks, and designed the *baccalauréat* exams that determined each spring which final-year students had succeeded and could continue their studies in Tunis. This elusive prize was harder for our students to attain than for those from the larger coastal cities. As a rural backwater, Kasserine was perpetually underserved in

teaching and administrative staff as well as money for supplies. Our chipped chalkboards and missing windowpanes were so taken for granted as to not even merit comment. When November brought snow to the slopes of Chaambi, the students' only protection from the bitter winds consisted of the hooded woolen jellabiyas that enveloped them as they huddled at their long wooden desks.

The school building's shortcomings were the least of my problems, as it turned out. The director Monsieur Nasraoui, who was little more than a puppet for the all-powerful Education Minister, was only slightly apologetic when he handed me in early September a timetable of thirty-two hours a week : all of the *4ème* and all of the *5ème* classes (9th and 10th graders, roughly), or eight sections of about forty students each. My Peace Corps colleague Steve would have an equivalent workload, with all the *6ème* and *7ème* classes. Kasserine had been promised four new English teachers, Monsieur Nasraoui explained with a shrug. Since the Ministry had sent only two of us, there was no alternative but to split all the classes between us. I passively accepted my fate at first, both because it didn't occur to me to protest, and because keeping very busy seemed an effective antidote to homesickness. By the time I realized that

those teachers carrying the usual work load of five sections were earning the same salary we were, the inequity of it all was of less concern than my mental and physical health — both quite precarious by mid-October.

In theory, the *5ème* classes should have already studied the first half of our textbook, but I was neither surprised nor disappointed to discover that they needed to start at the very beginning, just like the *4ème*s. No doubt Kasserine's teacher shortage was a perennial problem, and the recruits the year before had refused to take on extra sections, necessitating the canceling of the elementary English classes. The up side was that I would have just one set of lesson plans to prepare each evening. It also meant, though, that for six to eight hours each day I struggled valiantly to maintain an imperious demeanor as I intoned again and again the exact same insipid dialogues imposed on us by the Ministry.

"Hello, John!"

"Hello, Ali!"

"What's that?"

"It's a bag!"

"Is it heavy?"

"No, it's light!"

My waving arms, pointing fingers and bobbing head instructed them to stand, sit, listen, repeat, address

me, address a neighbor — all the while parroting these gems of wisdom in unison or in small groups. Translating into French was forbidden by our methodology, so I had practiced ahead of time the gestures and facial expressions that would reveal the meaning of "heavy" and "light" as clearly as the "bag" I could simply point to. If this all sounds like a wonderful game, it certainly seemed that way to students accustomed to a much more dignified and magisterial teaching style. I had observed my Tunisian colleagues, all men, all products of the rigidly hierarchical French education system. They arrived for class, briefcase in hand, just as the bell was ringing, and entered the classroom while the students waited in two straight lines outside the door. When summoned with a curt nod, the young people filed silently into the room and stood behind their desks until they received the signal to sit down. Then they sat for the next hour, listening passively and taking notes.

My greatest challenge, as an outsider and an anomaly by virtue of my gender as well as my teaching style, was to find the very fine line that separates a lively, engaged and cooperative class from a chaotic one. My success or failure in finding that fine line distinguished the good days from the bad ones, the satisfying classes from the ones that left me utterly destroyed. I tried to

maintain some semblance of a dignified demeanor, but keeping a straight face was often hard because these young Tunisians were such faithful parrots of what they were hearing. They were genuinely eager to learn English, if only so they could harass tourists at the town's weed-choked Roman ruins. And they were mostly very quick studies. Having already learned two foreign languages — classical Arabic and French — they were endowed with ears and minds remarkably well equipped to pick up a third. The first time "no, it's light" bounced back to me as "niiaayyoo, it's light" the effect of this linguistic mirror multiplied by forty was both jarring and hysterical. I was not prepared for John and Ali to speak English with an Ohio twang.

I soon learned that the peculiar blend of logic and theatrics that constitutes language teaching is something I very much enjoy and am good at. Many of my students, especially the younger ones, instinctively understood that if they played this strange new game by my rules, all would be well. They were charmed by my antics and thrilled to find themselves babbling snippets of English within a few weeks. When those kids were in the majority, or when I managed to keep the class mood from being hijacked by the jaded, insolent ones, my elation knew no bounds. On those occasions, however,

when the wise guys, many of them older than I was, outnumbered or intimidated the ones who wanted to learn, I couldn't do anything right. Knowing that my audience was laughing not with me but at me, I learned to stop smiling altogether. Their mocking, jeering faces and voices stayed with me long after the class was over. At the end of those days, I retreated to my monastic quarters in the center of town and hurled pens, pencils and notebooks into the whitewashed walls until tears of fury and impotence quelled my rage.

Even the more difficult students and I might have established a working rapport if I had started the semester with a humane timetable and had kept the same classes for more than a few weeks at a time. Realizing that nine months of trying to teach more than three hundred students would kill me if I didn't kill them first, I approached M. Nasraoui a few weeks into the term. I had chronic laryngitis and was so beaten down by the end of each day, even the good ones, that I often collapsed — sometimes in laughter, sometimes close to tears — and dismissed my afternoon classes before the end of the hour. To my astonishment, he agreed that my workload was unreasonable. Over the next two months, the changes he made in his attempts to staff all the classes were dizzying. He reduced both Steve's

hours and mine. He switched our classes around so that the older students approaching their *baccalauréat* would have teachers. Then he was promised new teachers from Tunis and so made more switches. Informed that the new teachers had fallen through, he fiddled again. He tried to fill the gaps with local administrators, but they turned out to be unqualified to teach English. He then made more switches to minimize the damage. And on and on. By time I received my third schedule in early November, all of the English students at the *Lycée de Jeunes Filles* had lost at least a month's worth of English classes, and I was physically and emotionally wrecked by my herculean effort to establish a serious classroom persona despite a constantly changing cast of characters.

After the final schedule change, as I picked up the pieces and began again, I was surprised to notice that the hardest classes to teach were generally those that were the most coeducational. In those sections that included ten or twelve girls along with thirty-some boys, the novelty of my teaching techniques brought out the worst in everyone. For most of their class day, these students did nothing more than sit staring at the teacher and taking notes, so the gender of those note-takers was irrelevant. English class was an entirely new world: a teacher who didn't fit any of their traditional role

models was encouraging them to move around the classroom and interact with each other. The girls could peek out from the clusters where they giggled quietly, bowed over notebooks in their colorful headscarves, while the boys vied shamelessly for their attention with smirks, guffaws and jokes that I knew to be lewd only by the reactions they elicited. John and Ali didn't stand a chance.

The young women, submissive and compliant to a fault, scarcely reacted to their classmates' antics, but they didn't need to. The most brazen and insolent of the boys reaped their reward each time they succeeded in disrupting the lesson. They had the satisfaction of knowing that they had stolen center stage from the eccentric foreign female who pretended to be a teacher but looked and acted more like their younger sister. My only recourse was to kick them out of class. Not until the second year did I figure out that this "punishment" was playing into their hands. The students who caused the most trouble had already been kicked out of school or made to repeat classes so many times that the administration had given up on them. I had validated their performance, and they came back the next day more determined than ever to steal the show.

I came very close to calling it quits at the end of

that first year, not just because of the teaching challenges, but because the agony of living physically and professionally in one place while I was still languishing emotionally on the other side of the Atlantic was more than I could bear. A regimen of staying busy and maintaining a positive attitude works only up to a point, and I reached that point in March of 1974. What saved me that spring and many other times before and after was the support and wisdom of a dear friend. Paddy (née Margaret Padwick) was a British TEFL teacher who had arrived as a volunteer five years earlier and had married Hassine Bacha, the local insurance agent, and made Kasserine her home.

Paddy and Hassine welcomed me the day I moved into the Peace Corps house, and over the next two years Paddy was there for me as mentor, confidante and cheerleader, generously shepherding me through culture shock, homesickness and nightmares in the classroom. She had survived it all. On Christmas and Easter, when the Muslim world went about their business as usual, Paddy and Hassine hosted candle-lit dinners complete with hand-printed menus and British pastries for dessert. When I needed an Arabic tutor to continue the lessons begun during Peace Corps training, Hassine offered his services. When he got too busy, he suggested

his mother Khadija, a feisty divorcée in a society where women are normally considered their husbands' property. It was a brilliant suggestion. In her living room and unencumbered by the safsari that covered her from head to foot in the market, Khadija was one of the brightest and funniest women I had ever met. She was also a wonderful teacher. Even though she had never learned to read or write, she instinctively knew what words I needed in order to navigate the streets of Kasserine, and she took tremendous pride in giving me those tools.

So when I casually mentioned to Paddy that I was thinking about going home at the end of the first year, she listened well and asked good questions. She reminded me why I was there. She helped me to remember that I had no job to go home to and that I had said many times that I wasn't ready to get married. Without saying so, she helped me see that I hadn't really given Tunisia a fair chance. The lemon trees in the courtyard were starting to bloom, she pointed out, and Berber women had begun coming door to door with divine wild asparagus. What's more, the butcher shop had just gotten some tender young lamb — so why didn't I come to dinner at her house that night? And we could stop at her favorite fabric stall at the souq on the way to look

for a bedspread to cover my bare mattress. She helped me to see that my loneliness was very real — and that the only way to survive that pain was to dive in and see it for what it was, and then find a way to cope with it. I couldn't replace the people I was missing, but I could admit that I was wretched and then do everything in my power to lighten the emotional load I was carrying once I had come to terms with its existence.

By the time summer rolled around, Paddy and I had formulated a list of things I should do differently in my second year of teaching: glower as much as possible during the early weeks; wait at least a month before introducing any sort of games; send students to the back of the room and ignore them the minute they begin to act up; negotiate with the administration about my contract, but never ever quibble with students about their grades. But I would have totally missed the chance to learn from my teaching mistakes had I not gradually come to accept and even enjoy the realities of my life in Tunisia, allowing me to relax into the possibility of a second year away from home.

The cross-Atlantic correspondence continued unabated, but I spent more and more time that first spring visiting Peace Corps friends in other cities. I relished everyday exchanges with the fruit vendor at the market

who cheerfully corrected my Arabic and always threw a few extra dates or apricots in my basket. Paddy and Hassine continued to be wonderful friends in every way, and the news that they were expecting their first child in October gave me a new reason to be excited about a second year in Kasserine. A two-week Arabic language conference during spring break also reminded me why I had been drawn to the Peace Corps in the first place: we stayed in a hotel adapted from a series of Berber cave dwellings in the remote desert town of Foum Tataouoine, near the Libyan border, a spot that is hard to beat for sheer beauty and exoticism. It was at about this time that I made the crucial decision to spend the summer vacation traveling in Europe rather than retuning to the U.S. for two months. I needed to make the most of my time on the far side of the Atlantic, where I had wanted to be for as long as I could remember. I promised myself that I would try very hard from then on to live in the present rather than pining for the past or worrying about the future.

The summer in Europe had many ups and downs, but one of the very best moments was in early September, when I pulled my shabby backpack out of the Tunis to Kasserine *louage* (an inter-city taxi service) and opened the familiar metal gate to enter our sunlit courtyard

for the first time in two months. I had come home, and it felt wonderful. That year's *rentrée* — the "coming home" or start of the new school year — had very little in common with my experience from the previous September. My *lycée* had a new director who actually consulted my preferences before handing me an entirely reasonable teaching schedule.

I had bought for a few dinars an ancient but very sturdy three-speed bike and equipped it with a new pair of tires and a luggage carrier for my book bag. I set off on it for the first day of school feeling very liberated indeed. The heads that turned in amazement as I whizzed by, bareheaded and with pants rolled up to my knees, brought me both pride and amusement. Commuting to school in such an unseemly manner saved me time, money and hassle, and if my neighbors were startled, that was fine with me. The people of Kasserine knew me by then, and they had devised a special set of standards for the American English teachers: we were respected for our work and our interest in learning their language and either admired or tolerated for our eccentricities. The bike rides also assured that I was getting the exercise I needed to keep my endorphin level up — an insurance policy against the inevitable classroom aggravation that awaited me.

The one teaching preference that my director had not been able to accommodate for the second year was a request that I not teach any of the same classes I had taught the previous year. I thought I needed a fresh start. Four of my five classes were in fact new; the one group that already knew me were the *5èmes Science-Economique*, the smallest of my five sections with only about thirty students, and also the brightest. This particular class was also more co-educational than most, with about one third girls. Both of these factors might have worked against me since the brightest kids were often the cheekiest and the presence of girls was so often a huge distraction. Fortunately, however, this class was an anomaly in every way. Having very few kids who had had to repeat grades, they were young and still eager to learn. So it turned out that the students whom I got to know the best were exactly the ones I was happiest to spend time with. For the most part, that feeling was mutual.

> *June 10. 1975*
> *Dear Mom and Dad,*
>
> *Things in Kasserine are drawing to a hectic finish. Everyone has given up all pretense of teaching. Wednesday morning I went to Haïdra, a very small town in the*

*mountains near the Algerian border, about 1½*
*hours by bus northwest of here. A student in*
*my 5ème Science-Eco. class, a girl named*
*Aïcha whom I've taught for two years now,*
*invited me to spend the day with her family.*

And so I was granted an ending to my Peace Corps adventure that allowed me to come full circle, to remember the frightened new teacher and the eager young Tunisian girl who had come together on a sultry September morning in Ramadhan almost two years earlier. In Aïcha's confident English as she proudly showed me the Roman ruins of Haïdra, I saw the fruits of my own blossoming skill and self-confidence as a language instructor. In her family's simple abundance — water carried from a well, butter and cheese from their goats, delicious flat loaves of bread baked in an outdoor clay oven — I glimpsed an alternative to the American conspicuous consumption that I dreaded returning to. When her mother gave me a guided tour of her spice rack, I was thrilled to finally identify some of the fragrant powders I'd been puzzling over in the souq since my arrival. And even though their very humble abode, a few rooms without electricity over the primary school of which her father was the director, seemed at first far

removed from my own family's elegant two-story college faculty home, this dwelling reminded me both how far I'd come and how close I'd always been to home.

I ended up spending the night in Haïdra because there were no evening buses back to Kasserine, a fact I suspect they were aware of all along. As I sat in their living room that evening while the family read, chatted, and did needlework in the glow of a kerosene lantern, I thought with amazement, "This could be my family." Their warm hospitality and easy, loving conversation pulled me into their circle and made me feel at home.

Friends had warned me to expect reverse culture shock when I returned to the States, and it's true that the initial re-entry was brutal. I found Americans to be loud and insensitive, and was horrified by the expanses of pavement and the quantity of huge cars. The neon-lit supermarket aisles lined from floor to ceiling with hundreds of different breakfast cereals filled me with panic. But I was genuinely happy to see my family again, and to reacquaint myself with Kevin, whom I would marry a year later. My two hundred transatlantic letters, thoughtfully saved for me by their recipients, give glimpses of a young woman who joined the Peace Corps because she craved adventure — and who found much more.

The process of unpacking the memories and assimilating the lessons from those two years continues even forty years later. So much has stayed with me: the stark beauty of Kasserine's arid plateau dotted with prickly pear and reaching interminably to the hazy purple mountains in the distance; the crackly static from the recorded muezzin's call blaring from the mosque near the house as I emerge to catch the pre-dawn *louage* to Tunis; lonely evenings filling blue aerograms with upbeat news as Tom Rush's voice on the eight-track tape deck makes me ache with homesickness. But mostly I return in my mind to the people who brought Kasserine to life and in the process brought me to life. Were it not for the students at the *Lycée de Jeunes Filles*, I would not be the teacher I am today. Thanks to the gift of many hours in the presence of Khadija's courage and humor, I have some inkling of what it means to be an oppressed woman who thrives. And it is because of Paddy's warmth and wisdom that I began to glimpse during those years a reality that I'm still struggling today to live into: that success and happiness aren't really about scanning the ever-elusive horizon for a happy ending. They seem to be more about fully living the journey, eyes and heart open, arms stretched out to welcome the loads both heavy and light. ✌

# George's Cadillac

*by*

## SALLY HAMRICK

⌒≈⌒

*I* WAS TRYING to keep my shit together while I was on the phone to my insurance lady. It was still light out and relatively cool for July so I kept telling myself to *CALM DOWN*, it was going to be all right. But, after a half hour I knew she didn't know where to send the tow truck. She kept asking if I had my GPS on. When she asked what business I just passed, I lost it.

"Lady," I yelled, "there's a farm on my left, a farm on my right, a farm in front of me and I just drove through a mountain!" I didn't know where the hell I was.

Pennsylvania is a long, lonely drive between New York City and Ohio, and I've made it dozens of times. I've hit the densest fog in the Blue Mountains and gusts of wind have thrown the car into the adjacent lane while I was coming out of the Kittatinny Tunnel. But I love driving. Especially in my thirteen-year-old red

Cadillac. It's detailed with "The Ohio State University" in script on the side and "LOVE BUX" license plates. Buckeye fans drive by, honk, and give me a thumbs-up. Michigan fans, sporting their maize and blue decals, just give me the finger when they pass.

I had just put $1,400 worth of repairs into the old Cadillac and it had been running perfectly. Now, suddenly, the lights on the dashboard were flashing red: "Engine Overheated." The speed limit was seventy and I was probably doing eighty. I knew that I had to pull over. I looked in my rear-view mirror to see if one of those giant semis was barreling down behind me on the turnpike. Then I saw the "Emergency Pull-Off 1000 Feet" sign, and I knew where I would land.

My daughter and I had had a huge brunch before I had to say goodbye and leave Brooklyn. We had eaten at Lopez's across from Patty's apartment with the local Brooklyn hipsters. I had my favorite huevos rancheros and cafe au lait. We stopped at the bakery counter before walking back to the car. I was planning on driving through until dinner. But, here I was halfway home in the middle of Pennsylvania. Trying not to think of every slasher movie I had seen about evil tow truck drivers, I cursed Stephen King. "Mutilated Woman Found Inside Abandoned Cadillac."

The State Highway Patrol finally sent a tow, and when Josiah arrived, I knew I was in good hands. He was about the same age as Patty; a big, shy, Amish young man with his collar buttoned. He had me sit in the truck cab while he hooked up my car. Still trying to figure out where I was, I asked Josiah how far it was to the West Virginia border. It was an awkward moment. Finally, "I really couldn't tell you, Ma'am," he replied. I guess he doesn't get too far from the farm.

When we started moving, he explained that he could take me to Jiffy Lube or to the Cadillac dealership and then he would take me to a motel. I said I would really like to go to the Cadillac place. Luckily it was a Monday and the mechanic stayed until 7:00. I spoke to the mechanic as Josiah unhooked my car. The guy asked me if I go to all the football games. I guess the "I root for two teams, O.S.U. and whoever plays Michigan" bumper sticker gave me away. It's funny how people ask if I had ever met Woody or what I thought of Tressel's firing. They never ask, "What year did you graduate? What'd you major in?"

The mechanic said he would look at the car and that I should call him the next day. So, I grabbed my duffle bag and Josiah drove me back down the road. He waited for me while I checked to see if the Comfort

Inn had a room and then he took off to save some-
one else.

Of course, the motel clerk said I was entitled to a
discount on my room since Cousin Josiah had brought
me. Then she said the words I hadn't heard for ten years:
"Would you like a smoking or non-smoking room?"
"Are you kidding?" I said. "You have smoking rooms?
Give me one of those!" Oh, how I needed a cigarette!

I had plenty to read and phone calls to make and
the Comfort Inn was providing much comfort. When
I asked the clerk where I could get dinner she gave me
a coupon for the Pine Room across the road. No smok-
ing section there. The Pine Room served a simple, meat
and potatoes menu. I had the best baked potato and
asked the server how it was cooked. He said "Nothing
special, but we just picked them this morning." I thought,
"Dude, you started your shift picking produce?" Unless
those Brooklyn hipsters came from Idaho they never
had baked potatoes that tasted this good.

The next morning I opened the curtains expecting
to see the Blue Mountains. But what were these beau-
tiful tiny houses just outside the window? The sign on
the tractor-trailer said, "Amish-Built Chicken Coops."
No way! These were chicken coops for the rich and fa-
mous. Each little house was made of cedar with shingles

on the roof and shuttered windows. They were hooked up with electricity. They weren't anything like I had ever seen on "Green Acres." I wondered if those chickens could afford their electric bills.

Then the mechanic called with bad news. An eight-hundred dollar water pump and no guarantee.

It was time to put the Caddy to rest. Cleaning it out, seeing the cracks in the leather seats and unscrewing the "LOVE BUX" license plates drove me to tears.

I had been so excited to inherit the red Cadillac from my father-in-law, George. He was a true Buckeye fan. George received his Bachelor's and Master's Degrees from The Ohio State University. He was the O.S.U. County Agricultural Extension Agent. We all wore scarlet and gray to his wake and he had even donated his body to the O.S.U. Research Facility.

George had earned money for tuition by working at a garage. Do you remember when service station attendants pumped gas and cleaned the windshield while you sat in the car? They had a repair shop too and every time a Cadillac pulled in George jumped at the chance to drive it around back. He dreamed of someday having his own Cadillac.

On August 2, 2002, at the age of seventy-eight, George bought a brand new, crimson red Cadillac

DeVille. One of his favorite things to do was drive up to his friends at Christmas and deliver Buckeye candy in his red Cadillac. Buckeyes are a peanut butter concoction dipped in chocolate; they resemble a buckeye nut. They are delicious, and George would buy two hundred-fifty boxes a year to give out as presents to his family, friends and neighbors. He especially loved sending them to his niece, a University of Michigan graduate.

The mechanic referred me to a car salesman. It was difficult trying to explain why I couldn't buy any vehicle that was blue. The salesman was such a nice guy and the picture of his family on his desk looked lovely, everyone dressed in matching Pittsburg Steeler jerseys.

I ate steak and potatoes at the Pine Room for lunch and drove off in my brand new certified-used Chevy with "LOVE BUX" license plates. I had a long drive ahead of me and was sure I would come up with an excuse for buying a blue car, but leaving the Caddy in the middle of Pennsylvania was bad. I hoped a Pitt or Penn State fan wouldn't buy it. I figured some nice Amish fellow would like it to transport his homemade chicken coops to town. George would have liked that. ✒

# Tiny Houses

*by*

## KATIE KNECHT

*T*HE BUILDING WAS structurally sound. Upright walls, rectangles of brick, a thickly shingled black roof. A warm light burned inside the window next to the front door. I picked the miniature house up off the shelf and examined it more closely.

"These are cute," I said to Emily, who was running her hand along a row of wooden clogs to select a pair to try on. Emily looked over.

"Ooh yeah, those would be good gifts," she said, turning back to the shelves and choosing a European size thirty-nine, setting the shoes down with a clunk.

I sighed. "I'm so tired of worrying about what gifts to bring back to people who haven't even talked to me since I've been here." I returned the tiny building replica to the shelf. "We're in the middle of the Amsterdam flower market —," I gestured my gloved hands around

me, toward the rows of blooming tulips, geraniums, and narcissus; the buckets of flower seedlings, and the river streaming by, "— and I'm calculating how many miniature villages I need to buy..."

We were indeed in the midst of the bustling Sunday flower market, or Bloenmenmarkt, which floated on barges on the waters of Singel. The March wind was biting, but we were used to the cold by now, having lived in England for three months so far. I had sometimes questioned my decision to study abroad in the spring semester, but always concluded I would rather the weather improved throughout my four-month European tour rather than get steadily worse. We lived in a manor house in small town north of London and attended classes there, with our weekends free to travel. A small group of us, including Emily, were now practiced at hopping trains, planes, and buses together to see the Eiffel Tower, Arthur's Seat, Big Ben, and more.

Emily slipped her feet into the clogs and took a couple of clumsy steps forward, laughing. "Don't think I could fool anyone that I'm Dutch," she said.

I smiled at Emily, who had been a complete stranger three months ago at the beginning of our semester. Now, we had traveled to London, Paris, Ireland, and Scotland together, and had a bond so strong that I couldn't

believe how short our time together had been. It seemed that traveling created a connection that could transcend time and circumstances.

I tried not to apply that same thinking to my burgeoning relationship with James, though. I didn't want to think that the circumstances — living in a miniature Hogwarts manor house with only a hundred other students, spending late nights preparing for our British Studies exams, traveling together to European cities every weekend — influenced our decision to start something romantic, but rather a true tug at our hearts that we could not resist.

Spending a semester abroad was not supposed to be about a boy. I had chosen to study abroad because I wanted to prove my independence to my family and to myself. I often proclaimed my autonomy, but it was hard to back it up with fact, having grown up comfortably in a small town in Western Kentucky. I chose to study abroad in Grantham, England, in a manor house that brought students from universities across the country together in a proclamation of independence.

James and I were paired together when we were assigned families, which were mostly older, charming British couples from Grantham who wanted to occasionally spend time with American students. During our first

week, we had dinner with our family at a pub in town, and spent our time together marveling at how difficult it was to understand each other through our accents and colloquialisms, even though we were speaking the same language.

That night, James and I had held eye contact across the table for a few seconds too long, laughed at each other's jokes a little too hard. Later that week, James asked me if I wanted to run into town with him to get some groceries, and we spent a snowy Tuesday afternoon in Grantham, wrapped in that bubble of interest and curiosity when you're first getting to know someone. That day ended in a quiet kiss outside the manor house.

A few weeks into the semester, James, Emily, Emily's friend Cody, and I were eating lunches together, studying together, and planning trips together. Cody, who went to college with Emily, was ridiculously entertaining. He told stories with a flair that cracked everyone up even if the content itself wasn't that funny, he had little to no filter when it came to his opinions, and although he claimed to have a girlfriend back home, I had strong suspicions he was gay. Cody's ridiculousness, Emily's positivity, James' hope for adventure, and my organized, always-planning self made for a solid traveling group.

Our group had planned this trip to Amsterdam

about a month ago in the cozy manor house common room, with Cody providing outrageous commentary over my shoulder with every hostel website I visited ("Are they goddamn serious with the length of those bunk beds? I'm six-foot-four!"), while James researched activities including the flower market and "coffee shops" as they were known in Amsterdam. We had so far spent three days touring the city and eating our way through Dutch fries, stroopwafel, and kibbeling.

Now, I could see James and Cody, his spiked hair shining in the sun, weaving their ways through the market stands toward us. Having stayed out later than Emily and I the night before, they were hung over and wanted more sleep before facing the cold. Emily and I, with the goal of making it to the canals at sunrise and the flower market when it opened on our last day, had turned in after a couple of drinks at a neon-lit bar near the Red Light District.

James slipped his arm around my waist, squeezing my red pea coat.

"Feeling better?" I asked.

"Not any worse," he said.

"Cody seems to have made a full recovery," I said, watching him enthusiastically pick out a pair of wooden clogs adorned with flowers to try on.

"Who the fuck actually wears these shoes?" Cody said, his sharp humor splitting the air. He slid his feet into a pair. "Honestly, these are so impractical," he said, tottering from side to side with repeated clunks.

"I don't think anyone *actually* wears them," I said, giggling. "They're just good for souvenirs."

"Ugh, if my mother asks me to buy one more goddamn souvenir for her sister's step-uncle cousin's kid..."

"We were just talking about this!" I said. "I wonder how much money I'll have spent on gifts for other people by the time this semester is over."

"We probably could have afforded to stay in a hostel with beds long enough for my body if we didn't have to buy so much shit for people," Cody said, dramatically flinging the shoes off and replacing them. He came over to where James and I were standing and started looking at the shelves of miniature houses.

"You know what," Cody said, looking into the distance, clearly seized by some idea. "Fuck this. Katie, open your bag."

"What?" I asked, confused. I was holding a plastic bag with a few packets of flower bulbs to give to my grandmother.

"C'mere, open your bag," he said, pulling me toward him by the handles of the plastic bag. He wrenched it

open and dropped a couple of the small houses into it. "There, that's two less gifts you have to buy."

"*Cody!*" I hissed, shocked and upset that I was now an accomplice. My eyes darted to the wooden table set up as a cash register at the end of this stall; the middle-aged woman manning it was showing flower bulb options to another customer, her hair pulled back with a handkerchief.

"It's fine," he said, already walking toward the next stall. "You can thank me later."

I looked at James, who shrugged. "There are worse things," he said.

"C'mon, let's just keep moving," Emily said from behind me, tucking her curly hair behind her ears, and we followed Cody to the next vendor. I gave Emily a pleading look, and I was sure she understood how I was feeling. She motioned me on.

The plastic bag felt hot in my hands, and as we walked past the lady working the stall, I was sure she would be able to see the tiny houses I had taken without paying, glowing red in my mind's eye, clearly visible through the bag.

"Cody, what the hell!" I said once we were in the midst of a new inventory of bulbs and Amsterdam-related trinkets.

"Katie, relax," he said, rifling through packets of seeds and not making eye contact with me. "Honestly, live a little."

I didn't respond; this statement perhaps hit too close to home. James squeezed my shoulder and I closed my eyes. There was something to Cody's comment, however irrational and outrageous he seemed at times. I was always planning, always running on a schedule, always thinking ahead. As whimsical as I had talked myself into believing this semester abroad would be, I had organized and categorized my way through it, down to attaching myself to a guy — in case any of my plans didn't work out, at least I wouldn't have to be alone.

The hot feeling of shame spread over me; I was used to being called out for being a rule follower since I refused to let the other kids copy off my homework in elementary school, which had translated into my being a "goody two shoes" in high school. Studying abroad hadn't changed who I was or my urge to stick to the guidelines laid out before me. Frustrated with myself, a surge of irritation rose in my throat. I didn't always have to follow the rules. I could be spontaneous. I could go off script.

I glanced around me and saw James inspecting his fingernails, Emily leaning toward a cluster of violently

purple tulips to smell them, and Cody purchasing a few packets of flower bulbs. Before I could think on it any longer, my hand jumped forward, I scooped a few more of the miniature houses toward me, their snow-covered roofs twinkling in the sun, and dropped them into my plastic bag with a thud. My instinct was to get away from this spot as quickly as possible, even though I knew no one had seen me.

"C'mon, are you guys ready?" I asked the other three. "Let's get some coffee or something."

Cody shrugged and Emily, who looked tired, agreed; James followed along in their wake. We wound our way off the floating barges of flowers back into the street.

Seeking validation, I nudged Cody and held the handles of the plastic bag apart. "Check it," I said, nodding toward the little houses.

"Oooh, we've got ourselves a criminal!" Cody said, whistling and pumping his fist. Emily laughed, clearly used to Cody's behavior and perhaps unaware that what I had just done was such a big deal to me, such a departure from my character. I looked around at James, who was sleepily looking at the shops we passed and seemed unperturbed by my thievery.

In order to control my worry about what I had just done, I began assigning the four stolen items to who

back home would receive them: one for each of my two college best friends who were still at Western Kentucky University this semester, one for my aunt, and one for a good friend from high school. I mentally checked them off my souvenir list. Now, who else remained? My grandfather, my goddaughter, another friend back at college...

"Hey, let's stop in here," I heard James say. I looked toward the shop he was entering, followed by Emily and Cody. It was a catch-all type of corner store, offering coffee, pastries, cigarettes, and gum along with some of the same trinkets that we'd seen being sold at the flower market. Everything was more expensive in here, I noticed as I made my way up and down the aisles. Now that I had successfully marked a few people off my souvenir list, bolstered by my successful first thievery, I was eager to get more gifts for people so I could concentrate on enjoying myself and prove how self-reliant I could be.

I stopped at a section of stuffed animals, thinking of my goddaughter, the daughter of family friends I had known since I was little. There was a small stuffed lamb that was looking up at me. Lambs had nothing in particular to do with Amsterdam or the Netherlands, but the idea of marking her off my list justified this choice.

Like I had done before, I scooped the white lamb into the now-sagging plastic bag, glancing over to the cash register, where the Indian man working was perusing a magazine, licking his thumb to turn each page. James, Emily, and Cody were paying at the refreshment counter, and I joined them.

"Here ya go," James said, handing me a small paper cup of coffee. "Milk and sugar," he added, smiling.

"Thank you," I said, my fingers hot with the heat of the coffee and with the adrenaline of the stolen lamb.

Emily stirred the sugar into her coffee at the countertop, replaced her lid, and turned to the group. "Let's get some breakfast?" she suggested to nods all around.

We walked out of the store together, whose door was open to the bustling sidewalk, and it happened in an instant: a screeching beeping sound went off as we walked out, there was a strangled yell, and a hand tight on my upper arm, which turned me toward its source.

It was the magazine-flipping store worker, a harsh anger in his eyes and across his forehead. "You stole from me! Let me see your bag!" he yelled, still holding onto me.

James stepped closer. "What's going on? She hasn't done anything," he said. Emily and Cody were staring on behind him.

The man released me and pointed toward my back. "She stole from me!" he said angrily. "Open your bag! I'll call the police!"

I had never wanted to evaporate on the spot more; this was not something I did, not something that happened to me — this man did not understand.

"I will call the police!" he yelled again, flecks of spit falling to the sidewalk. People were widening their paths around us.

My feet felt like concrete. Without thinking it through, I held the plastic bag out to him, my chest thumping so wildly I was sure anyone could see it through my winter coat. He jerked the bag out of my hand and yanked the tiny lamb, which I now saw had a security tag attached to its ear.

"This is from my store!" he said, shaking the creature at me.

"I — I got it from somewhere else," I said, my lips sticking to my teeth.

"I will call the police!" the man said again, his breath rising into the air.

I looked at James, my fear burnt across my face. What would happen to me if I were arrested in a foreign country? How could I talk my way out of this? How could I have been so stupid as to steal something and

to think there wouldn't be consequences? James looked back at me, his eyes searching mine. He pulled in a breath, a moment's pause, and —

"RUN!" James yelled, dropping his coffee on the concrete, the liquid splattering our feet. It took me only half a second to follow suit, my coffee hitting the ground, the plastic bag still hanging in the shop worker's hand, my purse beating against my side as I ran; Emily and Cody had taken off down a side street as soon as James gave the order; he and I followed them, our feet pounding on the cobblestone road, windows of houses and shops flying past. I chanced a look over my shoulder and saw no sign of the Indian man or the plastic bag, but I sped up anyway.

"Your coat!" Emily cried, tugging at my sleeves so that she nearly stumbled. "It's red, it's too bright, take it off!" She was panting as we ran. I undid the buttons of my red pea coat and she clumsily pulled a sleeve off; I bundled up the coat and Cody took it from me, stuffing it into his plastic bag on top of the flower seeds he had bought at the market.

We turned right at the end of an alleyway, grey stone buildings stopping our progress, and zoomed down another narrow street, pedestrians looking over their shoulders at us and calling out for us to slow down. A

left turn, another alleyway full of planters and clothes hanging out to dry, and we emerged into the larger, busier portion of the sidewalk that led to the flower market. We slowed but kept walking, now protected by the crowds of locals and tourists, clutching stitches in our sides and sucking in the cold air as calmly as possible.

"What — the — hell," Cody said between breaths.

I resisted the urge to laugh; a sort of hysteria seemed to be breaking over me. What on earth had I been thinking? I got away with stealing a few trinkets from an open-air market, so I thought I could shoplift from a brick-and-mortar store with precautions against that very thing?

"I don't know, I don't know," I muttered, another tide of shame rolling over me. Even without my coat, I felt hot and clammy. "I don't know what I was thinking!"

"Don't take me so seriously next time," Cody said, and he started to laugh. Emily giggled too, and then we were all sucking in shallow breaths, laughing at the ridiculousness of what I had done and at our dramatic escape.

"Good call back there, James," Emily said after her laughing subsided.

James slipped his arm around my shoulders and

squeezed. "That's what happens when you're dating a fugitive," he said, and in that moment, as I looked at my friends whom I hadn't known existed until three months ago, I felt okay. Embarrassed, afraid, but with a sense of perspective that was usually difficult for me to grasp.

Here we were, a laughing group, wandering around a new city that was thick with history and relationships of the past, forging friendships and making mistakes we would always remember. I felt like I was zooming out, seeing us from above as we walking along the canals, looking at the larger timeline of my life, looking at ourselves on a map, right in the heart of Amsterdam, the Netherlands. I continued to zoom out as though I were taking off in a plane, and I could just make out the miniature Amsterdam houses below before they turned into dots beneath me. ✣

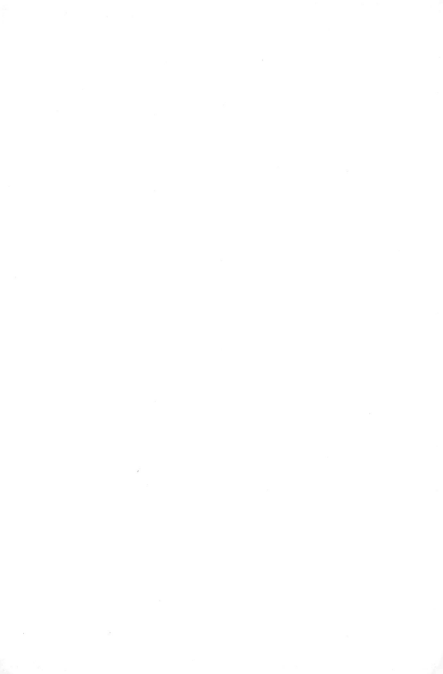

# Brighton, Benighted

*by*

## ANGELA KREUZ

*I*T WAS GOING to be my last joint.

I arranged to meet an old friend of mine in Brighton the day before the turn of the century — *millenium* still sounds like *Götterdämmerung* to my German ears. Claudia and I have never been big fans of New Year's Eve parties and in spite of the turning of an historic page, we preferred to welcome the new chapter privately at the seaside.

That year I had graduated in psychology at the University of Constance and kept myself afloat waiting canteen tables. I was the only one of my peer group who applied for work solely within the region, although there was hardly a chance to get a good position. My friends — like Claudia — were already scattered to the four winds.

Claudia was a budding medical doctor in the local hospital and lived in a service accomodation the size of

a storeroom, so I snatched one of the last beds in a backpackers' hostel close to the beach. Unfortunately she was asked to take the night shift for a sick colleague at the last minute before my arrival. After having checked my email, I knew that I had to prepare to enter the new era without her company. She suggested that we meet for breakfast the following day at a bistro by the pier. Great. *What a start to the New Year.*

I shared the dorm with a group of black women. I lay down on top of the bunk bed. I still had a bitter taste in my mouth from all the canned beer on the airplane, and my hair smelled of smoke. We were at close quarters and these ladies were dressed to kill. They ignored my attempts to join their conversation, and I began feeling a little bit lonely. The tension in the room was palpable: Maybe there was some infighting or they considered me a racist or both. I was hoping I could find a quiet stretch of beach around midnight and already regretted having wasted my scarce savings for the ticket — better I had celebrated on my own with a view of Lake Constance, at home, holed up in my bed, pulling the covers over my head. Halfheartedly I resolved to start walking along the seaside promenade around eleven until I left everyone else behind. I looked through the window; the first skyrockets burst cracking and

whistling. Wallowing in self-pity, I felt like a child-stuck in a war zone.

A lighter clicked and a sweet scent wafted across the room. While I was staring vacantly with these thoughts, a joint appeared next to my shoulder. I hadn't smoked pot for ages. Every toddler knows that alcohol and THC don't go well together. But if I took a drag, my room-mates would talk to me and I needn't feel all alone in the whole wide world — at least I hoped so secretly.

I was torn. The hand stirred impatiently. 'Thanks.' I took the joint and inhaled. Once long ago, I had persuaded myself that pot would increase my creativity, but some ingenious, convincing reported experiments gave rise to doubts, and I soon quit.

Toking winched up my mood; my pulse quickened. As I was gazing at the naked bulb on the ceiling, pe-culiar thoughts occured to my mind and I giggled. It took effort to slur out my best joke. 'Do you know how many psychologists it takes to screw in a light bulb?' A grumpy snarl cut me off; I passed the joint. Clearly, now was supposed to be a chill, silent evening of hang-ing out before the great event.

As fast as I soared into high spirits I dipped low. Suddenly I couldn't think clearly and a shoreless con-fusion spread in my head. Time extended endlessly, but

the hands of my watch didn't move noticeably. I felt dumb, birdbrained and excluded. I feared I would never utter a straight sentence ever again. Then, all at once I had a great thirst, and unfortunately the water bottle on my sheets was empty. My arms and feet were heavy as lead and by no stretch of the imagination could I figure out how to climb down from the bunk bed. When the burden of suffering was great enough, I braced myself, but to my surprise I bounced up. I got dizzy and latched onto the bedpost until I roped down, finally standing on the swaying ground. The girls dozed.

My attention was focused on keeping my balance. With the plastic bottle in my hand I navigated through the room like an overloaded steamer, wobbled to the corridor and turned in a generous curve on the left hand side into the bathroom. For hours I fumbled for the light switch until a miserable lamp illuminated the walls. I locked the door. Instead of a sink there was a bathtub next to the toilet bowl. I was suddenly gripped by nausea and at the same time that I urgently needed to pee. I sat down on the big white telephone. Black spots danced in front of my eyes and formed a weird contrast to the pale rug. The moment I pulled up my blue jeans, darkest night surrounded me and I lost consciousness.

When I came round my jaws ached and my mouth

was even dryer than before the collapse. The bottle lay on the tiles half way towards the door. I started to crawl on all fours. On my knees, I latched onto the rim of the tub. I turned on the cold water tap; it squeaked, but nothing happened. With *hot* I was out of luck too. In sheer desperation I propped myself on my elbows and straightened up. I vaguely remembered seating in the corridor and unbarred the door. There must be another tap somewhere in the house. With bottle in hand I sat down on a chair and waited for the next person coming along, but no one showed up. Maybe everybody was already at the pier drinking champagne.

After what seemed like an eternity, a sleepy-eyed guy with dreadlocks came out of a dorm room.

"Excuse me, can you fill my bottle with water, please?" I held it towards him and sensed that I blushed.

He disappeared behind the next door, obviously a second WC, and returned with a full bottle.

"Happy New Year, man," he said and off he went.

I put the bottle to my lips and drank the freshest, coolest and best drink of my life.

Happy New Year. ⟿

# White Girl
# in Indian Country

*by*

## MAGGIE STARR

⌒⌒

*I* DON'T REMEMBER why I decided not to use a set of cross-country bicycle maps. If I had, they would have sent me down the most direct and bike-friendly roads, shown me where food and shelter were available along the way, and even laid out the elevation of the route so that I could be mentally prepared for the road ahead.

Instead, eight years before I would get my first smartphone, I looked at state maps and asked for directions, setting my destination for each night as the next campground sixty to ninety miles to the west or north of where I started the day. Enough west with the right touch of north would get me from the Boston suburbs where I grew up to Portland, Oregon on the only set of wheels I had at the time of my college graduation — my bicycle.

~

By the time I get to southeastern Montana in early August, everything is brown, and the vastness of the landscape challenges my New England eyes. Since the rolling plains of western Iowa, they've been struggling to adjust to finding trees only at higher elevations, and to the horizon being so, so far away. I'm used to the rhythm of riding out here by now, though. When I started back east, I didn't make a lot of stops. Out here, the towns are sixty miles apart, and I never pass by a chance to refill my water bottles and talk to locals about the road ahead.

Ashland, Montana looks like many small towns I've passed through, though maybe a little more run down. It's still mid-afternoon, and I only have forty-six miles under my wheels for the day. As I prop up my bike outside the grocery store, a grandfatherly white man starts a conversation that I have had over and over since leaving Massachusetts seven weeks ago. Where did I come from? Where am I going? Am I raising money for charity?

I am used to this conversation, but I still enjoy it. I get a kick out of people's admiration and astonishment at me, this young blonde showing up out of nowhere

on a bicycle. I find myself basking in the bafflement of people who can't imagine what would motivate me to do something so strange and extreme. A woman in South Dakota told me she was driving to Portland the next month, and that I could wait and get a ride the rest of the way. She didn't understand that getting there wasn't the only point.

I respond with my own questions, inquiring about the road ahead. Some nights I already have a state park picked out, a little green patch ahead on the map, but I'm not sure where I'll sleep tonight. Most of these small Montana towns have a town square I can camp on, but I'm not sure if the same is true in the next town, Lame Deer, just over the border of the Northern Cheyenne Indian Reservation.

The old man wants to know, am I really alone? This is my favorite question. I already feel like a modern pioneer, making my way west under my own power, but when I can break new ground in someone's conception of what is possible for a young woman to do on her own in the world, I feel doubly so.

He asks another familiar question: Aren't I afraid? There are a lot of bad people out there, after all. By this point, I have a standard response: "Everyone tells me about these bad people, but I haven't met any of them

yet." And it's true. All the people I meet are so afraid for me, it seems, that I have nothing to be afraid of myself. They want to feed me dinner, let me sleep on their couches, take me on sight-seeing trips to Mt. Rushmore, give me a ride twenty miles to buy a new tire, or just slip me fifty dollars because they know I'll need it down the road. I have never before been the recipient of so much spontaneous kindness. I have also never been so frequently and explicitly reminded that I could be raped, robbed, and murdered around the next corner.

That reminder is what this man has for me, or a version of it. I often get a general warning, but now I'm about to cross into an Indian reservation, and he warns me that I should be careful. I'll probably be fine, he says, but I shouldn't spend the night there, and especially not on a weekend. Things get wild. There's a lot of unemployment in those parts, he says, and that means people have more time to get into trouble.

I've heard this refrain about several reservations at this point, and it sounds like the same thing white people say about people of color's neighborhoods all over the country. If what I'm learning from all these friendly people on the road is that there's nothing to be afraid of, can't I dismiss this fear mongering, too? And if what I'm learning is that I'm safe because of the kindness of

strangers, why should I dismiss this well-intentioned advice because I think it smells funny?

For better or worse, I'm wary of the Northern Cheyenne Reservation. I'm not from here and all I know about the places I go is what people tell me. Maybe traveling by myself on a bicycle isn't the best time to test the line between caution and prejudice, I tell myself. Maybe I should spend the night in Ashland.

My next stop is at the post office, where I ask the middle-aged white clerk about camping. Don't camp in the town park, she says, or anywhere else, for that matter. People get drunk and wander around at night around here. The next person in line, another middle-aged white woman, overhears my inquiry and offers to let me set up my tent in her backyard. I take her up on it.

The lonely state highway west toward Lame Deer not only crosses the Reservation boundary right out of Ashland, it also crosses a big ridge. It takes me almost an hour to get the first five steep miles out of town. I am sweating, grumpy, and spinning my pedals to get over the final hump, when an old sedan with three Native men in it, only the eighth or ninth vehicle I've seen this morning, pulls up just ahead of me and stops. Huh.

I keep pedaling until I get to the car, and peer in

the window to find a grinning driver with all the standard questions for me. Hey! Hello! Where are you coming from? Where are you going? Wow, that's far. You know, I have a cousin in Massachusetts. He introduces himself as Jonah, says he's from Lame Deer, and I chat with him and his two passengers about my trip. As I always hope for, they start telling me about the road ahead. The worst of the climb is over, which I'm happy to hear. I have a big downhill into Lame Deer to look forward to, and then rolling hills most of the rest of the way through the Cheyenne Reservation.

Jonah is enthusiastic about the area, and says that if I take the next gravel road on my right, it will loop past some ice wells, where the water stays frozen all year. A little further down the road is Crazy Head Springs, where there's a Cheyenne language immersion program. He tells me that Cheyenne water is good water, and that if I take some with me it will get me where I'm going. The other two men in the car laugh at that, and Jonah says that they don't believe it, but that I should get some water anyway. He reminds me his name and says that I should tell people in Lame Deer I know him. They'll treat me well.

We wave at each other and they take off. It's just what I need after that climb — an upbeat talk with some

locals, the prospect of some neat sights off the beaten path, and reassurance that people who wish me well are all around. Gravel roads can be tricky, but they're doable on my tires. And it's probably not far to those ice wells, though he hadn't exactly said, and I had forgotten to ask.

The gravel road comes along about a mile later, and as I start down on it, I find myself having a few second thoughts. Somewhere in the unwritten handbook for solo female travelers there is probably a line that specifically advises against going down remote roads in reputedly unsafe areas that no one knows you're taking except for three men you've just met. But I had acted on travel advice from two white people yesterday, hadn't I, and accepted hospitality from a third? Tips from locals have led me to some fun sights in the past, and since I'm already violating so many unwritten rules by being on this trip in the first place, what's one more?

I keep coasting downhill, riding my brakes so I don't build up too much speed on the gravel. Around the next bend, there are cows in the road and I can see two men on horseback up on a grassy ridge with the rest of the herd. They must be able to see me, but if they do, they're not acknowledging the sight of a white girl on a loaded bicycle on their road with their cows. They're too far

away to hear me, but I find myself wanting to wave, yell Jonah's name, and tell them that I've been invited. All of a sudden, I feel like the worst kind of pioneer — someone who has no right to be here. Instead of calling to them, I turn around and ride back uphill to the highway.

With each revolution of the wheels through the gravel, I change my mind about what's going on. Am scared for my safety? And if so, is my fear justified? Am I scared of the horsemen's anger or disapproval? Am I acting with good judgment, given that I have vague directions, a rumored destination and no independent knowledge of the area? The gravel runs back into the pavement, and I'm back on an easier road.

There's a sign for Crazy Head Springs a few miles later, and when I see it I think of the school. There'll be people there, I imagine. I can introduce myself give them the answers to the questions — where I'm from, where I'm going — whether they ask or not. I can drop Jonah's name, get some special water, and then continue my ride. That's still a great story, and there's no reason to be scared. No reason to believe that this Native land is any more threatening than anywhere else. No reason to treat the place or the people with anything other than my usual friendly and open approach.

I take the turn down a dusty dirt road and soon pass the sign for the school, directly next to a sign informing visitors that non-members of the tribe need a permit from an office in Lame Deer to use the area. Should I go get a permit and come back? That seems impractical, given that it's still fifteen miles to Lame Deer, and potentially unnecessary. Jonah told me about the place, didn't he? Maybe he knows someone there. And young adventurers don't need permits, right?

When it occurs to me that the permit is hardly the most important thing in the scenario in which I would show up asking, in English, for special water at a Native language immersion school, I turn around again. The ride into Lame Deer is all downhill, as Jonah had told me. I buy a liter of Aquafina at the grocery store and stay on the highway.

～

Ten years later, I can still see myself riding away from Lame Deer through endless brown grass, brow furrowed and eyes focused on the road in front of me. I was trying so hard to be open to people helping me rather than closed off from them hurting me, that I was unable to imagine the story in which I wasn't at the center, the

all-important wanderer and pioneer. That story is one in which I didn't earn my way across the continent by conquering fears and learning how best to go it alone, but one in which I leapt into a net made of paved roads, white privilege, youth, luck, history, feminism, and femininity. One in which I'm not even a dot on a map, just a speck on the wide-open plains. ⟿

# The Farthest Track

*by*

## HILARY ENGLAND

*IN ALL MATTERS* regarding the physical world, the elements take no pity on our social circumstances, our wants or needs. They simply and inexorably do what they must do.

I would learn this truth through unexpected cultural immersion in the Margao train station, when our train would be delayed.

By then I'd been in India for two weeks, my journey having started off with a bang, or rather, with a bite. A giant Asian hornet had been waiting to welcome me the moment I stepped into my hotel room and sat with relief on *her* toilet. Mother Nature and the Elements do not care about such things — they carry on, oblivious to foreign artists who wander unknown territories, unsuspecting.

After the sting, my leg ballooned to proportions I didn't think were possible. "The skin must shred, or my leg will choke and fall off." This was the only conclusion I could imagine, based on what was occurring to my body. I monitored my left appendage grimly, as it turned red, purple, and then blue from groin to ankle. I had no medical information. I only languished semiconsciously and let things proceed as the Universe would have them.

Although I was desperately ill from the sting's venom, I was still lucid enough to appreciate my surroundings. The small economy resort I was staying in was very hospitable. The staff would check on me daily, and room service accommodated me with food selections they thought would be "good for my healing." Every day at four o'clock, a tray would be brought to my bedside by a cheery, very young attendant. Under the metal warming lid I'd find a new and interesting local dish — sometimes a mildly spicy chicken with white rice; another day, a savory fish with tender potatoes; every day a single cold bottle of 7-Up with a straw. This made me feel cared for, less homesick, and less afraid that I would die.

Upon their daily arrival to my room, the staff asked if I would like a medical attendant, but I always declined.

Being on a very tight budget, I was afraid I didn't have the funds for a doctor.

So the kind resort employees provided fresh bandages and offered advice: Put honey on the wound; go float in the ocean for one hour; wrap an onion around the wound. I politely thanked them for the interesting suggestions. They would return to check in on me again, then disappear quietly and leave me to battle the fever on my own terms.

The large bed was very comfortable with clean linens that the staff changed every other day while I sat in a lounge chair that overlooked the grounds from my balcony. The room was cool and pleasing, with high white ceilings and a bamboo ceiling fan. The resort would have been very enjoyable if I had been healthy, and I was thankful for the pleasant accommodations and amenities.

Still, I'd listened to the monsoon lash violently against the windows alone in my hotel room for two weeks of anxiety, pain, and restive recovery. When it was time to go, I looked forward to the rest of my trip despite my swollen leg. I left with the eagerness of fervent attempt to rinse away bad hair color.

~

Though my travels started badly, the resort had been delightfully accommodating, and I held fast to my belief that the rest of my journey and accommodations would be up to similar standards. I was in India to be part of a cultural exchange Visual Artists' residency in Kerala. My two weeks in Goa, where I'd wished to "rest and relax" prior to the start of my work, was certainly not what I had anticipated. Now I was hoping to flee to restful landscape painting and a smooth trip from this point onward. Hoping. Serene images of lush landscapes and quaint villages sprang to mind, and I embraced those thoughts.

To begin the obligatory part of my trip, I had to make my way down the East coast from Goa to the southern-most point, Fort Cochi, and then on to Kerala. I had elected an eighteen-hour overnight train ride versus a three-hour flight, so as to see the Indian countryside and enjoy the sights.

I would travel from Margao to Fort Cochi, or "Kochi" and from there, I would take a taxi I had prearranged online Stateside. It would be a two-hour taxi trip into the "backwaters" of Kerala, to Lake Vembanad, where I would meet up with my group. I had all things planned down to the moment — as a seasoned solo female traveler, I was very good at planning. I took comfort in this,

and had actually grown a little smug due smooth to sailing in the past.

Shiva, the congenial taxi driver employed by the resort, navigated the pitted dirt road that led up to the Margao train station among the crush of other taxis funneling into the area. The building that stuck out among the other dilapidated structures was The International Fellowship of Alcoholics Anonymous. I smiled and thought to myself, "If I get chased by a mob of lascivious men, I can always find sanctuary in an AA meeting." I had been warned about all of the evils of traveling alone as a woman, and had filed them serenely away into the "not going to happen" file at the back of my mind. I couldn't allow other people's hysterics to interfere with my own goals and dreams, so although I pretended to appreciate these well-meaning naysayers' advice, I thoroughly disregarded it.

We pulled up to a dilapidated-looking area that had a very large awning with a holey, rusty tin roof. Beneath was a hive of activity where cabs disembarked people with luggage that looked like it came straight off a 1920s steamer — old-timey trunks with brass locks and leather straps; and battered 1970s Samsonite luggage in burnt orange or avocado green, held together with black electrical tape. Suddenly, my sorry, battered,

black spinner with its silver duct tape and epoxy reinforcements looked positively cosmopolitan and in vogue, not to mention expensive. I bit my lip momentarily, said a quiet prayer of affirmation, and just cleared my mind. "I'll be fine."

Shiva unloaded my suitcase, and bid me, "goodbye and God bless," with a slight bow and handshake. As I stood watching him drive slowly down the muddy drive, disappearing into the traffic jam, I half wished I were leaving with him. But I put some resolve in my shoulders and straightened my stance. I turned my attention to the station and slowly walked, dragging my suitcase and bloated, bitten leg behind me, trying not to look too inept, too injured, too incapable, too vulnerable.

The train station was bustling with activity in the blazing Indian heat. The information booths were swamped, and although the signs were in both Hindi and English, they were not very helpful, since some of the English phrases were almost as incomprehensible as the Hindi: "Departing Forward Relative to Track Four." Layer after layer of badly written paper updates were taped one on top of the other onto the foggy glass, fluttering in the light, stifling breeze.

One of those updates flew off and drifted to my feet. I picked it up. It was the newest timetable. Appar-

ently, all of the trains were experiencing delays. I sighed and headed around the queue to the open cobbled area that had a more permanent covering, where I got my first glimpse of the several platforms and tracks.

There were at least five track areas, and my ticket, printed online back in the comfort of my home office in Pennsylvania, did not provide track area information. My ticket simply stated the train track would be "assigned at the time of departure." That vagueness made me newly uneasy. With my leg throbbing and my suitcase growing no smaller, getting to the track now seemed a daunting task. Would I be able to lug this gigantic suitcase that distance, given the condition of my leg, the number of stairs, and the uncertainty of the train's arrival? I wondered if I would be able to manage the task of boarding without any assistance, so I decided to see if I could find a helping hand.

I looked around, and seeing a man in a uniform, I asked him if there were porters who could help me with my luggage? He looked at me indifferently and shrugged, pointed to the information counter with the large group of frantic people all vying to get to the front of the line. I cringed and decided to seek the help of one of the other official-looking people standing around the station's other offices.

But surprisingly, at just that moment, a large LED board lit up overhead. Destinations and track area information miraculously appeared. I noted my track number with relief, but the relief turned to distress when I saw that my assigned track was the very farthest from the station. I would have to lug my suitcase up and down some big staircases with my bad leg, and worse yet, the overgrown vegetation looked as if it had swallowed the track into nothingness. I gulped at the prospect of being alone over there, separated from the throng and more importantly, from the police presence.

A message began to scream forth from the loudspeaker overhead: "Delays for trains. Please check information desk for appropriate delay information." The message was just barely comprehensible with the crackling in the system; the crowd heaved collectively in confusion. Everyone was just as lost as I was at this point. There would be no help from any of them, as it would be the blind leading the blind.

Many of my fellow travelers looked deeply impoverished. They wore rags; they sat on the ground in little groups, looking around quietly, resignedly, stoically. Some ate, others slept, or they murmured to each other. Starving dogs meandered quietly among the partitions of people, looking to glean a few crumbs.

I figured I had better find my own spot as well. I decided it was best to sit where I could watch the LED board, and listen for announcements. The crush of cars at the entrance of the station had not abated, and the teeming depot was overflowing. All of the benches were full, and in every square inch of the station people were sitting on their luggage, lying on the ground, or sleeping. Since it was hard to maneuver without hitting someone, I carefully backed against a shaded wall, out of the strong late afternoon sun, and balanced myself on the edge of my suitcase. Not comfortable, but at least I was less conspicuous than I had been.

I perched on my suitcase for about an hour, watching the flies buzzing about in the oppressive humidity. Food vendors had taken advantage of the delays and now set up their carts, and offered steaming packets of rice, meats, mysterious and exotic fish dishes wrapped in tented tinfoil packets. They also offered treats, such as candied fruits, fresh local fruit, bagged nuts, and drinks of chai tea and bottled water. I had a large bottle of water with me, four Kind bars tucked into my suitcase, and one inside my purse for survival purposes. I knew I could live on these rations for a day at least, if I didn't want to brave the local or train foods. As good as it looked, the prospect of a bout of food poisoning

was enough to keep my hunger in check. I looked in my purse at my melted granola bar and gave a shudder of disgust. "It's going to be a long ride," I thought.

As I quietly watched my surroundings, I noticed that one of the men left the crowded wooden benches. It was a coveted end spot, in the shade, and I quickly made my way to it and sat down. A young, nicely dressed Hindu man sat on the other side of me and barely glimpsed over his newspaper as I settled in. Decently dressed men occupied all the seats on the benches; the obviously poor sat on the floor. Women were in groups and they too sat on the floor.

After a few minutes, a thin, grizzled-looking man, very dirty, naked barring a filthy loin cloth — one of the many beggars in the station — came up and stood directly in front of me, so close that his navel was near-ly touching my nose. He glared down for several long, uncomfortable moments. It became obvious he was not going to leave until I acknowledged him. I finally looked up at him, and with a very slight smile, nodded.

He began to yell at me in Hindi, holding out his hand, and pointing into it with his other hand. Obvi-ously, he was demanding money. I looked up at him, said, "No," and shook my head. Mistake. He came so

close that when he yelled at me, I could feel his spittle hit my cheek.

Suddenly, the young man sitting next to me jumped up and pushed the beggar away, yelling at him in Hindi. The beggar instantly ran away, disappearing into the ocean of people. I heard the word, "Police" in the barrage of yelling, and I just sat there for a moment, stunned, to digest what had happened.

The young man stood until he was satisfied the accoster was gone, then he sat back down. "That was inexcusable." He smiled, "Are you American or European?" I gulped as I regained my composure. "I'm American." I managed a smile of gratitude. "Thank you for helping me!" He just smiled and nodded in return.

His name was Ajit and he was awaiting the arrival of his wife on one of the overdue trains. Ajit was an educated man, an industrial engineer who, having visited Europe, still longed to visit the U.S.A. We conversed until darkness fell and his wife's train was finally on the horizon.

Ajit told me there was a special enclosed waiting area for first class ticket holders; it was air-conditioned and guarded by police. He showed me to it, but there was a waiting list for the waiting area. Still, Ajit reassured

me, there was another area, this one strictly for women, which was also safeguarded by police. "You must not stay out in the general waiting area of the station by yourself," he warned. "Please be safe. The general waiting area is very dangerous for a woman alone."

We noted that my train was indeed coming in on the farthest track in the sprawling station, a now dark and ominous area that required me to drag my suitcase up four very daunting staircases before crossing over. I sighed in dread of that next leg of my journey. Ajit noted, "Do not go to that area of the station until you are *absolutely* certain the train is only a few kilometers away." I nodded and agreed, and then entered into the women's waiting area as I said my farewell to my helpful guide and protector.

～

The women's waiting area was a large, well-lit room, with fluorescent overhead lighting that flickered occasionally, as the monsoon rains battered the leaky tin roof above us. The walls had various signs welcoming us women, and there were amusing, bizarre murals of women, some dressed like prostitutes, fighting off caricatures of leering men. Long rows of wooden benches,

slotted for seating, lined the walls of the room, and there were, in addition, back-to-back benches in the center of the room.

The ladies' waiting room had a smooth cement floor, unlike the cobblestone of the station, and was very clean in comparison to the other station areas. It was well maintained but utilitarian; and although it was not air-conditioned, it was a still and cool and refreshing retreat from the stifling heat of afternoon.

There was a nice spot open on one of the benches, right at the very mouth of the room. The entire front of the spacious room opened to the main track area, so from the spot I was able to claim, I had a full view of the station while I still enjoyed the comfort and safety of having police close by guarding us females. I murmured a quiet prayer of thanksgiving as I sat down and made myself as comfortable as I could, not knowing how long it would be until my train arrived. No one knew.

The hours ticked away with excruciating slowness. I sat, occasionally standing to stretch my legs, swat at a mosquito, or look around the room. Women were in every crevice, sleeping propped on one another, some sitting or lying on the floor, feeding children, or quietly conversing. I yawned and looked out at the dark and quiet train station, now asleep like one giant organism,

with oceans of bodies resting peacefully against each other, and the full Indian moon serenely glowing down upon the scene like a giant night light.

I had not used the rest room in many hours, and now realized I was in a situation of sorts, since I had to urinate pretty urgently, but I was not sure what to do with my suitcase. There was a "bathing" area off the back of the ladies' waiting room, where you could pay a rupee to use the toilet or two rupees to toilet and bathe.

Looking around, the women who were still awake and quietly chatting seemed coy yet curious, as they watched me standing in the room looking indecisive: Should I risk losing my suitcase to a thief (the police were asleep at their posts) and giving up my coveted seat, or wetting my pants? I opted to take a chance in the bathroom.

There were three older women sitting at the entrance to the bath area. One was obviously an attendant, and the other two, travelers. The attendant was dressed in a drab sari of navy blue, with a soft gray set of pants, while her two companions were more elaborately dressed. One woman had a ruby red sari that was ornately decorated with gold threading, gold sequins and red rice beads. Her companion had an equally pretty sari but more subdued, in a deep green with a yellow ochre embroidery.

The trio sat there having a low, animated conversation in Hindi, when I came lumbering along, dragging my suitcase. "One rupee," the attendant said evenly. She did not seem overtly curious about me, nor did her companions, but she smiled sympathetically, and they all looked me over as they stopped their conversation at my arrival. I carefully fished out the rupee from my disarrayed bag, and then asked the attendant, "Can you watch this?" I motioned toward my suitcase. "Yes, yes, no worries" she said, and waved me forward into the mysterious room.

I entered into a large room with overhead lighting, with roofs only over the stalls. There were several sinks set up, almost like a barnyard trough, and beyond, was a wall with several doors, which I assumed were the toilets. I walked over to a warped wooden door that was slightly ajar, and peeked in. Nothing. Just darkness. Then, my sleepy eyes adjusted, and I saw only a dirt floor with some old floorboards to stand upon, with a hole in the center. I shuddered, but entered.

Luckily, I had some napkins tucked away in my purse, and was able to be done quickly in there. The dark "toilet" hole in the ground scared me, and nightmares of yet another wicked creature jumping out and biting me in the ass prompted me to hurry. I rinsed my

hands under the water with several other women and exited, giving my hands a precautionary squirt with anti-bacterial gel from my purse as I left.

The few minutes in there had not left me luggage-less, and I thanked the attendant, giving her an additional two rupees for her vigilance, and so she would think well of me should I need to have her watch my suitcase again. She smiled and nodded, and then went back into her conversation. My seat hadn't been jumped into either. I reclaimed it, relieved, and now curious. Was the train actually going to arrive within the next twenty-four hours?

As I sat there pondering in my sticky and stale clothes, a very young, white couple slowly walked by. Obviously American by their clothes and accents, they looked tired and confused. They whispered to each other and looked around as every sleepy eye in the vicinity opened to stare at them and then whisper their shock amongst each other as the two ghosts in the moonlight passed by.

I felt both pity and relief that someone else was now the object of curiosity. At that, we locked eyes, and they made their way right up to the entrance of the women's waiting room where they pitched their camp literally in the doorway, at my feet.

"The monsoon has washed out the tracks up a-ways." It was the young man who spoke, quietly, almost whispering. "Where are you headed?" he asked. I looked into the distance, into the blackness of the unknown, and said, "Fort Cochi." He nodded but said nothing. I didn't ask where they were going, so we sat there for a while, just watching the laconic movements here and there of the station occupants and the animals. "Do you have any information about how long the delay is?" I asked hopefully. "Long time." He said this resignedly.

Long time? Like as in hours? Days? Weeks? Never? I suddenly felt scared that I didn't have a back-up plan. What if we were stuck there for more than twenty-four hours? How would I reroute myself to Kochi? It was literally a whole country away. My Indian cell phone didn't even work in this place!

I hadn't planned on what to do should a situation like this arise. I took it at face value the train was a sure bet, because as a Westerner, it never even occurred to me that such a thing could happen. The train was delayed twenty-four hours for flooding? That would have made the regional news, maybe even national news, with Amtrak working feverishly to fix the situation. No, this was something my Western mind could not comprehend. I looked miserably around at the chaos that was now

sedated, but just waiting to reactivate with the sunlight of the approaching morning, and I felt the fingers of panic start to choke me around my throat. As a middle-class American traveler, I was totally unprepared for circumstances I had stumbled into.

For the first time, I felt genuine sadness and panic at being in India. Even the horrible hornet sting I had endured didn't make me feel as helpless, because at the time, I hadn't felt as if I were in the midst of an enemy camp. In Goa, I had a comfortable room, First World amenities, and the safety of the armed guards on the resort grounds. Here in the Margao train station was chaos and squalor, the threat of attack by both man and beast, no cell phone signal, no Wi-Fi to figure out an alternative, no sanctuary to hide in, nothing or no way to alert anyone that I was even on planet Earth anymore. I could simply disappear, and that would be the end of it. No one would really kick up a fuss but my family, but as middle class Americans — and lower middle class at that — our officials would not pursue it. My family was certainly not important or wealthy enough.

I had a momentary surge of hysteria, in which I told myself, "I want to go home *now*! Which door opens to transport me back home? Which leads me back into

my own room, to my own family, my dog, my bed, all waiting and welcoming!"

Still, I began to giggle at the irony, realizing I had done this to myself. I had "exiled" myself to this place, and now I couldn't undo it. I had to go through the full measure of it, whatever "it" might be, and now just deal with it, should I even survive it. I immediately shook the escalating craziness out of my head, and got a hold on myself. Now was not the time for insanity. Now was the time for lucid thinking.

I looked down the tracks into the pitch-black void, and began making some plans should the train not arrive by morning. Find a taxi, find a local hotel with Wi-Fi, and start looking at other options, including flying out to Kochi. I began to feel order return, and again, I just knew all would be resolved.

As I sat there making back up plans, the LED board that had been dormant for hours suddenly sprung to life, as did the loudspeaker system. The entire population of the train station, so subdued and sleepy, instantly sprang to life, with people running to mill around beneath the sign, excitedly chattering.

I could see the board clearly from where I sat, and now, the arrival times of the trains were up, as well as new track assignments for these arrivals and departures.

Fort Cochi, scheduled to depart from train track D was now to depart from train track A. I looked around, and then realized that the track right in front of me was A. "Hallelujah! Woo hoo!" I cried out of sheer relief — I would live to fight another day! The ladies around me giggled as they watched, whispering amongst themselves. I embarrassedly apologized for my little outburst of uncontainable gratitude, and they smiled and nodded.

In ten minutes, the trains all arrived at nearly the same time, as if some mysterious force had held them prisoner, and they all escaped together, bursting down the tracks. The train to Fort Cochi pulled in, and I walked nervously alongside it on the platform before it even came to a full stop, desperate to find the 1AC car and my own assigned compartment. It was deep into night, nearly 3:30 a.m. The 1AC car pulled to the very end of the track, as it was close to the front. I went jogging down, dragging my spinner suitcase on its side and I jumped aboard before the baggage handler could even help me.

As I entered the train car, all of the 1AC compartments were empty, none marked by number. I found the one that looked cleanest toward the middle of the car, and I plopped myself down inside. I sat to catch my breath. After a few moments, a middle-aged train

attendant came along, and I showed him my ticket. He insisted I leave the cabin I was in and move to another.

I was prepared to quiz him as to why I had to move, but as we were speaking, a giant cockroach ran down the wall of the compartment to the metal sink in the middle of the small cell. It sat there, clearly to taunt me. "Okay," I said, "Let's go."

The attendant took me to another, identical looking compartment near the front of the train car, and said, "You stay here Miss. This is nice compartment, very convenient to toilet, so you do not have to walk far." I was grateful for this concern, and I thanked him. He showed me where the common toilet was, and how to make sure the door was locked on my compartment, and how to raise and lower my bed to make it into a sitting couch.

"Will I be alone for the journey?" I asked cautiously. He thought for a moment, and then said, "For now..." ⇝

# About the Authors

## VOLUME 2

⁊๏⁊

**MAGGIE SWEENEY**, *Writing Home*, of Greenfield, Massachusetts is a life-long teacher of French and English to Speakers of Other Languages in both secondary schools and community college. She has traveled extensively in France and Tunisia and has visited other parts of the world vicariously courtesy of her students. She has enjoyed journal and letter writing since childhood and is thrilled to have some of that prose included in this collection.

**SALLY HAMRICK**, *George's Cadillac*. Sally Hamrick is a proud 1977 graduate of The Ohio State University. She retired after thirty-two years with the Columbus Recreation and Parks Department. Sally lives in Canal Winchester, Ohio and is married with children. Her current favorite author is Joe Hill.

**KATIE KNECHT**, *Tiny Houses.*  Katie Knecht is a Kentucky native living in Brooklyn, NY. She earned her MFA from Manhattanville College and has been published in *Foliate Oak Literary Magazine.* She visited eight countries during her semester abroad and continues to travel the world.

**ANGELA KREUZ**, *Brighton Benighted.* Angela Kreuz is a bi-lingual writer whose most recent awards include the Vigilius Mountain Stories 2017, the Brandenburgischer Literaturpreis 2015, third place, and the Kulturförderpreis der Stadt Regensburg 2012. Born in Ingolstadt, she lives in Regensburg, Germany. Kreuz has published a volume of short stories, a novella, two volumes of poetry, and four novels in German, recently *Straßenbahnträumer* (2017) and *California Dreaming* (2013). *Train Rides and Tides—Ebbe, Flut und zurück* (2011) is her most recent poetry, with English and German on facing pages.

**MAGGIE STARR**, *White Girl in Indian Country.* Maggie has fought forest fires in seven states, ridden the Trans-Siberian Railroad, and holds a Level 3 Certificate in Animal Track and Sign Identification from Cybertracker Conservation. She lives and works in Portland, Oregon.

**HILARY J. ENGLAND**, *The Farthest Track*, is an artist and freelance writer based in the Northeast USA. She travels internationally to explore and interact with new cultures. She is as a social realist artist and an avid plein air painter who exhibits her works globally.

# She Can Find Her Way

## Women Travelers at Their Best

*Essays by Independent Women Travelers*

# She Can Find Her Way

## WOMEN TRAVELERS AT THEIR BEST

*Essays by Independent
Women Travelers*

**EDITED BY**

# ANN STARR

Upper Hand
**PRESS**

Cover and box design by Myeong Sik Ryu
Interior design by David Moratto

Upper Hand Press
P. O. Box 91179
Bexley, Ohio 43209
U. S. A.
www.upperhandpress.com

Printed by Häingraph

ISBN: 978-0-692-36867-1

*That man over there says that*
*women need to be helped into carriages,*
*and lifted over ditches, and to have*
*the best place everywhere. Nobody ever*
*helps me into carriages, or over*
*mud-puddles, or gives me any*
*best place! And ain't I a woman?*

—SOJOURNER TRUTH

# Contents

*Contents*

## VOLUME 2

〜

## VOLUME 3

〜

## VOLUME 4

# VOLUME 3

# Etna

*by*

## SHERYL LOEFFLER

*Now huge crags of itself,*
*out of the bowels of the mountain torn,*
*its maw disgorges.*
— VIRGIL, *Aeneid*

*I*WENT ALONE to Sicily for two reasons. First, because I wanted to go somewhere. My husband, Douglas, had flown back to our permanent home in Canada from our temporary home in Malta. For a few weeks, I'd be on my own. I wanted an adventure. And going to Sicily for the day was an adventure I thought I could handle. I'm a cautious — read *anxious* — solo traveler. But after living abroad for a year, I was convinced that I was ready to travel alone. I was ready to flirt with danger. I wanted — I was ready — to see an active volcano.

I went alone to Sicily, secondly, because I had to go somewhere. My Maltese visa was about to expire, which meant another interminable, wasted day at the police station in Floriana applying for an extension. In those days, leaving the country and reentering it conferred

automatic permission to stay for another three months. Going to Sicily for a day was a way of avoiding the deadly immigration office.

My fear of spending another day at the immigration office trumped my fear of traveling alone, of gaping into Earth's molten core.

### At the Deadly Immigration Office

I feared Hell less than I feared Purgatory because I'd been to Purgatory.

There was nothing to do at the immigration office. Nothing to see.

Nothing to see but the paper documents spilling from boxes and boxes on careless shelves stacked high to the ceiling behind the manned and womanned desks. Each box an anachronism in our electronic age. One lit match, I thought. Just one lit match. And — poof! — an immigration crisis.

Nothing to see but the snaking lines of silent petitioners under the whirring fans, the immigration officers barking "No talking!" whenever the noise level rose above a murmur.

### *Deeper and Deeper into Purgatory: A Digression*

⌒

Nothing to do but people-watch ("Nine-hundred-ninety-nine-thousand-nine-hundred-ninety-nine bottles of beer on the wall..."). On one occasion, I noticed a woman of about my age, wearing a black tank top, with a great mole on her arm a little lower than where the armpit meets the breast. I'd never seen a larger mole (about the size of a thumbnail).

But the more I looked (there was really nothing else to look at), the more I wondered whether I was seeing a nipple rather than a mole, the breast squashed, forced up and outside of the tank top. Can a breast even *do* that? Mole? Nipple? Nipple? Mole? I wasn't sure.

I couldn't ask Douglas. The others jammed with us in line in the narrow waiting room, including the woman herself, would have heard me. I asked him later.

"Did you notice?"

"I couldn't help noticing."

"A mole or a nipple?"

"A mole."

I still wasn't sure.

### *Some of Us Were Lucky*

Although the world wouldn't know it until nearly a decade later, African asylum seekers had already begun casting themselves into the Mediterranean Sea in the painted wooden boxes and dinghies I couldn't even call boats, losing their lives, often by the hundreds at a time. Some of those who weren't grinning, sea-changed, on the seabed were sitting with me on the wretched, long benches, scooting down a space or two every ten or fifteen minutes as each next person was served.

But I'd already decided not to go to the immigration office. I was going to go to Sicily.

### *My Own Private Odyssey*

The day trip to Sicily had a reputation for being epic. It was.

I got up in the middle of the night so that I wouldn't miss pickup an hour before dawn at the hotel around the corner from our apartment building.

I wasn't looking forward to walking and waiting alone in the dark. I stepped out of our building — cautiously, anxiously — into the black early morning. But

I found that I wasn't alone. Malta wakes early. Walkers, runners, cyclists — single and in twos or threes — walked, ran, and cycled the Tower Road promenade. A bus pulled up to the stop in front of the hotel and parked. A few minutes later, about forty straw-haired German adolescents emerged from the street behind me and boarded. The air was warm and sweet, the street benign, and waiting in the dark wasn't frightening. But I became even braver when another woman joined me in front of the hotel. Pickup was fifteen minutes late. Martin, our friendly driver, put us both in the crowded front seat of a full red tourist van.

In spite of our late start, we got to the passenger terminal in Valletta in plenty of time for the ferry. The immigration officer stared at my passport with its myriad extensions of stay for a long, long time.

### *Sea Crossing*

The interior of the ferry, the San Ġwann, a high-speed catamaran, looked like the interior of a plane, with rows of seats fourteen across (separated by three or four aisles) on its two decks. On a good day, the crossing takes ninety minutes, and ours was easy, uneventful.

But, oh, how bleak the sea was — the ancient, time-eating, Odysseus-confounding, Paul-shipwrecking sea — how long and desolate those fifty nautical miles.

Before we docked, the ferry crew divided us by language groups among three tour buses. I was in Tour Group Two (but I checked twice to make sure) with a guide called, wonderfully, Attilio.

### Nervous Stomach

We docked in Pozzallo (Puzzaddu, in Sicilian). As soon as we'd cleared customs, we were driven to a restaurant for breakfast. I had no appetite — a nervous traveler's stomach. I walked alone outside, taking care not to lose sight of the restaurant, so that I wouldn't get lost or be left behind. The early April day was overcast and chilly. I was glad for my coat and gloves.

The restaurant looked out on the grey-green sea, a sea very different from the cobalt blue Mediterranean outside my dining room window in Malta. Small green waves broke on a sandy beach. Blue paint peeled from an abandoned, red-roofed boathouse. White, blue, and red fishing boats rested on low stilts in the sand or were turned over, waiting for fairer weather. Workers trimmed

the palm trees lining the streets. A poster flapped on the Carmelite missionary house. A kind-faced, bespectacled sister of the order was going to be beatified. Old men (I counted twenty) sat in the square, gesturing and talking, I suppose, about what old men everywhere talk about — how things were when, how things are now, how things will never be the same.

### When You're on the Right Tour Bus, There's Absolutely Nothing To Worry About

I'd always thought of Sicily as mainland Italy's poor cousin. But mainland Italy's poor cousin looked far richer to me than Malta did.

We drove on beautifully paved *autostrade*. We passed meadows of white and yellow wildflowers, greening fields of wheat, stands of silver-green olive trees, and orange groves in harvest. We passed over rivers on arched bridges, the white-capped, blue mountains sentinel in the distance.

Idyllic.

We arrived at Mt. Etna, Europe's highest and most active volcano (nearly eleven thousand feet above sea level), in late afternoon.

### *Beautiful Mountain*

It's called Montebello in Italian, Mungibeddu in Sicilian — Beautiful Mountain. Twenty-five percent of Sicily's population lives in its shadow. Their vineyards and orchards thrive in its rich volcanic soil.

We circled upwards.

The landscape and the temperature changed the closer we got to the summit. The landscape became increasingly blasted — black lava rock (basalt) falling down the mountain, vegetation just beginning to grow again. We passed the burned and ash-choked ruins of cottages and other buildings. We saw two cottages side-by-side, one untouched, one destroyed by lava. It also became increasingly colder. There was snow on the road on the way up, snow on the mountain. I was cold, even with a coat and gloves.

### *Legends*

Greek mythology had it that Zeus, King of the Gods, thunderbolted and imprisoned a hundred-headed dragon named Typhon (or Typhoeus) under Etna. He'd made more than a nuisance of himself, with his fire-shooting eyes, shrieking mouth, and wrong-headed political as-

pirations. Snow-covered, wind-swept, bitter Etna pressed him, contained him. Except periodically, when he grew angry and tried to escape. Then smoke and lava spewed from Etna's mouth, scorching and dissolving the land, and the earth trembled and broke apart.

Less spectacularly, Sicilian legend had it that the forges of the Greek god Hephaestus (the Roman god Vulcan), the god of fire and blacksmiths, were located under Etna. Etna's fire and smoke were the fire and smoke of a metal-clanging, working god.

There's also the possibly true story of fifth-century-BCE Greek philosopher Empedocles, who jumped into Etna's fire at age sixty (c. 430 BCE) in hopes of climbing out as a god or finding another kind of immortality as his body, breath, spirit, and blood transformed into the universe's irreducible four elements — earth, air, fire, and water. The volcano, in answer, was said to have spit back a shoe.

If I should slip (or jump), would my shoes be returned?

### *Crater's Edge*

The volcano, however, was having a day off. It wasn't shooting off the spectacular red, orange, and yellow fireworks I'd seen in travel brochures.

There were tourist shops and restaurants below the craters at the summit, which are vaporized every time there's an eruption. Official crater tours had been suspended years earlier. Freak eruptions kill walkers. Even though the volcano was quiet, suddenly I wasn't brave enough to walk it. Whatever made me think I could? Fear of heights. Fear of falling (or of jumping) in. But I watched a couple in jeans walk the blasted black and red rim of one crater. By the time they'd circumnavigated half of it, she'd put on a red jacket.

I was feeling colder and colder myself. I bought a navy blue fleece jacket, *Etna / Sicilia* stitched in lighter blue on the left side, and put it on under my coat. I also bought a black basalt egg. So much for risk-taking, bravery, adventure.

### *When You're on the Right Tour Bus, There's Absolutely Nothing To Worry About*

We left before sunset to catch the late ferry back to Malta.

I sat across from Attilio on the bus back (always stay close to the tour guide). A man of about my age, tall

for an Italian, unshaven, with curly black hair to his shoulders, a bandana around his head, wearing jeans. He initiated the conversation, holding up his little finger.

"What is this called in English?" he asked. Flirting, perhaps.

"Little finger or pinkie," I told him.

Pinkie delighted him. "And are the toes called the same?"

The sky at sunset, in the Etna-influenced atmosphere, was extraordinarily, beautifully layered. A layer of green hill met a layer of blue mountain, then layers of pink, dusty rose, powder blue, gold, burgundy, and blue-black sky — nature teaching graphic artists posterization.

The sky was beautiful. Life was beautiful. I was triumphant. I'd done it — cautiously, anxiously — but I'd done it, even if I had bailed at crater's edge. I'd traveled alone. I hadn't gotten lost. I hadn't slipped and fallen into the mouth of Hell. I hadn't jumped. I hadn't been left behind. I was where I was supposed to be — on the right tour bus. An hour or so at sea, a short ride from Valletta in a Martin-or-his-equivalent-driven red tourist van, and I'd be conquering-hero home again.

### *When You've Made the Right Ferry Connection, There's Absolutely Nothing To Worry About*

We made the ferry connection easily. A diminutive English woman sitting in the window seat in my row (I was on the aisle, with a seat between us) told me that the crossing was expected to be rough.

It was.

Long-story-short department — most people were seasick, including my diminutive English woman, the three women in front of us, everyone to my left, and everyone behind us. I was surrounded by vomit. The only thing the sea-legged ship's staff could do (how could they even stand in the ship's lurch and hurl?) was to collect the used barf bags, pass out new ones, and give cold compresses to those who were sickest.

After two hours, I saw the lights of land. "Malta! We'll dock any moment now!"

"No," the English woman said miserably. "That's Gozo."

We didn't dock for another heaving hour.

I wasn't sick myself, but it took all of the peppermint gum I had and a roll of peppermint candy (minus the pieces I offered to the vomiting English woman

beside me) to distract me from vomiting's auditory and olfactory triggers. When we docked, she thanked me profusely for my meager, ineffectual help.

"I just wanted to die," she said.

We got to Valletta well after midnight, the San Ġwann discharging its green human cargo. I'd never been happier to see the great limestone walls, the city's high bastions. They said *safe* and *solid* after three hours on (and in) unsafe, roiling liquid. Martin met us at the terminal, tried to make cheery conversation, pointing out landmarks along the way. But no one was in the mood. Someone told him to shut up.

## *Home Again*

When I got home, I poured myself a stiff scotch. Stood at the sink, drinking, trying to decompress. I'd been awake for nearly twenty-four hours.

A cockroach ran across the counter.

A bleeping, freaking, pardon-my-language cockroach!

We thought we'd won the cockroach wars a few months earlier. I blew. Screamed at it. Cursed it. Then

bashed it into overkill oblivion with a ferocity I didn't know was in me.

Like angry Typhon under Etna. Like spewing passengers on the rough, infinite sea. ✺

# Tourist No More

*by*

## STACEY FREED

*T*HERE WAS SAND everywhere — gritty on my scalp,
behind my ears, irritating the crooks of my arms, be-
tween my toes. Sweat mingled with sand ran in thin
brown rivulets down my neck barely making it to the
top of my t-shirt before drying under the hot desert
sun. I squinted against the swirling sand carried on a
*hamsin* wind and searched the distance for an oncom-
ing car, a possible ride. Sand settled and disappeared in
the golden brown rock formations and curved dunes.
If I stood still long enough, I too could be covered,
buried, lost in the Israeli desert.

I had been in Israel for about eight weeks traveling
with a friend, part of an open-ended journey we had
planned: How long could I travel on five thousand
dollars — a princely sum in 1983. Although we are both
Jewish, it wasn't a strong sense of Zionism that sent us

to Israel. The flight had been cheap and it seemed as good a place as any to have an adventure, to get away from our parents and "find ourselves."

It was my first time so far from home, fresh out of college where I'd majored in television and radio but heavily padded my course load with classes in feminist theory, philosophy and left-wing politics. My head was full of righteous indignation against "capitalist patriarchy" and gender and class inequality.

The night before, my friend had gone off with other travelers we'd met at a youth hostel near Tiberias. She and I were to reunite the next day in Jerusalem. I had stayed with Yossi, an off-duty soldier I'd met at the hostel. We'd swayed and nuzzled on the dance floor then snuck back up to my room. His gun remained by his side all night. "*Isha-li*," he had said. "She is my wife." For three years he would not part with that gun, he said.

By the second week of traveling I had become inured to the guns. They were nearly as ubiquitous as the sand. Sit in a seat on a bus and turn your head and you were as likely to bump your nose on a gun as on a backpack. The sight of them made me feel both safe and scared. And yet, these were Jews. My tribe. Every one of them a lawyer, doctor, accountant, teacher as far as what my mother had always led me to believe. This was

a country full of Aunt Shirleys and Cousin Andys. I was able to swallow my fears.

The next morning, Yossi had come with a group of us to the hot springs at Hamat Gader. He with his khaki green army pants and gun, laughing as we Americans slathered ourselves in mud and washed it off under cool, clear water. He promised to get me to Jerusalem to meet my friend.

Yossi was dark skinned, with thick, curly black hair, a "Jew 'fro," and his family was from Yemen. He loved Israel, and like every Israeli I'd met he wanted to know why I wasn't moving to their country. And yet, he was angry at how he felt his family had been patronized by the lighter skinned Ashkenazi Jews (from northern Europe) who held political power. Those who felt the need to teach the Yemenite and other Jews who had fled or were forced from Arab and African countries how to be. As if they were less than. This he explained to me as best he could in his limited English. This he explained to me as he moved his hands along my skin, naming body parts in a language that I had heard in snippets in my childhood but which I had no real understanding of. I had so much to learn about who I was, what I wanted and where I wanted to go.

And so we stood under the hot sun, not far from

the Jordanian border, hitchhiking. The landscape was foreign, a moonscape, timeless and stark. It was easy to imagine Biblical times. Sand arched at the edge of the roadway where I stood arm outstretched, my thumb in the air. Yossi pressed himself behind me, pushed my thumb into my hand and pulled out my index finger. This was the way you hitchhike in Israel, he said. As if to say, "Stop here. Stop now." A thumb up was a pleasant question Americans had the luxury of asking — "Going my way?"

I would never hitchhike in the United States, but in Israel it was common for men and women — soldiers especially. While it wasn't seen as an obligation, every Jew over the age of 18 had done some form of military service and picking up a hitchhiking soldier was a courtesy. If you were going to hitchhike the best and safest way to do it was accompanied by a soldier.

When I saw a car weaving in the shimmery heat lines, I lifted my arm and pointed. I was a quick learner. I was authentic. You wouldn't mistake me for a tourist. Yossi pushed my arm back down. "Blue license plates. Arabs," he said. I filed the information. This was a decade after the Yom Kippur war, and the Israeli-Egyptian peace agreement had gone into effect only three years prior. The tension in Yossi's voice, the wari-

ness in his eyes and his springy readiness were things I'd find mirrored in other Israelis.

Soon an "acceptable" car — a small, non-descript light blue sedan in need of a good coat of wax — pulled to the side of the road and stopped in front of us. Two dark-haired, bristle-chinned men commanded the front seat. Mirrored Ray-Bans blocked their eyes. Yossi exchanged pleasantries in Hebrew. I understood a few words. Then we were off, my hair ribboning out in the hot wind blowing through the car's open windows.

There are moments when you feel life is just beginning. "This is the real deal," you tell yourself. I'd been saying this in my head almost daily since I'd left the States. College was a fake life. My parents, hypocrites. Everything up until now had been playacting. I could go anywhere and do anything I wanted. No one need know my whereabouts. I was free.

I leaned sideways and put my head on Yossi's shoulder. I smiled to myself thinking of what my mother might say of the driver and front seat passenger. They didn't look like the "nice Jewish boys" she wanted me to date. For that matter, neither did Yossi. The landscape slid around us, more sand, more scrub, the occasional shepherd with his sheep. We took a curve and a handgun slid across the dashboard racing its reflection in

the windshield. It bumped against the side window and fell into the passenger's lap. The men laughed, all teeth in the rearview mirror.

I'd like to say that I did the smart thing, screaming until they let me out of the car. But I didn't. Somehow this gun, a handgun, was different from the guns carried by the young soldiers. Those guns were connected to a body; they were sturdy, upright. This gun was loose, skating on its own. Anything could happen. This gun lent the tiny *frisson* of danger and adventure I had been craving. The burnt black edge to my crisp white suburban life. This, I thought, *this* is real life.

And yet. The Hebrew chatter, which had been backdrop, like radio static, began to sound harsher, more directed. I stiffened, my body stilled to listen more closely. "What are they saying?" I whispered to Yossi.

"They want to fuck you," he said.

My stomach clenched. Frisson became fright. Who was this boy/man I leaned against? I didn't know him. How had I gotten into this? My brain was thick with the heat. My throat parched from the dry air.

Yossi said something I didn't understand. But I heard the word, "*isha,*" which I knew. The men in the front seat laughed. Yossi pulled me closer to him.

"What did you say to them?" I asked.

"I told them they couldn't have you. That you were to be my wife." He patted my hair.

Ants seemed to run all through my skin; fear narrowed my vision to pinpoints. Yet I seemed to be functioning somewhere above myself. My mouth finally formed words. "*Dai. Dai*," I shouted. Stop. Stop.

Thoughts formed deep in my head, but I wasn't really conscious of them. Was my soldier saying that it would have been all right for them to fuck me if he wasn't going to be my husband? If I weren't his property? Did he agreed with them? Or was he a decent guy, understanding their culture and knowing that the only way to stop them was to play the game?

Later, I would recognize how profoundly naïve and vulnerable I felt in that moment, how angry I was that I had put myself in that situation. Because, of course, I blamed myself. Later, I would recognize how frustrated I felt that I needed a man to protect me. Maybe I am part of the last generation taught to believe that you "gave yourself" to a man. It took years to understand that might mean you "lost yourself" — or worse — to men as well.

I jerked away from Yossi and grabbed for the door handle. The men shouted at Yossi. Yossi shouted back. The driver slowed the car to a stop. I clutched my back-

pack to my chest and pushed open the door. My feet hit the hot sand, and I practically fell from the car. My arms and legs trembled. Yossi had gotten out, too. The car skidded out onto the roadway and drove off. I stood next to a gnarled tree, alone, Yossi a few yards away. I didn't know where we were, how close to Jerusalem. There was still the same golden light and dry scrub, hot wind, sand and more sand. Blowing sand stuck to the hairs on my arms. I would become part of the desert, dry as Lot's wife. I could feel Yossi's eyes on me.

A car wobbled in the distance. Yossi raised his arm and pointed to the ground. The car stopped and Yossi leaned into the open passenger window. He nodded over his shoulder at me and stepped away from the car. The car rolled toward me. A young woman with a British accent looked up at me from the open window. She smiled. "I'm Karen. This is my boyfriend, Les." She pointed to a blond-haired twenty-something man in the driver's seat. "Your friend told us you're headed to Jerusalem. Get in."

I looked over at Yossi. He raised his hands as though surrendering. I ducked into the back, pressed myself into the corner and slammed the door. I kept hold of the door handle. I was a quick learner. I was authentic. You wouldn't mistake me for a tourist. ⁊

# Mermaids and Monsters: An Adventure in Copenhagen

*by*

## LAUREL RICHARDSON

◦✎◦

*W*HAT WOULD IT be like to grow up with a one hundred-fifty years of Hans Christian Andersen stories shaping my country's psyche, shaping my culture? To grow up in Copenhagen where the national symbol is not the Statue of Liberty but the Andersen fairy tale character, the Little Mermaid? A four-foot bronze sculpture of her, bare breasted and fish tailed, waits for immortality on a rock at the edge of the sea.

In the fairy tale, the Little Mermaid falls so madly in love with a prince she saves from drowning that she trades her beautiful voice, long life and afterlife as ocean foam, for human legs, excruciating pain, and a chance to marry the prince. Should he marry her, she will become fully human and share his immortal soul. Alas, the prince marries someone else and, although the Little Mermaid has the opportunity to murder him before his wedding

night, her love for him prevents her from doing so. So, because the little mermaid is so good, she becomes a "daughter of the air," doing good, awaiting her immortality. But her tears flow and her waiting increases whenever she sees a wicked child.

If I had grown up with this story — and seen the little mermaid, perched on a rock waiting for her immortality — would I not have felt guilty if I behaved badly? Wouldn't I have absorbed the cautionary tale? Know your place in the scheme of things. Or, would I have tried to create a different life for myself? Could I have kept my voice?

~

My adventure in Copenhagen began with an embarrassingly engaging email from Astrid, a sociology graduate student at the University of Copenhagen. She had read my book, *Fields of Play: Constructing an Academic Life*. Maybe she had committed some of it to memory because she was quoting me to myself. She invited me to come to Copenhagen to teach a three-day graduate seminar at the University of Copenhagen. Could I come?

How could I not? I was flattered and enthused because I thought of Denmark as a socially, academically,

and culturally progressive country. How wonderful to share my work with the like-minded.

Astrid gave my seminar a high-falutin title, "Postpositivistic qualitative research: Representational practices and legitimacy." Every important word in the postmodern contemporary social-science lexicon was included. My honorarium and expenses were yet to be settled.

"Will I grade papers?" I email.

"No we don't write papers."

*How European,* I think.

"What departments?"

"It'll depend upon the advertising strategies."

*How American,* I think.

Two weeks later, Astrid emails me: "We have had to turn many people down. Everybody tells how wonderful and interesting the readings and the programme look. Thus, there's absolutely a very positive atmosphere."

*Why shouldn't there be a positive atmosphere?*

"Any progress on my reimbursements and housing arrangements?" I email.

"My sociology department will not take care of your expenses. They will only give an honorarium for the course," Astrid emails me back.

I check the exchange rate and figure the university

will be "honoring" me with a princely sum — enough to cover a few Danishes and black coffee.

Her email continues: "They arrogantly assume that your work is not as relevant as quantitative methods seminars; they're paranoid regarding postmodernist thinking and even more so when this thinking is done by a woman, or even worse, a feminist! Thus negotiation has been very difficult. But I suppose this is not an entirely new and surprising situation for you to hear about?"

*Not at all surprising, but surprising to hear this about Denmark.*

"Any progress on expenses or housing?" I email two weeks later.

"We can give you the subsistence-money-rate given to Danish researchers going abroad — 50 kroners a day."

This converts to about $8.00 a day. How do Danish researchers live in America on that amount?

"Who is 'we'?" I ask in an email.

"Our Underground Graduate Woman's Collective," Astrid replies. "Please don't tell anyone about us."

I am flummoxed, uncomfortable taking money from anyone, much less secret money from women students in another country.

"Can I bring you some books for your library?" I email, trying to mitigate my guilt.

"That would be wonderful!!"

"What will the weather be like?" I email about two weeks later.

"About the weather — coldish — yes and probably also rainy. It could begin snowing in a just a few minutes from now."

"Any progress on housing?"

"Regarding housing, we will borrow Karina's apartment for you. We hope it'll do."

～

As instructed by Astrid, on the Saturday morning of my arrival at Kopenhagen Lufthaven, I take a cab to Karina's apartment off Gonnergade. The entrance to the apartment building abuts the narrow sidewalk, like my cousin's loft in Soho, I think. The litter reminds me of Soho, too. I push the button for 7D. Astrid and Karina, a new sociology graduate student, bound down the stairs, open the worn wooden doors, and greet me. Both of them have blond bobs and bright blue eyes. In near unison, they say, "We are so glad you are here. Let us help with your luggage." I like them instantly. We spontaneously hug. They give me fresh flowers, cheese, bread, wine, a map of the city, and important phone numbers.

The apartment reminds me of the student apartments that surrounded the University of Chicago fifty years ago — high-ceilinged large flats cut-up into "units" with a bathroom, bedroom, living room, and kitchen. But the layout of Karina's apartment is peculiar, mazelike.

I have entered 7D through a narrow hall that led into what was probably once a dining room, but now contains Karina's desk, books, and clothes. Off that hub-room through pocket-doors toward the street is a tiny living room, probably once a parlor. In it there is a couch, rabbit-eared television set, high-end stereo equipment, and tall windows, covered with Indian cloth. Behind the hub-room is the even tinier bedroom, its floor covered wall-to-wall by the bed, a mattress on the floor. By the head of the bed an extremely narrow opening leads to a hallway that ends in two steps down to the bathroom, where a combination washer-dryer abuts the toilet. Or, I can turn right out of the bedroom and down a step to the 1940's American kitchen. Out the back door a set of wooden steps lead to a spot of yard shared by all the apartment buildings flanking it. Trash overflows bins.

If I were a *little* mermaid, I would be small enough to fit into this apartment without banging my elbows, knees and head. I would fit into the bathtub.

Karina explains how to turn on the hot water heater and tells me not to wash the sheets or towels and to turn off the hot water heater when not in use. She shows me how to use the telephone, television, and stereo. But, the directions are too complicated — this off, before this on, then, this off...

"I'll come for you on Monday at 8:30 and walk you to the university." Karina says, putting on her backpack. "It's not far."

~

Monday morning opens cold, dark, and bleak. Karina arrives on a bicycle. "I did some exploring over the weekend," I say, pulling my scarf close around my neck, grateful for my full-length fleece coat. *Pay attention*, I tell myself, *so you can retrace your steps back to the apartment.* I have no sense of direction. I can get lost in a thimble.

"I got wonderful Danishes at a bakery — ah — I think in the opposite direction," I say, feeling hopelessly lost already. Backpacked Karina beside her bike, and me with Mephistos on my feet and my purple Danish schoolboy's bag over my shoulder, begin our trek.

"I ate twice in the restaurant next to the apartment,"

I say. "The dolma and aubergine were good and the people were friendly."

"Mm. Yes."

"Hafez restaurant. Of course, I had trouble reading the menu. Arabic, I think."

Karina's apartment is located on the central-city side edge of the Norrebro quarter. Over 200,000 Muslim immigrants mostly from Turkey, Somalia, Pakistan, and Iraq live in the quarter. Whiffs of coriander and cumin and cinnamon and cloves emerge from the fifteen Turkish restaurants nearby; kiosks sell sesame candies, spices, and oils. Women's heads and bodies are covered. No Danish is heard on the streets. Young men look restive. I am not certain if I am safe walking alone or even with Karina by my side.

Walls and fences swarm with Arabic graffiti. Arabic explodes over the brick fortification surrounding the Roman Catholic cathedral we've just walked past. Loops and whorls, crescents, scimitars adorn the wood fence enclosing the scruffy little playground where boys are speaking in Arabic.

I pull my scarf over my head. We walk up one street for a few blocks, across another, down some steps, through a brown patch, to a pedestrian path beside a river, across a bridge, circling a construction site — "where

some of the rioting occurred" — and then through a maze of streets jutting here and there into the center of Copenhagen, until, at last we reach the university, the "City Campus," consisting as best as I can tell of a large restored stepped-gable building. We walk up stairs to the third floor, where Karina shows me my office. It is 9:45. My seminar will start at 10:00. My shoulders ache.

Twelve students — six men and six women — sit around a wooden rectangle table, leaving the head seat vacant. Everyone is drinking coffee. If it weren't for the notebooks, book jackets, and conversation all in Danish, I feel I could be in any American university. Other than the large number of men — and maybe my sense that the students are older and the women quieter — there is nothing distinctively different. All of this is blissfully familiar.

"...so we welcome Professor Laurel Richardson..."

Astrid introduces me, and the students give a little round of applause.

"Please call me 'Laurel' if you are comfortable doing so," I say.

I begin, as I always do, by asking the students about themselves. They are all sociology majors, with "sociological" interests who are "interested" in the seminar. I lecture on postmodernism and answer questions. I go to

lunch with the women students at a nearby café, shocked at the high prices and the menu's listing of fifty different kinds of beer. The women order their favorite beers. I refrain. That afternoon, I engage the students in an analysis of an interview snippet. All is going well.

"See you here tomorrow," Karina says, as we leave the building. I button up my full-length fleece coat.

"Ah...ah..." I stammer. "I don't know how to get back to the apartment." I don't have the slightest idea. The criss-cross of walkways, breaking spaces into irregular triangles, and the sameness of the rows of period six-story buildings confuses me. "Stop gloating," I say under my breath to a gargoyle under an eave.

"Oh? "Karina says, clearly surprised by my ineptitude. "Then let's get started." She walks her bike and I put on fleece mittens.

"This bridge looks different," I say. "Where is the construction site? The river walk?" The wind cuts through my fleece coat. It is getting dark.

A small group of Arab men approach. Karina steers me across the street. I cover my cheeks and mouth with my mittened gloves.

"I am taking you a different way," Karina says, smiling. "You'll see more of Copenhagen this way." *Great*, I

am thinking, *now I'll never find my way back to "campus" tomorrow.*

"Karina," I say. "Please do me another favor. Please call a cab to pick me up tomorrow morning."

~

"Are you sure this is the university?" I ask the cab driver. The entrance does not look familiar. "Are you sure?"

"Yes, yes, yes." he says, clearly annoyed. "This is the back entrance."

It is 9:30. I climb the stairs to the third floor and wander the halls, hoping I am in the right building.

"Good morning, Professor Richardson — ah, Laurel," Frida says, as she steers us toward the seminar room.

My lecture on the second morning is about voice — the researcher's and the researched. "Break into groups of two," I tell them. "Interview each other and then write up your interview in either a traditional or creative way. But be sure to honor the voice of the person you are interviewing."

The students nod.

"Any ideas for the general topic of the interviews?" I ask.

Silence.

"Well, you know I am a feminist, so I would be interested in learning more about gender relations in Denmark. Let's reconvene at 1:30."

Feeling proud of my pedagogy, welcoming some down-time, and looking forward to learning more about the feminist successes in Denmark — and feeling confident that I will not get lost if I don't stray too far from the City Campus — I set off on my own to explore the environ that my trusty *Lonely Planet* guidebook calls without any explanation, "The Latin Quarter." I pay strict attention to where I have walked, doubling back and retracing my steps every few minutes.

The "kultorvet," a pedestrian plaza that *Lonely Planet* says might have street musicians, flower stalls, beer gardens, has only dour looking people, refusing to make eye contact with me, or anyone else. Blank faced people on ten-speed bicycles whiz by each other. The bright red and blue single speed bikes *Lonely Planet* says are free for anyone to use fill a rack, unused. A bookstore in a building basement is closed. But a massive neo-classical cathedral is open. I enter. I am alone. I see a sculpture of an open-armed Jesus and his twelve disciples. They are surrounded by grotesques.

"Why don't people greet each other?" I ask Astrid when the seminar resumes.

"Oh, they do — they will — when the sun comes out," she says. "In about two weeks."

Karina and Oluf are the first pair to report on their interviews with each other. Karina gives a sociologically traditional report. Then Oluf reads his report:

I like doing this kind of research, feeling the power of getting into Karina's mind and feelings. I ask her questions — any questions I want — and she answers. I have power over her. I can do anything to her I want to. I can enter her body like I enter her mind. She answers me. She comes to me. She wants me. I am going to follow her home, watch her undress. And then watch her again and, when she is not home, I am going through her underwear drawer. She wants me to. I know she does. See? She answers my questions.

Karina is shaking. I am shaking. In my thirty years of teaching, I have never had an experience even remotely like this one — humiliating, mortifying, violating, threatening verbal violence from one student to another. If a

man had done anything remotely like this in one of my classes back in the States, the feminist women would have been up in arms and would have shouted him down before he finished his last horrid words. But here no one speaks. The men smirk. "Any comments?" I ask, waiting. Incredulous.

Silence. Like little mermaids, the women have lost their voices.

"Oluf, in my country," I say — aware of my jingoism, but unable to stop myself — "you would be called a stalker."

More silence. One man taps the eraser on his pencil on his belt buckle. Tap, tap, tap.

"In my country, it's against the law to stalk."

Another long silence.

A male voice. "What's a stalker?"

"Pass in your interview reports," I say. I don't say, "Please." I dismiss class.

Four women follow me into my office. "We want to walk you toward your apartment. " Astrid says. "So we can talk,"

"Gender relationships in Denmark are in backlash," Frida begins. "When you raised the gender-relations issue, you raised a red flag."

"I did?"

"Few women choose to get married, now. Most choose single motherhood because the state will provide for their children. They don't need husbands," Astrid explains.

"What about the fathers?" I ask.

"They have no rights to their children if they're not married to the mothers. Many of the men are angry about this. They have meetings about this."

My sympathies are with the men, as I think of my son's struggle to gain joint custody of his son. I wonder if the women choose not to get married because the Danish men are so awful or if the men are so awful because the women choose not to get married.

"The backlash is everywhere," Karina says.

"I was a Women's Studies major before I came to the Sociology Department, but I don't want it known because I won't be taken seriously, if it is known," another woman says. "It is too dangerous for me."

"What?"

"Feminists are not welcome," she says.

Then they tell me about Oluf. He had made uninvited passes at a sociology graduate student. When she told him to stop, he didn't. Instead he spread nasty rumors about her and undermined her credibility by calling her a feminist. Most of the male students supported

him. Oluf's advisor was a powerful man in the department. The woman was forced to leave.

"Oluf was empowered to do the same thing to another woman. She's gone, too," Frida adds.

"So Oluf is a real threat to my body, mind, and academic future," Karina says.

"And we can't talk about any of this — feminism, anger, sexual imposition — in the department," Frida concludes. "We're afraid."

The University of Copenhagen is the largest, oldest, and best research university in Denmark. According to the social science department's website, the university's location contributes "to the inspirational atmosphere that characterizes the study environment of the faculty" and there is a "long tradition" and "great demand" for the social science graduates to fill "leading positions" in "the public and the private sector."

"Does Oluf know I am staying in Karina's apartment?" I ask.

"I don't think so," Karina says. "I don't think he would be willing to enter this area of the city, anyway. But double-lock the door and don't go into the yard."

Seven years earlier my body and soul had rebelled. I was exhausted from defending the right of my specialties — gender, qualitative research, feminist theory — to

exist in my Sociology Department. And, I was troubled by the treatment of feminist graduate students. But those experiences are froth compared to the experiences of these Danish women. I am humbled by the courage they have shown by inviting me to give a seminar.

"Do you know how to get to Karina's from here?" Astrid asks. We've just crossed a bridge.

"Draw me a map," I say, but what I want to say is *Come with me...stay with me...tell me more...I am like a fish — no, a mermaid — out of the water...I am afraid.*

～

I arrive at City Campus by cab the next day at 9:55. The students and I act as if nothing happened yesterday. I don't debrief the seminar. I cannot put Karina through the experience again. I cannot trust Oluf and, clearly, I cannot give the women voices.

～

For the next two days, I do touristy things in Copenhagen and try to forget the seminar. I explore Stroget, the long pedestrian mall, the grounds of the Royal Danish family's home, the fence enclosing Tivoli, which

is not yet open for the season, and the Round Tower, from which I can see red tile roofs, church spires, and patches of brown.

I greet rambunctious tow-headed children running down the tower's spiral walkway, stroll along the canal, and stare at the painting on a building of a gigantic bare-busted blond woman holding two oversized blue-eyed snow-white baby boys. "Maelk" the lettering says. The babies eagerly point to her monstrous snow-white breasts. Each breast must be a dozen feet or more in diameter. Each nipple resembles a big fat bull's-eye.

There are sculptures everywhere — a gigantic sculpture of Hans Christian Andersen looking like the mad-hatter, bronzed little people, and gargoyles, in small, medium and extra-large sizes, freestanding and as scuppers. On four Palladian windows of a restored gothic building are blood-red renditions of the Woman's Liberation Movement symbol — the clenched fist inside Venus's mirror. It is one of the largest buildings in Copenhagen. It is the battered women's shelter.

～

"Are you sorry you didn't go see the Little Mermaid?" Karina asks as she carries my suitcase into the cab.

"No, not at all," I say. *I saw too many of the Little Mermaid's voiceless incarnations.*

~

I settle into my Scandinavian airplane magazine. "A Journey Away from the Cold" captures my attention. It's about a Danish woman who has finally received her "license to kill." "Long overdue," she says, "because I'm a woman." Now, having realized "her ambition to become a big-game hunter in a male-dominated world," she's leading buffalo hunting groups in Tanzania. "It's dangerous as hell," she says. "But tracking a cunning old bull, bringing him down, that's the greatest pleasure on earth."

Hello! It sounds like this Danish woman has found a way to speak. ⊱

# The Surface of the Moon

*by*

**JACKI BELL**

*Moving with no direction*
*Living with no goals*
*Travelling tunnels with no light at the end*
*Following rainbows with no pot of gold*
*Just keep on moving*
*With no destination*
*In infinite circles that have no end*
*Stuck on a timeless road to nowhere.*

THIS PALTRY ATTEMPT at verse was penned by me, at seventeen, while riding in the cab of a semi-tractor trailer with two friends and a driver who had plucked us off the side of I–75 just outside of Knoxville. My girls, Stephanie and Valerie — beautiful, long legged girls who, like me, had ridden a wave of discontent, wanderlust and altered consciousness out of school, away from our Midwestern world and onto the carnival circuit. Contrary to the sentiments of the poem, we did have

direction — we were on our way to Mardi Gras in New Orleans — and goals: to work the parades selling *garbage* out of shopping carts, and take, or 'glom' as they say in the business, as much money as possible from harried parents, sticky children and tourists wearing cheap beads and tightly cinched fanny packs.

*Garbage: Hats, toys and cheap novelties bought for a song and sold for three hundred times their purchase price.*

"Where you gals headed?" You can imagine the lecherous edge to the trucker's voice, the John Deere or Peterbilt cap, possibly a toothpick or cigar clamped between his teeth. But the three of us, back in the cab, legs crossed, heads bent, giggling like the high school girls we should have been, knew it was the truckers who would take care of us, keep us off the side of the road by calling ahead to find us rides that would be waiting for us at the next Stuckeys, or the one after that. Three teenage girls who couldn't be bothered riding Greyhound. We believed, mostly, and in spite of the many ways the world had already proven itself a contrary and dangerous place to live — that we were invincible. Believed it so completely that we stuck our thumbs out again and again, and trusted that *our* heads anyway, would stay connected to our shoulders, and not end up in a garbage bag in a field somewhere in Alabama.

Mostly we travelled together, clad in cut-offs and halter tops, we flaunted our bodies to get quicker rides. We came to accept certain things as part of the deal. The 'put out or get out' ride wasn't good, especially when it happened at three in the morning on SR–41 in the middle of the Everglades. Or worse at an exit ramp closest to the Arizona Women's Correctional Facility under a sign that read *Warning hitchhikers may be escaped convicts.*

Then we walked.

But mostly we didn't. Girl hitchhikers don't wait much for rides. We could make a cross country trip in the same time as a car with rotating drivers. We learned things. We learned that *most* people aren't dangerous, at least not life threateningly so — or maybe we learned that sometimes luck stays with you even when you make every attempt to outrun it. We learned to play "Spot the Jack Off." The first time we had no idea what was happening until the suit-clad, tie loosened "I'll just get y'all across the city" Chevy sedan driving jack ass started breathing hard and weaving in and out of lanes. Looking over thinking he might be sick, or having a heart attack, not a bad guess considering his girth, only to find him pulling his sausage, one hand barely on the wheel, willing to run the car across the median, or into

a concrete divider as long as we got a look at his cock. Which we did all the way across the city until he deposited us at the promised outskirts, us fuming and disgusted, him spent and hailing farewell like we just had a Friday night date. Soon enough we were pros. We learned to spot the nervous twitching of the hands, the sweaty brow, the urgent tone to the voice, and finally, the hand drop from the wheel to the lap, at which point we would yell "Jack Off" and scream and laugh hysterically, threaten to, or actually open the car door until the poor son of bitch pulled the car to the side of the road and we all spilled frantically out onto the berm, flashing ass in short shorts, and wondering where all these creeps *come* from.

The carnival season really began after Mardi Gras at the Dade County Youth Fair in Miami. Lined up outside the office trailer, waiting to be assigned a gig and issued an I.D., I rarely held out much hope that I would be given a money maker. The real money came from a roulette wheel (illegal on the midway now) or the billiards table. Games that required fast talk and even faster hands, and an edge that I could never quite hone. These games went to Stephanie, dark eyed and wild, with a facility for theft that boggled the mind. She was

the dine-and-dash queen. Could slip out of a Denney's in Memphis and be in a Denney's in Little Rock before the manager realized that the pretty girl who flashed him a smile on her way out had run out on a thirty dollar breakfast bill. She could glom money from a convenience store cash register while the clerk was giving change. She was the one who worked the wheel, or dealt the cards in after-lot games.

I was no Stephanie. For me it was always the Duck Pond or Whack a Mole, easy children's games that required no cut-throat game row mentality, just a body willing to take a child's last dollar in return for nothing more than cotton candy scented air. I had something in me that held me back in that world. Something that wasn't a nagging conscience or a made-for-better-things aspiration (maybe a little of both). Mostly it was fear. A kind of fear that didn't seem to exist in the people around me. A fear born of the certain knowledge that the way we were living: the drugs, the hitchhiking, the seediest lodgings in the most dangerous cities, the shady business, were not going to spare us forever, or even for long. I was scared. They weren't. They made money. Me, not so much. What kept me out there wasn't the money, or the midway lights, or the Score. It was each time I came upon a desert sunset or through a stand of

redwoods or over a mountain to see an ocean, or a city, or a vista that might as well have been the surface of the moon as anything I had experienced in that flat Midwestern place I had come from. That was my drug.

For Valerie it was Go-Fast. Basement speed. Crank — the dirtiest dope you could find. Dope that made your eyes pop out of your head and refused to let you so much as blink for days. She found it on every lot in every town and mainlined it until her arms looked as scarred and chewed up as Bullet's: a sixty year old ride jock heroin addict who could only get a hit in his neck and bragged he had not eaten a full meal in twenty years. But no one wore a habit like Valerie. Ninety pounds on a five foot eight frame. What should have been gaunt was sylphlike and men followed her like she followed speed; relentlessly and futilely.

What kept Stephanie on the road was the absolute fitness for the job she was doing. She was carny from the first spot we worked. She seemed to have been born with the get-over mindset that promised something for nothing. That's all the carnival was for her: *something for nothing.* For the marks it's about allowing themselves to be fooled. About looking at the flash on a joint — the huge stuffed animals (almost impossible to win) the lightbulbs that chase and chase each other frantically, the

rhythmic come-on: *here it is folks only a quarter to win* —
and convincing themselves that the lights and the noise
and the colors are telling them the truth. For Stephanie
it was about doing everything right to keep it a lie.

After Dade County it was more garbage selling at the
St. Patrick's Day parade in Savannah; the Cherry Blossom
festival in D.C. Then back to New Orleans for Moth-
er's Day. Flowers off the corner this time: green and
pink carnations; cheap roses that smelled only of the
plastic wrap they came in. Then off to the West Coast
for a string of carnivals and festivals that started in Del
Mar in June and ended in September at the Renaissance
Festival in Navato. Finally down to San Diego where
we wintered in a rundown Mission Beach hotel that
catered to junkies, drunks, kinkers and carnival work-
ers, there to spend our money in sandy bars on sunset
colored drinks and in seaside boutiques where we
bought beaded bracelets, tiny bathing suits and earrings
that hung longer than our hair. There to rest and par-
ty until Fat Tuesday called us back to the circuit again.

It was my fear that set me apart from the others. And my
words. I was a thinker in a world of manic doers. I was
a writer in a place where nothing was ever willingly put

on paper. I wrote down the stories that my friends had no words for. I wrote the story of Lloyd 'Double L' Shaw — a coke head operator who hired young girls as agents, called us his best flash, said a person couldn't pretty up a joint better than to put a pretty thing out front — and in return for the work we took care of him. Cashed him out at a seventy five percent take instead of the usual sixty most workers took, or the eighty percent that most operators thought they were getting. But that's not Double L's story. Double L's story became this: one night on the move from Turlock to San Jose, Lloyd Shaw got pulled over for speeding in his brand new Mercedes Step Van. We weren't there to talk him down. We weren't there to say, 'just talk to the cops, get your ticket and move on.' No one was there to keep Double L from reaching into his pocket and pulling out a quarter ounce of pure grade cocaine and no one was there to say you're wired as hell and you're panicking and don't eat that shit it will stop your heart within the hour before the cops can even get you to the station and you will die with them on that highway and your girls will show up in San Jose without a gig.

And there were other stories, not-so-true stories written in the back of utility vans among vinyl ETs, invisible dog leashes and Chinese thumb cuffs. Stories

about sweet tow headed little girls who charm hard hearted carnies out of their flash only to come to a messy end when ejected from a faulty midway ride. Stories riddled with trite language, illogical plot development and stock characterization. We all had stories to tell but no one seemed compelled to write them down except me, and for the first (and thus far, only) time in my life an audience clamored for my words. My carnival friends thought my poetry brilliant, my rhyme schemes tricky and my prose, moving. I wrote them into my stories, featured their heartache in my verse. At the time I relinquished my stories and poems as easily as I would offer a piece of jewelry or a nice shirt. I wrote with no sense of proprietorship, no eye toward publication. Words were a thing to be given. The only thing I possessed solidly enough to give. *Step up, Step up...See the wonders that await you.* My own operation. My own gig. Everything else: hitchhiking on a cold highway, spinning cotton candy all night in an abandoned warehouse, rolling out a sleeping bag behind the Ring Toss joint...was liquid, as if I had chosen some watery course as a means of escape, thinking it the fleetest, only to find the currents deceptively strong. I was a mediocre carnival worker at best. No particular facility for tapping marks, no deep throated seductive row

call to bring them in droves to the rail, no sleight of hand where the sawbuck is flashed but the fin is passed...just a head in the clouds writer with little skill, or sense of craft, obsessively vigilant in a constantly changing landscape.

Valerie married into the carnival business and for many years came through town for the State Fair, always a bigger and better RV. She moved beyond facing peril in order to make the show. No longer had to worry about the cut. But she's the only one who kept to the road, who fell asleep in a moving vehicle more often than not, who remained hypnotized by wheels eating up the white lines on the highway.

Stephanie made a fortune on a policeman's ball scheme and her affluence mostly eliminated the need for her to steal, and yet, there was always a restlessness in her. An itch. She'll always believe in the flash of a thing to turn the eyes of the marks away, just long enough to get it, whatever it is, and quick enough to get away with it, leaving nothing behind except the memory of a smile or the flip of the hair.

And I returned more than two decades later to the classrooms I had left behind at sixteen. An unskilled laborer, self-medicated and self-taught, ex-carny, friend

of junkies and thieves, after a long and circuitous route full of hairpins and switchbacks that took me from city to city, crisis to crisis, found myself in the Academy. A virtual nest of writers. I penetrated a world that fancied itself every bit as bright as any midway. A world that would, if propriety allowed, string itself with lights and display itself gaudily to the masses. There was a journey in that as well. A constantly changing landscape that came with learning. Like the carnival, it was a world of specialized jargon and particular skills. I mastered some, failed at others, but I still write it down, still cruise the memories as if they were the fastest ride going the furthest mile. No matter what journey I'm on I know that it's all in the way that I spin it. All it takes is a little shine, a little flash, and that's where the marks are going to look. ✌

# Trip to Mexico, Side Trip to Heaven

*by*

**SUSAN PAGE TILLETT**

⁂

*I*LEARNED FROM my mother that a smart woman always says yes to travel. Even when I was a young girl, reluctantly heading off to summer camp, she told me that I must leave the confines of home and face my fears. If I did, meeting new people and learning new things would reward me, so that I could return to live a richer life. My mother taught me that an ordinary girl could become transformed into a heroine through her travels.

I invite you to come along on my own heroine's journey, which began as a spring vacation in Mexico and evolved into a remarkable adventure. What I will describe may sound unbelievable. I do not question its veracity; it remains one of my most vivid and significant experiences.

My journey began as a trip to the delightful small Mexican fishing village of San Pancho, thirty miles

north of Puerto Vallarta. Fellow Chicagoans Linc and Jill were living their retirement dream of running a small coffeehouse, renting rooms to friends. Both were fluent in Spanish, and they knew everyone in town, which made them excellent hosts. For three consecutive years, a group of Chicago friends gathered at Casa Manana for a winter getaway. We enjoyed lazy mornings of reading and writing, followed by afternoon excursions, and gatherings on the beach for sunset. We had found the perfect getaway until things turned serious, then extraordinary, in February of 2015.

As we know from fairy tales and travelogues, adventure begins when something unusual happens to upset life in the Ordinary World. The catalyst in my story was mundane. The lot directly behind the bed and breakfast was vacant; some squatters poured kerosene on a tree stump and let it smolder all night. The stump was directly beneath the windows where we slept, so my friends and I awoke to thick, black ash that settled onto every surface.

Linc doused the fire with a hose out the window, but not before the smoke had triggered my recurring asthma. My traveling companions offered tea and chicken soup. I continued to cough and had increasing difficulty breathing, even when I lay huddled in the garden

under a quilt in the midday sun, fighting a losing battle to hold on to my body heat.

The village of San Pancho is far better suited to vacation fun than medical care. The local hospital was said to be very rustic, the sort where patients brought their entire families to cook and care for them. No one suggested I go there.

I wondered if I was actually going to die in this foreign paradise. And as I lay huddled there, I had a vivid vision: I knew I was actually at the intersection where I could decide. So I chose to step forward through a doorway where all before me was light. As I left, I felt neither death wish nor any sadness. I simply sensed that it was time to go, sooner than planned, on a journey that I had always known I would take.

I went into a meditative state, where I accessed my Akashic Records, which has been my spiritual practice for the past twenty years. Sometimes called *The Book of Life*, the Akashic Records are said to be the archives of all souls throughout time. Meditation in the records provides a perspective of higher consciousness where the physical and the spiritual are one. The Records, which have been accessed for thousands of years by mystics, they are now readily accessible. During meditation, I open my personal records by reciting a prayer:

*Help me to know myself in the light of the Akashic*
*Records*
*To see myself through the eyes of the Lords of the*
*Records*
*and enable me to share the wisdom and compassion*
*that*
*the Masters, Teachers and Loved Ones have for me.*

Once my records are open, my practice is to pose questions and receive responses from my team of spiritual guides. Over the years, our frequent conversations have provided me with reliably helpful insights.

Six weeks before my trip to Mexico, I had purchased a new iPhone and I had been experimenting with recording my conversations in the Akashic Records rather than jotting them down in my journal. During my illness in Mexico I recorded ten sessions, which means that I have detailed account of my travels to an extraordinary dimension beyond San Pancho. I have jokingly referred to these as "Transmissions from Heaven." What follows are excerpts from the transcript of these sessions, interspersed with my account of what was going on in Ordinary World.

### *February 19, 2015:*
### *Through the Pearly Gates*

This first session was recorded in the garden of the bed and breakfast in San Pancho.

SPT: *I have been so challenged due to the smoke from the smoldering stump behind the house. I have never had trouble breathing in Mexico, but this has been terrible. I have wondered if I will survive. What is going on, Friends?*

GUIDES: *Oh dear Susan, we see and we want you to know that we are with you every breath, every step of the way. We hate to see you struggle, but this is your path. Nothing less than radical surrender will do at this time. Susan, you may have to leap, not knowing what happens next.*

SPT: *Can you tell me who is here, so I can see you? That would be so comforting for me.*

GUIDES: *Six people who have loved you dearly are here to greet you, plus we wise beings who speak with the collective voice of your guides. For years, you have glimpsed*

*us more than most people, and you know how much we love you. You have a very big committee, Susan, as you walk through that door.*

*Whom do you see when you step through that door into the light?*

SPT: *I see my grandfather.*

GUIDES: *Yes, there can be no one who has loved you more, who has seen you and delighted in your being. He will walk with you and be your guide. There is nothing to fear.*

At the time I had this experience, I did not know much about near-death experiences; however, from the many books I have read since, one of the most often-reported elements is being welcomed by a beloved family member or by friends who have died. The wise elder who headed my welcome party was my mother's stepfather, someone who had known and loved me since the day I was born. Five others accompanied him, including my mother and four dear friends who had died young. Together they represented the many ways I have been loved in this lifetime.

SPT: *I see elaborately carved stone gates, like the ones at my mother's last apartment. She used to jokingly call them "the Pearly Gates."*

Some of this struck me as funny, because it looked like a 1930s movie set. St. Peter was there, straight out of Central Casting, with a long beard, a toga and twinkling eyes. *He said, "We've been waiting for you." I smiled and said, "This time I am ready to join you for good."*

St. Peter threw open the Pearly Gates and in I walked, escorted by my loved ones. I was wearing a lovely cream-colored robe made of linen and cotton. I was delighted to find that I was restored to the youth and beauty of in my early thirties, with a well-proportioned figure, healthy color in my cheeks, and my blue eyes shining. I wore my long blond hair up.

SPT: *It is beautiful here. The gardens are filled with flowers, which smell...divine. I am surprised that they are all white — jasmine, orange blossoms, and pansies. The jasmine festoons from arbors and releases its scent when we brush against it. This has always been the scent I crave, sweet but not too sweet.*

GRANDPOP: *You see my Dear, ninety percent of what you have known on Earth is not here in Heaven. We have no politics, no violence, no television or advertising. All of those were created by men to control others out of greed, I am sorry to say. What we have left here is all about love. That is the only thing of lasting value. Here everyone is beautiful and everyone remembers that they are lovable and that they are loved.*

*There is so much for you to see, but not today. First you must rest. You have had a long, hard journey. We need you restored to your full health and vigor, so come with us and we will take you to a guesthouse where a woman will tend to your needs. There will be plenty of time for us to show you the marvels of this place later.*

My grandfather led me out of the garden, down a path to a small cottage. He introduced me to a woman named Armana, who would be in charge of my care. I had never heard her name before, but her kind eyes and her worn hands were somehow very familiar. I had the sense that I had dreamt of her and of this place since I was a little girl. She explained that she has always tended the care of my soul.

## *February 20, 2015:*
## *Meanwhile, Back in the Ordinary World*

A Chicago friend, who also spent her winters in San Pancho, noticed that she had not seen me for several days and came to check on me. She saw how ill I was and offered to call her Mexican pulmonologist, so I was very grateful when she told me that her doctor would meet me at the ER in Puerto Vallarta and that her trusted cab driver would deliver me there. Two of my friends who were also suffering from smoke inhalation decided to come with me, partly so I wouldn't have to navigate the Mexican hospital alone and partly to seek treatment for themselves. I will be forever grateful to this fellow independent woman traveler, for stepping up and offering a clear path to help.

## *At the Hospital*

In addition to providing care for the local population, the hospital in Puerto Vallarta is well set up to receive Americans dealing with sprained ankles, sunstroke, or

dehydration. A hospitable Walmart-style greeter escorts you from your cab to the front desk, where he explains that while they do not take your insurance, happily they can take either Visa or MasterCard. All three of us received excellent medical treatment in that cheerful, overcrowded ER. I tried to use my Spanish, until I realized I had told the nurse that I left my spouses, not my shoes, under the bed!

My friends were released with prescriptions, but the young doctor showed me my CT scan on his phone and told me that I had massive pneumonia, so I was admitted for treatment. When I saw my friends' faces recede as my bed was wheeled into the elevator, I remember feeling like my lifeline was being stretched until it snapped.

The third floor was very different from the bustling, bilingual ER. It looked like the set from a 1970s *Star Trek* episode...hushed hallways of endless olive green and harvest gold rooms, spookily lit with florescent lights. There were no sights or sounds of other people and I remember wondering if I was the only patient in this weird place.

My room was harsh, sterile, and totally devoid of comfort. I didn't have a pillow, let alone a toothbrush or a comb. No one spoke English, so I concentrated on get-

ting one item at a time. When they brought me a pillow, it was gigantic and rock hard, so I tossed it aside and balled up my clothes to cushion my weary head.

I was starving: I had not eaten in two days. When the dinner tray finally arrived, it brought only a glass of canned apple juice, unnaturally green Jell-O, a tea bag and a plastic mug with lukewarm water. With only fifteen percent charge left on my phone, I had little hope of communicating with anyone in the outside world. I have never felt more alone or forlorn.

### *February 21, 2015:*
### *The Rigors of the Hospital and Heaven*

My first night in the hospital was very long. I was hooked up to oxygen and a giant IV pushing fluids and antibiotics into me, which meant that I needed to go to the bathroom about once an hour. Due to the severity of my condition, the sides of my bed were locked, so each trip entailed ringing for a nurse to accompany me. None of the nurses spoke English and their focus was on managing the machines rather than interacting with me.

They persisted, however, in asking me about my religious preferences and if I wanted to see a priest.

When they woke me up to ask for the third time at four o'clock in the morning, I figured I was in real trouble. I finally agreed, fully expecting to see a padre sweep in to offer last rites. No priest ever showed up though, perhaps because it was the weekend.

Left in my room for long hours with no human contact, I once again opened my Akashic Records and continued my journey in Heaven.

SPT: *I would like to know what, Armana, my caregiver has to say to me about my healing and rest.*

ARMANA: *Susan, I welcome you to this little cottage that is so familiar to you. Your wooden bed has sheets of hand-spun linen and the blankets are the softest woven wool in beautiful peacock blue.*

*I greet you by bathing you with water infused with herbs, fragrant and comforting, cooling to your fevered body. I wash your hands, your face, your whole body, so that you are refreshed. Then I offer you delicious homemade broth filled with healing herbs, and fresh crusty bread. There is cool water with mint beside your bed for you to drink.*

SPT: *Armana, I can see that what is happening in this sterile Mexican hospital reflects the care that you are*

*providing far more beautifully on your plane. The shower that I was so grateful to receive is like your herbal bath. The giant IV bag filled with fluid is like the lovely mint water that I drink in Heaven. I prefer the herbal variety, but I am grateful for fluids that are washing my system, purifying my organs, and delivering the medicines that I need.*

Once my physical needs had been taken care of, Armana held my hands and asked:

ARMANA: *"What still remains heavy on your heart? Whether you remain in Heaven or return, this is the time to be sure your relationships are in order.*

SPT: *My sons know I love them, that I have loved them every day of their lives. There is no doubt that the bond of love is strong between us and that they will support each other.*

*My friends know I love them. I leave no doubt about my love for them and my gratitude for our special connections.*

*I know that my unfinished work is with my younger sister. I have not seen her since our mother's funeral five years ago, and it breaks my heart. Things fell apart*

*around Mom's death and I have not been able to find a way back to the sister I love so much. If I am dying, I need to tell her that I love her.*

ARMANA: *Yes, that's right. That is the work that remains. I know that it is difficult to find the words, but I want you to record a message that can be given to your sister.*

Once I received these clear instructions, I found that I was able to speak from my heart about the love that I had had for her since she was born when I was nine, how much she had enriched my life, and how much I have missed her. It was easy to tell her how much I still loved her. I recorded a message on my phone and left notes in my journal for my traveling companion to be sure my sister received them.

Late Saturday evening, Armana encouraged me:

ARMANA: *Dear Susan, you have worked very hard today and now you must let yourself rest, let go of old emotions, and find peace. Look out at the moon shining down on you and know that I am right here beside you, holding your hands, stroking your cheeks, bringing you comfort.*

*Let your stress, fatigue, and anxiety flow through me. I won't retain it, but I can siphon it off. This is the*

*next stage of your healing. You have been in touch with your friends, you have recorded a loving and beautiful message to your sister, and now it is time to focus on your own letting go.*

*Hear your teacher's voice saying, "Peace to all beings, may they be well and happy and free from fear. Peace to all of the beings we have been in the past, to all of the beings we will be in the future. May they be well and happy and free from fear."*

*Good night, my Dear. We will be with you tonight and so will all of your dearest friends. Feel their love surround you and know that if you are to stay here with us, you will be guided in how to move from one plane to the other.*

### February 22:
### A Surprising Change of Plans

When I closed my eyes in the early hours of Sunday morning, I was sure that it would be for the last time. I was at peace. I was unattached to staying. At about three-thirty in the morning, I texted a message to each of my sons to share a special memory, last words for each to cherish.

I had all but left this world when a phone call from

my older son Sam jolted me back into my hospital room only minutes after my text to him. I had been sure that my sons would be okay, but Sam was anything but okay: He was mumbling, crying, and scared. In that moment I decided without thinking to leave Heaven, its peace and beauty, and return to my life on Earth.

After a long, deep sleep, I spoke to Armana about this change of plans.

SPT: *Armana, am I right that my time with you is coming to a close, and it is time for me to return to Earth fully committed?*

ARMANA: *Yes, my dear. You had to come to that decision on your own. And I know that it cost you your heart's desire not to stay with us now, but you are right that your son needs you.*

*There is no greater love than a Mother's love. You still remember the first time your eyes met Sam's, when he was laid on your stomach with the umbilical cord still connecting you. There is work ahead for the two of you. You will see Sam through to being the whole, good man that he can be. You will see him with his family...a*

*beautiful wife, a child or two and a dog or two, and it will be worth it. You will never regret your decision. And in being there for Sam and Tom, you are going to live a very full, beautiful life.*

### Back Over the Threshold

My grandfather appeared and said, *"Well dearie, I guess it wasn't time, but it has been wonderful to see you. I lived another thirty years after the age you are now and they were good years. I wish you all of the things I enjoyed so much in those years… grandchildren, parties, flowers, and love. When the time comes, I will be here to greet you, and we will do this all again. You will have new adventures to share with me. Go with my love."*

I gave him a big hug. He kissed me on the top of my head and said, *"Off you go!"* and pushed me back out through the Pearly Gates. I knew that I was back in this world, in this body, in the clothes I had left in. Then I smiled, because I still caught just the faintest scent of jasmine. I knew for certain that I had been to Heaven and back.

### *February 23:*
### *Returning to the Ordinary World*

I found it surprisingly difficult to adjust to normal life after my three days in Heaven. The "real world" felt harsh and artificial to me. None of my electronic devices functioned and I began to wonder how I would live in the world if I could not access the phone or the Internet. I finally gave up and spent a couple of quiet days in the garden of the Casa Manana, limiting contact the outside world as much as possible. Again I opened my Akashic Records and asked my guides how I was to live my life moving forward.

GUIDES: *Susan, all you need to know is that you have seen Heaven. Everything that was not there is nonessential: That is your guiding principle. If you saw it in Heaven, pursue it. If you did not, you do not need it. For the rest of your life you will be sorting the ninety percent from the ten percent that is love.*

*Susan, love is your birthright. We brought you to Heaven to feel this love, so you could carry the message back to others who feel unlovable. Hold the lantern high for those who need to see their own light, beauty, and lovability.*

Two years later, I am still coming to understand all that my side trip to Heaven means about how I am to live differently in this world. I no longer watch the news or even own a television. I spend much more time in nature and in meditation. Time with my family and friends feels very precious. I have shared my experience and this perspective with many friends who are dealing with their own passing or that of a family member. I have no fear of death. I see it as a kind of graduation in a beautiful garden with our favorite people surrounding us, delighted to be having such a festive reunion. ~

# About the Authors

$\backsim\!\!\mathscr{A}\!e$

**SHERYL LOEFFLER**, *Etna*. Sheryl Loeffler is a Canadian writer and musician. Her poetry has been published in literary magazines in Canada, the USA, the UK, Austria, and Japan. Her book, *A Land in the Storytelling Sea*, was published in Malta in 2014. She was elected to the League of Canadian Poets in 2015.

**STACEY FREED**, *Tourist No More*. A freelance writer and editor, member of the American Society of Journalists and Authors and Rochester New York's Writers and Books, Stacey spent a year traveling after college and has never lost the travel bug. It all came full circle when she recently met up with her son (who was studying abroad) in Belgium where they stayed with friends Stacey met in 1977. Then she and her son had

an adventure in Iceland. She's happy she has been able to pass on her love of travel.

**LAUREL RICHARDSON**, *Mermaids and Monsters.* Distinguished Emeritus Professor of Sociology at The Ohio State University Laurel Richardson is an internationally renowned qualitative researcher with specialties in arts-based research. She has been honored with life-time achievement awards for her writing, mentoring, teaching and community outreach. Her innovative work has brought her to Denmark, Italy, Canada, Finland, France, Iceland, Russia, Lebanon, Israel and Australia. She is the author of ten books including *Travels with Ernest: Crossing the sociological/literary divide* (with her husband, the novelist, Ernest Lockridge), *The Other Woman*, After *A Fall: A Sociomedical Sojourn*, and, most recently, *Seven Minutes from Home: An American Daughter's Story.* She is working on a new memoir, "Twins, Not Quite." Most days she walks her Papillon dogs, writes, quilts, and walks her dogs some more.

**JACKIE BELL,** *The Surface of the Moon.* Jacki Bell is the grateful and proud recipient of the Critical Difference for Women Scholarship, and the University Fellowship for a year of graduate study in fiction writing at

The Ohio State University. She has an MFA in Creative Writing from Ohio State, where she served as the assistant and associate editor for the Sandstone Prize for fiction. She has taught Advanced Creative Writing, and Advanced Fiction Workshop. She is a single mother, high school dropout, and a lover of Story in all its forms.

**SUSAN PAGE TILLET**, *Trip to Mexico, Side Trip to Heaven*. Susan Page Tillett grew up in the small town of Gambier, Ohio, where she learned that travel is essential to a full life. Susan is author of two creative nonfiction books, *The Ragdale House Speaks* and *What's to Wear, Beatrice Bird?* For more than four decades she has supported the work of artists and writers, both in museums and artist communities. Susan lives in West Marin County, California, where she is Executive Director of the Mesa Refuge writing retreat.

# She Can Find Her Way

## WOMEN TRAVELERS AT THEIR BEST

*Essays by Independent Women Travelers*

# She Can Find Her Way

## WOMEN TRAVELERS
## AT THEIR BEST

*Essays by Independent*
*Women Travelers*

**EDITED BY**

# ANN STARR

*Upper Hand*
**PRESS**

Cover and box design by Myeong Sik Ryu
Interior design by David Moratto

Upper Hand Press
P. O. Box 91179
Bexley, Ohio 43209
U. S. A.
www.upperhandpress.com

Printed by Häingraph

ISBN: 978-0-692-36867-1

*Life is either a*
*daring adventure or nothing.*

—HELEN KELLER

༡

# Contents

## VOLUME 2

〜

## VOLUME 3

〜

## VOLUME 4

⁓

# VOLUME 4

# Rami Levy

*by*

## DONNA STEFANO

∽≀∾

 $\mathcal{G}$ ROCERY STORES IN Israel and Palestine don't resemble the clean, abundant, efficient systems that I was habituated to in the States. Rami Levy is unusually large for Israeli grocery stores, but the narrow aisles and coin-operated grocery cart system were constant sources of annoyance to me. It prides itself in offering the lowest prices on basic goods such as chicken, yogurt and rice. They offer family sized packaging for both the Orthodox Jews and conservative Palestinians who are engaged in a historic demographic battle of reproduction. It sells a wide variety of American-branded products including sugary cereals, granola bars, chips and canned tuna.

Why did it take me fifteen months to learn about this store? Because it is located to serve settlers and has a large quantity of kosher goods produced on Israeli

settlements. Any good principled supporter of the Palestinian cause boycotts these goods, as well as the chain. Principles rarely win out over convenience in my single-parenting world. The only reason I rarely bought products fabricated in the settlements was because I cannot read the Hebrew on the packages. I felt terribly guilty about my choice to patronize the store, until I kept bumping into other Palestinian friends in the aisles who looked just as embarrassed as I was.

I came to Ramallah for a year. I stayed for seven. I came as an expat. My official categorization was *al-ajnabiyah*; the foreigner. In Palestine, the term is used in a derogatory fashion, to denote their own victimization as in, "somebody who is not one of us because they have their freedom." But I was given some exception to this due in part to my Mediterranean roots, apparent in the curvatures of my hips, the reflective light of my black olive eyes, the mid-beige tones of my skin and my inherent knowledge of the Italian names of fifteen different types of pasta. Unlike the blonde expats in town, Palestinians would start every conversation with me in Arabic, assuming I was one of them.

I was seconded from a headquarters job to the Ramallah office position where I managed all the mundane tasks of keeping a large government donor happy

by fulfilling repetitive bureaucratic tasks meant to ensure the U.S. Congress that their money was being kept out of the hands of terrorists. As an *ajnabiyah* I quickly learned that I had privileges that few of my Palestinian colleagues had.

According to the Oslo Accords, land in the West Bank is divided into three areas: A, B and C. Area A is under Palestinian administrative and security control and Israelis are not allowed to enter those areas. Major cities like Ramallah, Nablus and Jenin are all in Area A. Area B is under Palestinian administrative control and Israeli security control. Area C is under Israeli administrative and security control and makes up sixty per cent of land in the West Bank. Security can be a confusing word to understand in this context, because in fact few people of any faith are fully secure in any of these areas, so it is easier to consider it as an area under "military" or police control. Most of the settlements are situated on Areas B and C. The law of military occupation states that the occupying force agrees not to move (or "settle") its population on to the land of the people it is occupying.

To bring order to this division of land, license plates of differing colors are one tool used to quickly determine who can go where. I could drive a yellow-plated

car (as opposed to a white-plated car), which enabled me to drive on roads both exclusive to Israelis and those exclusive to Palestinians, and of course, those few roads open to both. Those with white plates belong to Palestinians who have no status in Israel and can only travel there by a special permit issued by the Israeli government. Even with that permit, they will not be allowed to drive their white-licensed car (and are ineligible for yellow plates) through checkpoints and on roads exclusive to Israelis.

A special green-colored ID, issued by the US Government, enabled me to pass through checkpoints with a perfunctory wave. If I was stopped for a traffic violation, I could talk myself out of it by playing the role of a naïve American. I could lie and get away with it. I could go to the beach and swim in the Mediterranean Sea. I could go to a café in West Jerusalem without having to apply for a special permit. I could visit historical sites which a Palestinian would rarely feel comfortable going to for fear of an aggressive frisk down or physical removal: Masada, the Western Wall, Herodian. I could shop wherever I wanted to — the top of Jaffa Street or the bottom, a mall in Tel Aviv, a grocery store on a settlement.

There were many other things that I had a right

to do, not because they were granted as rights by the law, but because the invisible lines that exist between occupied and occupier which are as thick as the separation wall that runs around and through West Bank villages were translucent to my eyes.

I had been in Palestine for about fifteen months when a Palestinian-American friend introduced me to a grocery store located on a settlement in the West Bank that was part of the Rami Levy grocery chain. I had to ask the friend to repeat and then spell out the name for me. If it was Israeli, it must be Roni Levy, both first and surname would denote an Israeli. Was Rami Levy a real person? He is. And his mixed ethnic name combining a common Arabic first name and a common Jewish surname spoke to his lineage. He was born to an Israeli father and an Iraqi mother (both Jewish) in Jerusalem, near the historical central market which used to be filled with Palestinian farmers from the agricultural villages surrounding Jerusalem, who would come weekly to sell their goods. He embodies the ethnic diversity of shoppers whom his twenty-seven stores in Israel serve.

The closest Rami Levy store to Ramallah is located behind a gated settlement, but is freely accessible (with just a minor security check) to both Israelis and Palestinians. That fact alone makes this one of the strangest

geographic locations in the Holy Land. The Palestinian baggers and stock boys dress in black pants and dark green shirts with the yellow Rami Levy store logo pinned to their shoulder. The cashiers are secular Israelis of Russian origin who emit contempt and boredom as their bright-painted finger nails leisurely run the purchases over their scanners and brusquely throw the items toward the Palestinian bagger. I hate when they throw my food. Oddly enough, these Russian immigrants save their smiles and private jokes for the Arab baggers. They feel more affiliation to them than the settlers who risk the safety of their own children to live on Palestinian land.

The majority of Rami Levy stores are located at busy crossroads in the West Bank and around Jerusalem, as if to encourage the inter-mixing of the two sides of the conflict. Jewish settlers with countless children under the age of five dressed in the same outfits play between grocery carts and upright freezers in Rami Levy. Palestinian women with their colorful scarfs and long skirts seek out the Arab stockers to translate the backside of products. Nobody is yelling. Nobody is disregarding each other suspiciously. They don't pay much attention to each other unless they need to navigate their carts among each other in the aisles, which

they do without much affair. I've always hated the word co-existence (as if existence is a good verb to replace the word living), but at Rami Levy, I see people simply coexisting.

The architects of the judicial system that rules the occupied West Bank is one known as "rule by law." This basically means that law under occupation is formed by the military making a declaration of its need. It holds up in the Israeli court of Justice. Most rights which citizens of Western countries would assume under a democratic system are suspended in this occupation system — there is no assumption of innocence, evidence besides the statement of another military official is not required, and methods and lengths of detention are purposefully undefined. All in the name of security.

Israelis bristle at the use of the term Occupation. American Jewish audiences, who have rarely stepped foot into Palestinian towns of the West Bank or stared into the stark reality of Palestinians lives, have told me Occupation does not exist. The eyes of most American audiences glaze over while they whisper to each other, "Can't they just get along?!" I thought that was the simple question to be asked one time too.

One Friday morning in the summer of 2010, I drove out of Ramallah's VIP checkpoint to shop at Rami Levy,

trying to fit in an errand before Shabbat shut the store for thirty-six hours. Based on how I dress, I don't obviously fit into any category of shopper, Palestinian or Settler. I don't wear any type of head covering and my grocery shopping uniform consists of a pair of stylish jeans and a baggy shirt. If one had to guess in this setting, I might be categorized as a Christian Palestinian or a liberal American-Jew.

I was giving limited attention to my chatty son as I packed my groceries into the car. I stuck my head out of the trunk, instinctively drawn to the cry of a baby. I looked around and saw nothing. Then I noticed it wasn't just a cry, it was a wail. I was in a rush to get back through checkpoints and normally I'd be too stressed to give attention to such a distraction. But guided by maternal instinct, I investigated the sound. I told my son to stand by the car while I searched for the origins of the sound. The howling became louder as I moved towards a shiny black SUV. A window in the passenger side rear seat was cracked open a few inches. Inside sat an infant no more than six months old, wiggling fiercely in a car seat. I examined my surroundings — not a single person in sight. I babbled some soothing sounds into the window and noticed the baby was dressed in three visible layers with a fleece blanket covering her.

Sweat dripped down her face. I grabbed at the door handle aggressively but was surprised when it opened without resistance. Who would leave a child in an un-locked car (of course this was still several years before the summer of 2014 retribution kidnappings between Israelis and Arabs became another way the people of this Holy Land played out their conflict)? I needed to save this baby.

I was stopped in my tracks by the fleeting awareness of how complicated this conflict is. I needed to know who this car belonged to. Ultra-orthodox Jewish fami-lies rioted against Israeli police when they came to arrest a mother for starving her child. Would my actions be misperceived? If it was a Palestinian child in that car seat, I could be mistaken as an Israeli woman mean-ing to inflict harm on the child. I checked the license plate...white Palestinian plates. I could manage this, I spoke Arabic. But then my heart sank to my stomach. My actions could get a Palestinian into the hands of the law on Israeli territory (or ...occupied Palestinian territory), where a double-standard in legal rights exists between Palestinians and Settlers. Settlers can be tried under Israeli law on the occupied territories, but Pales-tinians are charged under the law of the Occupation.

Still, there was no reality of the conflict that was

going to let me further endanger the welfare of this child. I climbed into the backseat, found a bag on the floor containing bottled water and plastic cups and gave the baby the water which she drank readily. Her wailing stopped and I removed the fleece blanket. Whoever this child belonged to had no intention of making a quick trip in and out of the store, as a quarter of an hour had already passed. I told my son to keep an eye on the child as I ran to the front door of the grocery store. I tried to explain to the Israeli security guard what was happening, but he spoke little English. He waved over one of the Palestinian workers who was busy arranging the shopping carts. I explained what was happening, pointing to the car. He ran back into the store to find the parents. When I arrived back at the car, an orthodox Jewish women (identifiable by her head covering) had taken the baby into her arms and was undressing it. She didn't speak English, we gestured our way through communication. I felt a twinge of guilt that my fear had prevented me from picking up the baby and comforting her as the woman was doing. And she had done so with ease and confidence, never questioning the layers of identity discord that I conflated in my own head. Maybe because she had no concept that the rule of law can be used against another person? Or was she just more maternal than I?

The Palestinian workers ran over and became agitated when they saw the condition of the child. They grabbed the baby and ran back into the store. I climbed into my own car, figuring there was little more to be done. As I drove away, I saw young, Palestinian man, clean-shaven, dressed in a blue button-down shirt with a tie and blazer, holding the child in his arms. He was the father, probably this baby was his first born. He had a pained look on his face as the Arab workers screamed at him, "This child could have died? Are you crazy? Leaving a child alone in the car? Dead, she could have been dead!!" I felt a huge wave of relief that others were just as outraged as I was. Outraged by the possibility of the loss of another innocent life.

And here I was in a place where the news of stabbings and threats of missiles everybody of the fragility of life in more frequent rhythm than the daily news cycle. Could human instincts to protect and save a child move beyond this scene and apply to humans of all ages? Maybe it wasn't naïve for me to think that this grocery store is where peace will be made. ❧

# Sugar's Ride

*by*

## HERTA B. FEELY

⁓

*T*HE MAN, HE called me *Sugar*. "Why don't you get into the car, Sugar?" he said.

And on occasion those words still purl through my mind. I remember the date too: February 13th, a frigid night in 1970, about an hour before Valentine's Day. I was a freshman at Southern Illinois University in Carbondale and had just dropped off a heart-shaped confection at the house of some guys I knew. One of them I liked, though nothing much ever came of it.

That cold night — February 13, 1970 — sticks in my mind like gum to a shoe. As much as I've tried, I don't think I'll ever shake loose the memory of those couple of hours. Likewise, those years on either side of 1970.

It was a tinderbox time, when communities readily went up in flames. As happened in nearby Cairo,

Illinois, during the hot summer months of 1967. In April 1968, a bullet cut down Dr. Martin Luther King, Jr. in Memphis, and two months and a day later, a man shot Bobby Kennedy. A little over two months after that, on August 28th, violence engulfed the Democratic National Convention in Chicago. Another year passed, when, on my father's birthday and a week before I left for college, Sharon Tate and four friends were slaughtered, helter skelter-style. The murders were masterminded by Charles Manson, who'd hoped to ignite a race war.

"Why don't you get into the car, Sugar?" the man said. And after only a moment's hesitation, I did. As best as I recall, the reason for getting in was that I didn't want him to think I was prejudiced, that in my own naïve way, *I*, a white girl, didn't want to ignite a race war too.

The funny thing, in hindsight, is that all these events took place during the "era of peace and love." On the one hand, civil rights and Vietnam War protests regularly made the nightly news right alongside horrific images of police brutality and the ravages of war in Southeast Asia. On the other, the period heralded a lifting of consciousness among many of my peers: a growing awareness of the need to protect the environment,

to grow organic and eat healthier, to inhibit corporate greed, or at least instill social responsibility in companies, and many of us felt a widespread desire to explore Eastern philosophies. It was a period of colliding forces — political, social, emotional, and spiritual. Perhaps that was part of what made that period so confusing, especially for an eighteen-year-old girl.

～

This is how I remember what happened, memory being a corruptible, fungible thing.

On my way home after delivering the Valentine's cake, I only had to walk a short distance to my dorm, but the bitter cold made me wish I could snap my fingers and be home. Winter nipped at my face. The wind flicked its icy fingers down the inside of my long woolen coat. I tightened my red and white wool scarf, a gift knitted by a favorite aunt. Walking down the middle of the road, I looked up to see the trees' arthritic branches reach into the sky, hauntingly scary as they shivered in the wind, and the moon floated in and out of fast-moving clouds, illuminating the night sky with a milky, ghoulish light.

Then came the purr of a motor somewhere behind

me. I took a step to the side, turned and stuck out my thumb. The vehicle's bright lights momentarily blinded me. I blinked, trying to make out the car, but I could only see that it was big. And wide. And creamy white.

It rolled to a halt beside me. The door on the passenger side snapped open and a guy hopped out. A big guy. In one smooth motion, he gave me a genie-like bow and waved me inside with a flourish of his arm.

"Why don't you get into the car, Sugar?" he said with a beaming smile.

I'd known few black people growing up and felt intimidated at the prospect of getting into the car with two strange, black men clearly older than me. At the exact same moment, a voice in my head nudged me. *Don't be prejudiced,* it said, *get in the car.* I've thought about this a lot since then. Had two big white guys stopped for me in the middle of the night, I probably would have waved them away. *Not safe*, I would've thought. But in this instance, I scooted inside and sat between the driver and Genie-man, both of them appearing to be in their mid- to late-twenties.

"Where you goin'?" the driver asked, friendly and pleasant, putting me at ease.

"Over there," I said and pointed my hand in the direction of the very tall, concrete building that towered

over the town. "That's my dorm." It was a Carbondale landmark; you couldn't miss it. Off to the right. It would take maybe three minutes to drive me home.

～

Miles away on the West Coast, the Zodiac killer, presumed to be a white man, was contemplating his next murder, which he would set into motion on the night of March twentieth, when he gave a ride to twenty-two-year-old Kathleen Johns and her baby, the two of them stranded on the side of the road. Seven months pregnant, she carried her ten-month-old daughter on one hip. Unlike me, though, she hadn't been hitchhiking.

The men in the car and I made small talk. I don't remember what. Perhaps the same as Kathleen Johns as she rode with that stranger who'd offered to drive her to a gas station because the wheel of her car had fallen off. She wasn't aware that the man had engineered this mishap twenty minutes earlier when a flat tire had caused her to be stuck on the side of the road and he'd pretended to fix the tire, left her and then circled back, knowing it would fall off.

At one of the few traffic lights in Carbondale, our car stopped at a red light. When it turned green, the

driver, his face shaped like the moon, turned left instead of right. Thinking he'd made a mistake, I said, "My dorm's over there." I pointed.

"Yeah, I know," he said, "but it's late, got to tell my sister I'm takin' you home. Don't want her to worry. Won't take but a minute."

His answer sounded ridiculous and part of me wanted to challenge him, but another part hesitated. Even wanted to believe him. He seemed nice enough. I figured her place was only a few minutes away, so he'd tell his sister, and *then* they'd take me home.

I've returned to that moment countless times too. Should I have asked to get out? Was that an option? Would they have let me go? I know these thoughts ran through my mind, but I also recall how uncertain I felt — a girl afraid of what might happen, afraid of alienating these men, of angering or embarrassing them. And so I said nothing; I stayed put. Hoped for the best.

I wonder what Kathleen Johns said, or didn't say, after the strange man drove her and her baby daughter past the first open gas station and failed to stop. Did he come up with an excuse?

At once, a grunt came from the back seat. I swiveled, and there sat a third, very skinny guy hunched into the corner behind Genie-man. How had I not

noticed him before? I suppose he'd been quiet and hidden in the shadow of the backseat. Unlike the other two, though, he gave off intense angry vibes, like a Molotov cocktail ready to explode.

Like the Molotov cocktails protesters hurled at the Illinois National Guard and State Police a few months later, in May of 1970. *Ho Ho Ho Chi Minh, NLF is Gonna Win!* Protests that erupted on campuses nationwide after police killed four Kent State students protesting the My Lai "incident" in Vietnam, where U.S. troops had massacred several hundred unarmed civilians. Peace and love.

We'd been driving several minutes longer than the time it would have taken to arrive at the dorm. Cruising down Main Street, I noticed how unusually dark the area seemed, except for a few store windows, windows that in May protesters would shatter and owners would board up to prevent looting.

I searched for something to say, to find some common ground, and seized on the first thing that sprang to mind. A music festival, a bit like Woodstock, was supposed to take place in May. I knew one of the promoters, I told them enthusiastically, and by working at the concert, I would get in for free. I didn't tell them that I was a scholarship student with very limited funds.

"Maybe I can hook you guys up and get you in for free too," I said. Though driving such a big, fancy car, I wondered if they needed free entry.

"Yeah, that's good," Genie-man said amiably as we drove on.

Now, ten minutes into the drive, at least seven minutes further away from home than when I got in, all manner of thoughts twisted through my head, mostly growing more fearful of where they were taking me and why. What were they planning to do with me? But I also wanted them to know about me, things that would make them like me, things that might keep them from harming me. *I'm not prejudiced against blacks,* I wanted to say. *I'm in favor of equal rights, civil rights, all people's rights; I've memorized fragments of Martin Luther King's last speech*: "Be concerned about your brother...either we go up together, or we go down together." *I've read Eldridge Cleaver's* Soul on Ice*; I'm a fan of Angela Davis, Huey Newton and the Black Panthers.* But would they care about this? These guys didn't strike me as Black Panther types, not with their showy Lincoln or Cadillac or whatever it was.

Maybe they thought I was *exactly* the kind of girl I hoped they would. Or maybe they thought I was a trippy, hippie girl and everything that went along with

that. *Make love not war.* They couldn't know that I hadn't yet made love to anyone. That I was still a virgin. That I was saving myself for some knight who would sweep me off my feet and carry me to happiness. They couldn't know that I'd flirted with death all through high school, considered suicide on occasion, but now I just wanted to see my nineteenth birthday. How could they know?

—

I don't know if Kathleen Johns begged the man who'd picked her up to stop at the next service station, or the one after that. He could see that she had a baby; he wouldn't kill a baby would he? Or a pregnant mother? But then that hadn't stopped Charles Manson from ordering the killing of twenty-six-year-old Sharon Tate on August ninth, 1969. They stabbed her sixteen times, including in her very pregnant stomach. Leaving her lying there, a mess of flesh and blood. Killing four of her friends, including Abigail Folger, the coffee heiress. Using their blood to write *pigs* on the wall. And leaving a paw mark associated with the Black Panthers.

—

After several more minutes, we turned a corner and arrived in North Carbondale, a shabby, poor part of town, a place of mystery that white kids rarely visited, at least none I knew, especially not late at night. I tried to estimate how many miles we'd traveled. Three, maybe four? The further we went the more frightened I grew, the more intensely I watched the road and mentally logged the few turns we took.

My mouth, though, continued to talk, in an attempt to hide my real thoughts. Maybe I was chatting about how I'd seen John Lee Hooker grind out some amazing blues at a smoky bar outside of town, maybe not. I feared the silences. Needed to fill them. Where else did our interests intersect, overlap? Think, think. Perhaps if I'd read some of the many things James Baldwin had written or said, I might have quoted him: "Listen," I might have said to them, *"No label, no slogan, no party, no skin color, and no religion is more important than the human being."* And we're *all* human beings.

The houses grew more squalid, the streets empty, the windows dark. I wanted to but couldn't find the voice to ask how much further to his sister's. Wracking my brain for something else to say, I stumbled onto Ivory Crockett, the fastest sprinter on Earth. He came from St. Louis, my hometown, and had been a classmate

in junior high. The one black guy I actually knew. Now he was a fellow Saluki, who'd achieved fame in the world of track. A few months earlier, he'd been the US champion in the 100-yard sprint. I figured they might be impressed if we had a *brother* in common.

"Yeah, that's cool," the driver said, when I mentioned Ivory. But his mind seemed elsewhere and the conversation ended.

I wonder if white people believed, even briefly, that blacks had killed Sharon Tate and her four friends, as Manson had intended. He was clearly deranged and maniacal, but I imagine some whites would have wanted to believe it was the work of blacks. Had they not tracked down Manson and his followers, it's entirely conceivable some innocent black man would have been arrested. And convicted. Even executed. It happened all the time. Still does.

As our drive continued through the darkness, the obvious poverty leapt out at me. Dilapidated shacks, dirt yards. I wanted to tell these men that my family had been poor too, and wanted them to know that I dreamed of a more utopian society, one in which people of all races got along and respected one another, one in which blacks and whites didn't automatically think of each other as "honkeys" and "niggers." If they understood

these things, then maybe they'd let me go without hurting me. Without raping me.

At some point I returned to the subject of the May Fest and asked if they wanted the name of the guy I knew, and they nodded. I told them I'd write it down for them, all the while continuing to note the direction we traveled. Did Kathleen Johns keep track of their route?

~

"We're here," the driver finally announced as the car slowed to a halt.

Now that we'd stopped my stomach clenched. Every fiber of my being jumped to attention.

"Over there, my sister's," he said, pointing across the street to a small house sitting on a slight hill. To its right and a little closer to the road a one-room shack listed toward the earth. To the right of the shack, a field of tall grasses extended to the end of the block.

Genie-man asked if I wanted to come. Though he asked, instinctually I didn't feel that I had a choice. Somehow, somewhere in my brain, I thought if I just went along, I'd find an opportunity to escape. I don't know why I thought that; maybe some primitive part

of the brain says, play dead, and maybe through some miracle you'll get out alive. Or it was a form of prayer.

And so I said, "Okay," and continued to survey my surroundings.

To this day I wonder what would have happened if I'd said no?

What did Kathleen Johns say when the man refused to stop at the third gas station they passed?

On exiting the car, a sobering burst of cold air struck me. The driver and Genie-man walked alongside me as we crossed the street. The skinny guy brought up the rear. If I ran, I knew he'd catch me in a second. He seemed fast like Ivory.

On the other side of the street, Genie-man seemed in charge. I don't recall whether he touched me or not, but he guided me toward the shack, while the driver and the thin guy continued walking a little ways up the hill, then stopped a few yards from the sister's house. Though I'd begun to doubt the existence of the sister.

Genie-man opened the door of the shack and we stepped inside. "I'm gonna go next door and fetch some paper to write down that stuff about the rock concert," he said. "Wait here." What he said surprised me, the craziness of it, nothing about telling the driver's sister they were taking me home, the presumed reason for

dragging me all the way out here. As if his intentions were entirely innocent. Then he left me alone.

My eyes swept the room: one wall lined with bookshelves, a card table strewn with newspapers. A single unmade bed shoved against the wall. Then, two narrow windows, one of them facing the field. The other facing the street. And that was it. My escape.

I ran to the window overlooking the field that stretched to the end of the block. I pulled and pushed and struggled to open it, but it wouldn't budge. I leapt to the other window, the one overlooking the street. This was my way out. The only way. It had to open. *Please, dear God, please*, I begged.

~

When the strange man finally stopped at an intersection, Kathleen Johns jumped out of the car with her baby and fled. After running into a nearby field, she ducked down and hid. What must have been going through her mind, besides rampant fear for her child and herself? Besides experiencing sheer terror? How hard was her heart pounding?

~

How much time did I have before Genie-man would come back? Before he returned with the other two?

I tugged and pulled some more, but the windows refused to budge. Paint had soldered them shut long ago. Now I realized the only way out was the way I'd come in.

I stood trembling before the door, my hand on the worn knob. Thoughts raced through my mind. Adrenaline pumped through my system. If I opened the door, I was sure I'd find the three men in a huddle a few yards away, and imagined they were talking about me. I was now certain they were planning to rape me. Why else would they have brought me all this way?

Perhaps, since I'd never protested, could they have thought I'd welcome having sex with them? That notion has only arrived in hindsight; it was not a thought that entered my mind back then. Or, were they enraged by white people, and I would pay the price? As James Baldwin so eloquently stated in the early 1960s, "To be a Negro in this country and to be relatively conscious is to be in a rage almost all the time."

For the next few minutes, I felt no control over my actions. Something external seemed to be driving me. First, I cracked the door a few inches and looked out. There they were, all three in a circle, whispering, just

as I'd seen in my mind's eye. Then, I opened the door a bit wider, reluctant to step outside because a light bulb hung over the door and lit up the area. But even so, I couldn't stop myself and stepped outside. There I stopped. They turned and looked at me. My heart banged loudly inside my ribcage, so loud I was sure they could hear it.

But then a surprising thing happened. Instead of moving toward me, they began heading toward the "sister's" house. Away from me. As if to show me they really were going after that pencil and paper. Or that the driver planned to tell his sister, after all!

I watched them glide across the lawn, up toward the house, while I took two small steps backward alongside the shack, away from them. I still recall the skinny guy looking over his shoulder at me even as he moved. I froze, held my breath, and stared back. Still, they continued up the hill away from me.

Two more steps back and I'd reached the corner of the shack. One more and I was around the corner where they could no longer see me. I flew into the nearby field of waist-high weeds and brittle grass. I ran swiftly, like Ivory. My moccasins thrashed the frozen ground, my lungs sucked in the cold air, my scarf unwrapped itself and fell without my noticing.

Suddenly, footsteps sounded behind me. I ducked down, hoping to disappear inside the weeds, like Kathleen. My heart thundered and my breath came fast. I listened, afraid they would find me. What would they do?

Kathleen, in a similar circumstance, prayed her baby wouldn't release a cry. She placed her hand over the baby's mouth, just in case.

When I finally calmed down, I no longer heard the footsteps and realized the sound had been nothing more than my heart slamming inside my chest, rattling in my ears!

After a few more seconds of deep inhalations I gathered my courage and crept to the edge of the weeds. The car was about three-quarters of a block up to the right, still parked. I only knew one way home — the route we'd taken to get here — and so I took off, sprinting across the street. Me and Ivory. Me and a guardian angel. Just as I made it to the other side, the car's headlights erupted. I prayed they'd illuminated nothing but the pavement behind me.

The strange man waved a flashlight over the grasses and called out to Kathleen Johns, promising he wouldn't hurt her.

I wasn't sure whether the three guys had seen me cross or not, but I kept going, aiming for the shadows

of the houses, listening for the sound of the Cadillac. Or the Lincoln. Or whatever it was.

After a while, Kathleen Johns believed the man searching for her and her baby had finally given up. She crept out of the weeds and found her way to the road.

A few blocks later, when I thought I'd lost them, I suddenly heard the car's low growl. I raced into the front yard of a small house with a very large tree. I hid behind it, making sure to align my shadow with that of the tree trunk. My fingertips touched the rough bark as I watched the road. The Cadillac or the Lincoln or whatever it was turned the corner and slowed to a halt. It was maybe ten, fifteen feet away from the tree where I hid. Just then, the loud bark of a dog ruptured the silence. *Oh, my God. Shut up. Please, shut up!*

I could see the car's taillights and hear the engine idling. For a split second, I thought of one of those TV chase scenes and realized the real thing was nothing like that. It was terrifying. Is that what Kathleen Johns thought as she again stood alongside the road, this time sticking her thumb out? Or was she praying a car would emerge from the darkness and whisk her and her child to safety?

The Cadillac, let's call it that, started up again, prowling the streets, and I took off, continuing in the

direction we'd come. For at least ten minutes I ran full-speed beneath the dark sky, along the dark roads, past the dark houses with sagging roofs and peeling paint. Not a single home was lit, not even a porch light. In all that time, the car's path and mine didn't intersect. Still, I sensed them nearby.

When my breath came in short ragged spurts I stopped in the middle of the street, my head down, my hands propped on my knees as I gulped for air. When I looked up, I noticed her. A miracle. A slight woman in a white terrycloth robe and pink curlers in her hair. Halfway down a set of stairs, she was reaching for a newspaper. I peered into the darkness, half-wondering if she was real. What was she doing out at this time of night getting the paper?

Without even thinking, I loped toward her. I ran up the steps and placed my hands on her arms. I remember this precisely. "Help me," I said, "they're after me. They want to *rape* me." The word convulsed out of my mouth. And I looked at her, afraid of her reaction, as if she knew that *they* meant black men. And that *I* was a fool for getting myself into this situation.

Instead of responding as I feared, the slender woman wrapped in a white terrycloth robe didn't shrug me off or even act surprised that I was clinging to her. She

was like an angel, heaven-sent to rescue me. She simply took me by the hand as if she knew me and in a soft drawl, said, "Come with me, child. Come on."

Even now, coming upon her like that seems implausible, and yet it happened.

I try to imagine how Kathleen Johns felt as she stood in the darkness, still shivering with fear, and a different man stopped, another one offering a ride. Would she hesitate to get in?

Inside the kind woman's modest home I broke into sobs. She guided me into the living room. "You're not the first white girl I've seen middle of the night in these parts," she said, as if I were one in a string of many, and she was used to helping foolish girls who'd accepted rides from strange men when they shouldn't have.

She directed me to a phone and told me to call a cab, which I did. In the intervening minutes, the woman and I must have spoken, though I don't remember our conversation. I wish I did. A few minutes later a taxi arrived and I thanked her profusely.

"It's nothing, honey, nothing," she said, though about that she was wrong. Her help meant everything.

As I imagine Kathleen Johns must have felt toward the man who finally delivered her and her infant to the police station in Patterson, California.

~

The cab driver turned out to be an acquaintance of mine. Lew. What were the odds of that? While in the woman's house, I'd finally realized that my wool scarf was missing. How could I possibly go home and tell my aunt I'd lost it? So I asked Lew to take me back to the field next to the shack, where I was sure the scarf had been ripped from my neck. I wasn't thinking straight. It was a crazy idea; we shouldn't have gone there. But without hesitating he offered to search for it.

The next thing I knew we were back there, only yards from the shack. When he left the car and walked across the street to search I grew terrified. *What if they came back? What if they saw me? What if they hurt Lew?*

~

As Kathleen Johns spoke to the sergeant on duty, she noticed a police composite of the Zodiac killer and recognized him as the guy who'd driven her around for 90 minutes, terrorizing her. When she told the police sergeant, he grew afraid, imagining that the Zodiac killer might come back and kill them all, so he asked Kathleen to wait alone in the dark in a nearby closed

restaurant until he got help. There, trembling, she again clutched her babe and waited alone in the dark.

～

But for me, only minutes later, Lew had found the scarf, waving it over his head. Hurry, hurry, I waved back.

I couldn't bear to go to my dorm and be alone, considering the night's events, so I asked him to drive me to my girlfriend Sherry's house. When we arrived, she and another friend, Carey, were coming up the sidewalk toward us. I jumped out of the car and called out to them to hurry up. I was halfway to the front door when the Cadillac pulled up!

A moment earlier, the street had been deserted. Where had they come from and how had they found me? A mystery that remains to this day.

The terror still fresh, I yelled to Sherry to let me in and begged her not to let *them* inside. Once she opened the door I ran into the nearest closet and hid. A few seconds later, I heard Sherry shouting, "Get the hell away from here."

I heard Genie-man's voice. "Let me talk to that girl," he said, his tone carrying none of the congeniality with which he'd earlier spoken the word *sugar*.

Sherry repeated what she'd just said, adding that if he didn't leave she'd call the police. Grumbling, he left. The long, creamy white car drove away.

Despite all that, she decided to call the police. I finally emerged from the closet and begged her not to, but she did anyway. The police arrived a few minutes later. I told them the entire story, admitting that I'd hitched a ride and had gotten into the car, that no one had forced me. And they'd never laid a finger on me. Nevertheless, one of the cops asked for a description of the car and then they left. About half an hour later they returned.

They'd "apprehended" the three men and explained that they'd been arrested nine times. "For attempted rape." I didn't have the wherewithal or energy to ask what they meant by attempted; had all the women gotten away like me? The policeman went on to say that the men had never been convicted and urged me to press charges.

"But they didn't do anything," I said. "They never even touched me."

"They would have if you hadn't run," the cop said, his eyes suggesting that I knew little of the ways of the world. "Sooner or later they'll hurt someone. Those men belong behind bars."

Before they left, the police said they hoped I'd change my mind, but I didn't. I'd learned a lesson. One that had nothing to do with black men.

⁓

As for Kathleen Johns, the police finally returned to the restaurant where she'd held her babe in the darkness. They told her they'd found her car gutted and torched, but at least she and her baby were alive. Just as I was.

⁓

Still, for me, there was the aftermath. For weeks to come, each time a black man unexpectedly rounded a corner, I drew back, startled and afraid, embarrassed by my prejudice. I wonder what startled or haunted Kathleen Johns after her insanely frightening ride. White men who resembled the Zodiac killer? Did she suffer a sense of loss, as I had? A loss of innocence, of trust, of being afraid, instead of bold and daring?

It took time to recover from the intense fear I'd experienced. The flip side, however, was the immense gratitude I felt toward the angel-woman who'd rescued

me, toward Lew who'd risked his own safety to re-
cover my scarf, and Sherry who'd stood so bravely in
the doorway between me and a man I believed would
have harmed me had I not been graced by that almost
freakish escape.

For weeks afterward, I considered finding Genie-
man and asking him why they'd taken me to that shack
and telling him I was still committed to the dream of
whites and blacks living harmoniously. Wasn't he?
Prejudice, I would come to learn, is as universal as every
other form of hate and violence. It knows no bound-
aries — not class, gender, or race.

Not long ago, I again grew hopeful that the end of
racial prejudice had come when our nation elected its
first black president. Barack Obama. However, in the
wake of Ferguson, Baltimore, and countless shootings
of black men in other cities, I realize we have a long
way to go. Sometimes, the divide seems as great as ever.
Police brutality against young black men continues, as
does the disproportionate number of blacks in prison.

Will Martin Luther King, Jr.'s dream ever fully
become our reality, brothers and sisters?

I don't know. I do know that my black friends give
me hope. The black woman who saved me gave me
hope. In the days right after that crazy ride, I often

thought of the woman in the terrycloth robe, and oc-
casionally still do. The day after the incident, I had
plans to return to her home and present her with a
chocolate Valentine. A week later, I thought of taking
her a cake, and then after that, sometimes on the night
before Valentine's Day, I again recall her kindness and
wish that I could visit her. ᓓ

# Have Feet, Will Travel

*by*

## RUTHMARY MANGAN

⁓⁓

*M*Y FEET MUST have begun wandering quite young because one of my earliest memories occurs when I was three years old, as my mother tied me to the front porch with a long clothesline so she could get the laundry done without worrying about where on the planet I'd gone, the most likely place being Elmer's gas station down on the corner that was endlessly fascinating to a three-year-old. Fool that I was, though, I wiggled out of the tether, ran to the back yard and announced: "Ha, ha. I got out." She gave up.

In elementary school part of my daily route passed in front of a line of small businesses. Now and again, rather than take the sidewalk sedately — and boringly — home, I would go around back and travel through the yards, climbing over each fence as I went, greeting each trash can like an old friend.

Upon graduation from a Catholic girls' high school I joined the Franciscan women who had provided me with an excellent education for twelve years. A convent does not seem a likely place for such adventurous feet, but there was always the possibility of being sent to Napa Valley or even the cornfields of Iowa. I was too late for China; Mao had beat me to it, but I lived with several Chinese sisters who had fled the regime. I was enthralled by their stories, and the hope of Taiwan winked from the future. In fact, I ended up never leaving Wisconsin, teaching music to children and being church music director and organist. This became an adventure of another sort, as it was the musician's role to lead the charge of change after the ecumenical council dubbed "Vatican II" made major shifts in the church's liturgy. This meant, among other things, butting heads with intransigent priests and cajoling congregations to sing enthusiastically when all they wanted was to kneel in silence, clicking off rosary beads.

A few years in Michigan working on a master's degree at the age of forty plunged me into a wider world because eventually, feeling the need for change, I accepted a Teaching Assistant position at Eastern Michigan University and began working on a Master's degree in Music Theory and History. Mixed gender dorms were

a new thing and "streaking" was the latest craze. One day, eating peacefully in the cafeteria, I heard a sort of stir. Looking up I saw a tall male anatomy wearing only a ski mask "streaking" right at me. On another occasion I stepped off the elevator into a costume party and directly before another male who seemed to be wearing only an overcoat. He winked, said: "Wanna see?" and flashed open his coat. Fortunately this male was wearing swim trunks. Thus I began learning the wonders of male humor — so different from convent humor!

The University of Michigan and its neighbor, Eastern Michigan University, attracted many international students, and I was plunged into an even wider world. Standing on the street corner waiting for a bus, I was surrounded with the energy of youth, each chattering in a different language. On any given day I might hear Spanish, German, some Slavic language and assorted African dialects. Here began a new adventure as I started to learn about the cultures of the young folks around me. I learned to ignore being some twenty years older than my classmates and indeed felt I was finding a part of my own youth lost in the constrictions of convent life.

Beyond that, Catholic life in general no longer satisfied my spiritual hunger so I left the Franciscan

order. I searched through the various religions of the world for many years, ultimately finding a home in a western version of Sufi, which accepts and learns from all the religions.

But before that, my feet became restless again so the next stop was California and an evangelical/charismatic church that had training programs for lay counselors and healing prayer teams. This church spent much time and money on caring for the poor in and around Anaheim. We also traveled monthly to Tijuana. There we unloaded vans full of groceries at the villages, each a former dump site. We spent some time at four or five villages, praying for healing and mingling with the people, some with the terrible diseases found only among the poorest of the poor. The day ended around ten p.m. as we crossed the border for the two-hour drive back to Santa Ana.

Back in Anaheim, we weekly visited the motels around Disneyland, "The Happiest Place on Earth." These motels each had a section definitely *not* for tourists, and there we knocked on the doors of prostitutes and drug addicts, offering transportation and lunch back at the church. We generally filled several vans with kids anywhere from three to twelve or thirteen, all little hellions unacquainted with any form of self-discipline,

but all suffering from abuse ranging from "mere" neglect to beatings, to suspected sexual abuse. Usually a few Hispanic moms would accompany their children to ensure their safety — not an easy job in their circumstances — and, no doubt, to receive a bag of groceries to take home. During those years the Anaheim Vineyard gave out more meals than the Orange County food bank.

Besides these Saturday adventures I attended classes in lay counseling and healing prayer and in finding and caring for the poor. All of these things provided as much of a cultural shift as the international and academic milieu of the previous years in Ann Arbor. My understanding widened and, though my heart had long been open toward those less fortunate, or simply from another culture, my mind now caught up to it. I felt I could actually be helpful in situations that were once encountered only in reading matter, but were now real-life experience.

In 1994 my "day job" as a secretary was showing signs of vanishing so when I heard about a possible need for someone to go to Japan be liaison with a fledgling church, I jumped at the chance. At that time the Vineyard was involved in establishing new churches or partnering with other churches all over the world. The main message of the Vineyard was — and still is — that healing

is as available today, in the twenty-first century, as it was in biblical times. Two or three times a year, groups of volunteers would gather and fly off to Russia or France or Sweden or, in my case, Japan. These folks would give talks and then get everyone praying for each other, moving from group to group to offer assistance and advice. The exception in my case was that I was to stay on when the others left. Pastor Hosoe and I had agreed on a three-month trial season.

In all this time I grew immensely, psychologically and spiritually. But having advanced to a ripe old fifty-six years old, I had also grown physically and was, let us say, pear-shaped with a lot of stiff muscles to show for all that growing. This had a definite influence on my first encounters with Japanese life. In fact, one of the first things the church in Kani-shi did was add me to their gym membership and insist I visit there at least three times a week!

So, on a Friday in early September 1994 six of us Vineyard volunteers stepped expectantly, if a little scared, onto a plane at Los Angeles and, seventeen hours later, stepped off in Tokyo. I am by nature a frightened, shy person but a good pretender, and my adventures to this point had taught me much. Long ago a friend had taught me that the only to deal with fear was to walk

right into it. I found that when I did, much of it evaporated before my eyes as challenges or problems to be solved and thus manageable with a bit of creativity. So when I stepped onto that plane, I stepped right smack into the fear of the unknown, but felt confident that somehow or another I would come out the other side stronger and richer for it.

In Tokyo airport we found several cars waiting to whisk us off to a hotel in Yokohama where we were a healing conference led by Bob Fulton, a Senior Pastor at the home Vineyard in Anaheim. The conference was sponsored by the young church led by Pastor Hosoe and his wife, Hosoe Sensei (*sensei* meaning teacher). Titles are the usual form of address among the Japanese and first names are not used in any formal relationship. Hence I never learned the first names of either the pastor or his wife.

We arrived just in time to begin our ministry and entered into conference activities. That first evening I was introduced to Takako whose apartment in Kani-shi I would share for the next three months. Because we were "socially equal," first names were appropriate and, in this case, I never learned her family name! Takako was a bouncy, enthusiastic young teacher of physical education at a local high school. Because all Japanese

study English from the early years of elementary school all the way through University, her English was impeccable.

After the conference was underway, I sought directions to the restroom. I entered a short hallway and found myself looking directly at five men lined up at urinals. As I stood there in shock, five heads, without missing a drop, turned as one and looked straight at me. I hastily turned to my right and found, to my relief, a door. It was even marked "ladies" in English. Upon entry I saw several stalls and entered one only to find it completely empty except for a roll of tissue on the wall. Thinking it must be under repair, I moved on to the next and found the same emptiness. It occurred to me then to look at the floor and there, in the exact center, was a ten-inch wide, immaculately clean, porcelain-lined hole. I quickly divined the purpose of that hole and realized how grateful I was that my chiropractor insisted I practice squats as help for my lower back weakness.

Such was my first cross-cultural encounter with Japanese hygiene.

Following the Friday night conference session, we were divvied up among Japanese families for the next two nights before travelling to our final destinations. I was introduced to a lovely Japanese woman who showed

me to the bathroom. The commode was very modern and had many gold-colored levers. These were explained to me and I, in my exhaustion, tried to retain which one was the flush. The separate shower room was as large as a bedroom, beautifully tiled floor to ceiling. In the corner was a square pool of water, approximately four or five feet deep. The showerhead was on the wall on a long hose. One was meant to shower there, swishing the soapy water down the drain (another hole in the center of the floor!), and then step into the heated pool to relax one's muscles and have a contemplative moment. I settled for a shower.

In the guest room I found a beautifully appointed, traditional Japanese sleeping place. Three floor-to-ceiling, black lacquered cupboards sat on tatami mats. These are a series of skillfully woven straw mats covering the floors of most Japanese homes. Between two of the cupboards was a shelf with a gorgeous Ikebana flower arrangement. The whole made a room of great beauty, clearly based on the Japanese understanding of wabi-sabi, an aesthetics based on the acceptance of transience and imperfection. And there, in the center of the floor, lay a futon, way, way, way, down there on the floor and all alone in the center of the room with nothing to hold onto that might help me down, much

less up again. Not being a horse, sleeping standing up didn't appeal, so simply leaning over and letting gravity take its course seemed the best option. I'd consider how to get up when morning arrived.

However, the method of getting up became important in the middle of the night when I found myself in search of the bathroom. I don't recall exactly how I got up, but I'm certain it wasn't pretty.

In the bathroom I rediscovered the many levers and couldn't for the life of me recall which one I needed. In my befuddled sleepiness I had the strange recollection that one lever would turn the whole thing into a washing machine. Not really sure that might not be so, I feared trying any of them lest I find myself on the way to Mars, a cold and lonely thought in the middle of the night.

Next morning I came downstairs and found the dining room and another quandary. The table was beautifully built, with a matte black finish, and set for one with beautiful china — and way, way, way, way down there, far away from me. This lovely table with its lovely place setting was set in a three-foot recess in the floor. The only option, yet again, was to let gravity have its way and hope I landed on the cushion. My legs were then to be maneuvered under the table and left

hanging in the recess beneath the table. However, this time I was caught in the act. My hostess was just coming in from the kitchen and gave a small startled gasp as gravity did its thing with me. However, she said nothing; simply served my breakfast and afterwards we went our separate ways, I to the conference and she to her housewifely duties.

I stayed one more night at this beautiful home of an obviously well to do family. When I came down to breakfast on Sunday morning, I found my lovely place setting in the living room on the coffee table. I was much relieved and grateful for the unspoken thoughtfulness of my hostess. I enjoyed this breakfast even more for not having to add more bruises to my posterior.

Following the conference's close Sunday around noon, part of our group headed for Tokyo airport and the trip back to the U.S. The remaining three again piled into cars of various good-hearted folks, who rushed us to the famous Bullet Train. The car I was driven in had some form of GPS, then unheard of in the U.S. The driver, eager to show off this newest technology, took us by side road after side road, resulting in our being barely in time to catch the train. Our Japanese hosts urged us to aim for the last car. The Bullet Train has no human driver, and the doors close

automatically from front to back. Struggling with luggage, we stumbled and staggered and barely made it inside the last door; I nearly lost the heel of a shoe caught as it closed. We arranged ourselves throughout the car and settled in for a two-hour ride to Nagoya.

And what a ride. Traveling at speeds as high as 320 mph, we leaned back into very comfortable seats. There was no sense of motion and no train noise heard inside the car. Stewardesses came through offering drinks and snacks, including a sports drink called by the English name "Sweat." I declined that one, though I was assured it was tasty.

Once arrived in Nagoya we switched to a local, three-car, ordinary train for the final hour to Kani-shi. There we all unloaded and my new housemate and I walked the block or two to her apartment where I was installed for the duration of my three-month stay. I was much relieved to find that my room contained a real bed and a desk with chair on the tatami mat. And, to even greater relief, there was a real toilet in the bathroom.

On Tuesday the other two Americans departed for home and I began to settle into a daily routine. Takako would rise early and have breakfast before leaving for her school. I would rise after she left and plan my day. We ate meals separately because our tastes were so dif-

ferent and also to avoid the necessity of having Takako prepare all my meals as well as hers. Several times a week I taught English conversation at the church, some afternoon classes, some evening. Twice a week I took the local train to a neighboring village where the church had an outreach building with two apartments and a conference room. I left there to return home around nine p.m., having to walk about a half-mile to the train on country roads with no lights to catch the last train home to Kani-shi. Never once did I feel nervous or afraid, either there or on the two-block walk from the train to our apartment. There was a sense of safety and peace everywhere in the countryside, day or night.

The classes I taught were part of a church outreach where Hosoe Sensei taught teen-agers several evenings a week. These classes were to provide English experience beyond the general English high school classes. Each student who wished to attend University was required to pass a stiff English test. My classes were generally uneventful, consisting largely of adults who had been in the United States or England at some point in their lives and wanted to keep up the English they already knew. Some had not traveled, but intended to do so one day and wanted to add conversational speech to their reading abilities in English. There was one class of

teen-agers, which was a bit more lively, but, due to the innate politeness of the Japanese, never got beyond an extra twinkle in a few boys' eyes. It is interesting to look back and note the difference between that class of teen-agers and the one of young Hispanic men I had taught in California. In the latter there were often remarks to each other in Spanish and laughter, mostly at my expense I suspected. In Japan, these teen-agers rarely lapsed into Japanese and, when they did, they translated their remarks for my sake.

I had understood before leaving the U.S.A. that Japanese culture was a lot more formal than American style. Still, encountering it led to some faux pas on my part. Fortunately the Japanese were very forgiving, attributing these to some idea of "the dumb American." This was never spoken, of course: they are much too polite! A few encounters stand out in memory.

Sharing an apartment with Takako led to the first. I assumed that relationships worked much the same as they would here. So when a young woman whom I'll call Sumiko showed up at our apartment door one evening looking for Takako, I ushered her in warmly. Takako was out but would be home soon, I knew, and I thought Sumiko and Takako were good friends. First mistake. The second mistake was in not understanding

that Japanese do not lightly invite people into their homes. After a few minutes conversation with Sumiko, I returned to my room, leaving Takako to speak with Sumiko when she arrived. Next morning I was met with fury from Takako and was dressed down soundly for having let Sumiko in at all; it just wasn't done, I was informed. And secondly, Sumiko and Takako were definitely *not* friends, and I had put Takako in a difficult position by assuming so. Whew! I apologized profusely, but it didn't seem to help. The situation was resolved in the next day or so as the pastor's wife explained to Takako that Americans freely invite people into their homes and also that I would not have known that the two young women were only acquaintances from the church. I breathed a sigh of relief as Takako and I resumed a friendly relationship.

In another instance I did the "American thing" when I invited a young woman I met at the gym to come join the morning conversation class at the church. She hoped to travel to the United States one day. I told her to call the church for information, but she skipped that step and simply turned up at the door one morning. She stood, frozen, in the doorway as I greeted her warmly and waved her in to join us. I turned and explained who she was to the women already in class. Fortunately a

couple of them sized up the situation quickly and went over to the young woman and brought her in. Though I didn't know exactly what was wrong, I did figure out that one doesn't go around inviting people one meets wherever into church classes. Fortunately the women who did welcome her had lived briefly in the U.S. and understood American hospitality, so the incident passed off without comment. The young woman never came again. I learned, though, that "y'all come" doesn't really work in Japan.

Worst of all was the shock I gave everyone when I calmly explained the current meaning of "gay" to my evening class. A young woman had come to the class because she hoped to travel to the U.S. one day. In class the meaning of various words was being discussed and she responded that the word "gay" meant happy and light-hearted. I responded that yes, it did, somewhat. But, as I feared for her coming to the U.S. and one day announcing that she "had been to a very gay party last night" and being seriously misunderstood, I explained the other possible meaning, thereby shocking the whole class.

The Japanese are a polite, friendly people on the whole and will go a long way in order not to embarrass another person. A perfect example was when I "fell

down" to the breakfast table. My hostess said nothing to embarrass me, but next morning I found a different, more comfortable, arrangement. It is that sort of consideration that I found all around me. One more illustration: As I returned from teaching a class I had to cross a four-lane road. There was a stoplight, but it was over a block away so I regularly crossed at a point in the middle, just across from our apartment. One particular day the light in the distance was red and all four lanes were stopped so I ventured across. Three or four steps into my travel the light changed and all the cars to the right of me moved on. To my astonishment all four lanes of cars to my left waited quietly until I was safely on the far sidewalk. I found myself shaking and wondering, "what the heck was that?" And I realized: There was no impatience; I felt no anger coming at me. Every single driver simply waited quietly. This was so different from imagined similar situations in California, in which the traffic in the far lanes would rush on and, in the lanes I was stepping into, traffic would honk imperiously to hurry me across.

Nevertheless, as the only American and, in fact, the only native English speaker, for miles around, I was an alien in a strange land. At one point we went to a couple of schools as the children were leaving for the

day and handed out flyers announcing English classes. I was mobbed by eight- and nine-year-olds who had never seen anyone with blue eyes! No matter where I went or what I did, I stood out. There was a young Brazilian man, six feet tall, who had come to the land of his parents to work and learn more of his own roots. But the DNA said Japanese and he, despite his height, blended in in a way I could never do. On a deeper level, this left a loneliness I had never experienced before; a loneliness that was not personal, but which comes from being the outstanding one in every situation. This wasn't changed by all the friendliness and respect offered me. The young man had the Japanese DNA, and I did not. I could learn to bow to the appropriate depth; I could learn to say "Arigato" and "Ohaio" at the right times; I could learn to play the koto, but I could never *be* Japanese.

Shortly before Christmas, I got on a train at six one morning. I was truly touched that the Pastor, his wife, his assistant pastor and Takako, as well as a couple of kids from my class, were all there to see me off. This train led to the Bullet Train and another comfortable ride, this time toward home. I arrived a day earlier than I left, having crossed the International Date Line, and found three friends cheering for me on my way out of

customs. I was driven to the home of friends who had agreed to let me stay with them until I got back on my American feet. We arrived at the door and found a sleepy Maria and Jose staring in wonder. A moment of awkwardness, then one of my greeters said, "How about we drop off your luggage and then go out to breakfast? We'll be back later." Maria and Jose nodded in relief and we drove off again to breakfast. They had clearly forgotten that I was arriving that day. A stranger in a strange land once again, this time a land called "home. However, I was wrapped in the warm understanding of a tribe of travelin' women, as each of my three friends had traveled solo to far places: one to Russia for three months; one to China for four years and then by train across Eastern Europe; one to Chiapas, Mexico where she remains to this day.

Would I do it again? Perhaps to a different part of the world, or even a different part of Japan? If I were younger I would. Back in the '60s I longed to join the hippie brigade and travel the world, living out of my backpack. The circumstances of my life precluded that, but in the mid-nineties I was, in mind and heart, still that hippie up for global adventure. However, at fifty-plus, my body wasn't convinced it was a good idea. Shortly after I returned to the U.S. I had serious surgery

and was glad I could go through it in English rather than Japanese. So now I tie my longing feet to the legs of my chair and let Rick Steves travel in my stead. ❧

# I'll See the Prado
## on the Way

*by*

### ANN STARR

⁂

$\mathcal{F}$OR WEEKS BEFORE the trip, my two biggest suit-
cases became life obstacles, always in the way. First they
impeded passage across the bedroom floor; then they
sprawled across the double bed like an overbearing hus-
band. My room was a minefield of toiletries, currencies,
electrical current converters, and garments of uncertain
subtropical suitability. I had not one packing list but
several, all floating and in flux, and none close to com-
plete. They were scribbled on the margins of a newspa-
per clipping, on a coffee shop napkin, and across the
fine print of a credit card disclosure I'd been too lazy
to discard.

The splayed suitcases grew emblematic of the trip
itself. Christmastime travel to Senegal had become a
mental impediment so huge that it was impossible not
to fall all over it. Lucy emailed photos, but I could tease

no more idea of Senegal from them than of a stage with colorful props. Lucy apparently enacted a fiction called "Her Life" upon this sand-strewn set.

Since we had focused all of our planning on her lurid instructions about how to negotiate the Dakar airport, I had developed no idea of what to expect if I survived to exit. I guess I imagined that I'd step from a well-lit modern airline's interior — in which I'd collected swag and drunk Scotch all night — into a hushed Dark Continent. This would be the same one that I'd pictured since third grade, so ironically represented on the big pull-down map in the pastel colors of melt-in-your-mouth mints.

My adult ignorance now replaced those pastels with duskier swatches of...void. Large bugs skittered across the ominous blanks, and men ran around them shooting automatic weapons. I mustered nothing but grotesque imagery, outrageous neocolonial fantasies fed by clips from action movies. At least I felt embarrassed and guilty over my arrant ignorance.

Still, my anxiety about the trip dropped me into a debilitating depression unmoved even by the prospect of reunion with Lucy. I'd suffered medical depression for years, its episodes depriving me of energy, will, and decisiveness. This depression magnified my fear that I

would be incapable of judging reasonable courses of action. I began to doubt my capacity to travel at all.

So I had some serious talks with my partner, Tony, about the advisability of the whole undertaking. "Perhaps," I mused in discouragement, "I'll just read in the airports and avoid anything that could confuse me." I knew that I needed to marshal my forces for the doomsday project of the Dakar airport. Tony encouraged any self-protective thoughts.

～

I booked the cheapest ticket possible, on Continental Airlines, to fly from Columbus, Ohio to Newark, New Jersey, thence to Madrid overnight. I'd arrive in Madrid at nine forty-five in the morning, but I wouldn't leave for Dakar on Air Europa until seven o'clock in the evening. I finally awakened to the thought that a whole day's layover could give me the chance to realize a dream: I could see the Museo del Prado! I even did some research and took notes on the subway routes from the airport and the museum's hours. I felt a stirring of something like enthusiasm.

When he dropped me curbside at snowy Port Columbus, Tony collected my winter coat and scarf with loud silent resignation, then dragged my two heavy

suitcases into the terminal. I wore a brightly patterned, yellow and black rayon shawl coat from India draped over a royal blue cardigan and my favorite violet cotton, sleeveless shift block printed with an arabesque design. I sprang over the dirty slush to avoid getting snow in my Birkenstock sandals. Lucy had said to plan for temperatures of eighty to ninety degrees. I dressed colorfully for my subtropical destination.

~

Luck, encouraged by two anti-anxiety tablets, allowed me to sleep all night on the airplane and I woke up over the coast of Portugal feeling genuinely refreshed. The weather in Madrid was as brilliant and breezy as a perfect spring day. One step outside of the terminal invigorated me with a saucy smack of fresh air. A clement breeze riffled the leaves of abundant green trees that softened the clamor of the congested traffic. I was suffused with energy, like a droopy garden after the rain. *Carpe diem!* No sitting around for me! I locked up my anxieties with my hand luggage and by ten thirty I was wide-eyed and marveling as I glided through the art-filled platforms of the super-modern Metro de Madrid.

Like the parting of the clouds or the light at the

end of the tunnel, the lifting of depression brings a triumphant surge of joy. I felt as light as the ebullient gases that spew from an unscrewed soda bottle. As I made the last transfer before my destination, the only shadow in my sunshine was that I moved through this stylish, high-heeled city outfitted as a gaudy tourist on an African beach. I felt better when a smartly dressed woman boarded the train beside me and remarked on my red handbag in emphatic, gesture-punctuated Spanish. It was my favorite purse, so I smiled my appreciation for presumed compliments, and thanked her in English.

Hearing me speak, her companion stepped in, to practice her English I assumed. Glad to oblige, I leaned in, smiling in a faintly patronizing way while she — with admirable pronunciation and diction — explained in English that my red source of vanity had just been cleaned out by a pickpocket.

My brain sorted this out even more slowly than my trembling hand did. Indeed, the yellow wallet that held seven hundred dollars, a pile of euros, my credit cards, tickets, baggage claims, passport and immunization papers was, unaccountably, gone. The women gazed at me sadly with deep, dark, expressive eyes. In cascades of Spanish and English, they explained that it had happened instantaneously in the crush of boarding.

Their faces melted with sympathetic pain. Or were they smirking? I hadn't heard anyone yell, "Stop, thief!" when the robber had his hand in my purse — or had I somehow failed to hear? Maybe these two were going to divide my money after I got off the train. How stupid was I, anyway, to have felt good in the first place and brought this upon myself?

I emerged from the train as planned at the next stop, Banco de España. The station guard was a beautiful, uniformed woman with reasonable English and even deeper, expressive eyes. Those eyes spoke volumes of voiceless sorrow and compassion for me. Of course she would look for my wallet! But in the meantime, I should report the crime at the police station. She wrote the address for me in her beautiful Spanish hand, and delivered it like the Pietà extending fingers to her bleeding child.

It took several confused passes up and down streets ancient and narrow to find the precinct police station. They only sent me on a further quest for the district *comisaría de policía,* which I found after meandering a long time beneath shimmering plane trees along the stately, shaded Paseo del Prado. For all my wandering and groping conversations with Spanish policewomen (who, for their own purposes, spoke English and for

mine did not) all I gained was a single sheet of paper. It was stamped and impeccably handwritten in pen with a description of my yellow wallet and its contents, which no one would admit in any language, was history. By mid-afternoon I was finally instructed to go where I should have been hours ago: the American Embassy.

I couldn't miss, through all of this, how magnificent was The Prado's neighborhood. Grand avenues met in a climactic plaza where every building pointed heavenward. The monumental architecture was so ornate and ethereal that every detail saluted royalty or God.

Yet terrestrial life maintained an earthy course beneath the spires and volutes. A soberly dressed little band — three saxophones, an accordion, and two upright basses — tooted and sawed beneath a squat palm tree on a street corner. An antique shop displayed life-sized seventeenth-century figures carved of wood. In a drama with no resolution, buxom women in painted décolleté were posed on a balcony just beyond the clasp of handsome gentlemen who wooed them with arms extended, still ineffectually wooden after four centuries.

The click of heels on the crowded sidewalks, the playful wind, the palm and plane trees that rustled in happy response; the antic curlicues of wrought iron balustrades that musically decorated every building —

what a day it had become of mocking, rare beauty. Madrid held for me all the surreal allure of Oz.

When I found my way back to the Metro, my Lady of the Banco de España pressed into my palm a chit good for travel on the Metro for the rest of the day. She gently closed my fingers around it, marked the American Embassy on a map, blessed me and gestured me down to the trains with an expression that signaled exquisite sympathy for my likely doom.

I found the Embassy on the *très chic* Calle de Serrano, looking like a fortified desert outpost among the Cartier, Bulgari, Piaget, and Gucci boutiques. A conspicuously armed guard — yet another member of the warm-eyed and empathetic feminine militia — stepped around a jersey barrier to question me when I showed no sign of moving on.

"You have no identification *at all?*" She sounded shocked, as if she had never heard of such a thing before.

I had been worried up until then. Now I felt death's breath.

~

Suppliants at the U.S. Embassy in Madrid took numbers and waited to be called. We sat in a room designed not

to refresh the mind, delight the eye, or impress with America's prestige. There were no windows. The walls were made of painted concrete block. Every detail encouraged the applicant to procedural, businesslike thinking and the goal of speediest possible exit. With its fluorescent light panels set into an acoustical tile ceiling, the space had the atmosphere of the cafeteria at an under-funded middle school. The soda machine and photo booth suggested more the amenities of a bus station, however.

Along one side of the room, Embassy workers assisted the non-citizens — visa seekers, I think. That crowd was segregated in a waiting area of uncomfortable, molded plastic chairs, across the room from us few American citizens who awaited aid from a counter dedicated to our exclusive service.

How reassuring it was to be helped by Pilar, a beautiful woman who smiled at me with the whitest teeth I have ever seen. They gleamed like the abundant rows of pearls in which she was draped. She wore a red sweater set and had a rolling, comforting bosom that I longed just to rest my head on. I could never have imagined all the arrangements that she would have to make for me, or to think through all the work that I'd have to do either, just because I'd had the misfortune to be so

thoroughly robbed. But Pilar knew the management of desolation, and she treated it as routine and reversible. Her efficiency allowed me to check my dark emotions for long enough to absorb the real extent and gravity of my helplessness.

Pilar sat behind the counter on a tall stool. I stood opposite, partitioned from her bustling office by a thick Plexiglass wall, bulletproof I felt certain.

I would of course need a passport to continue my travels to Dakar, she told me.

I agreed. I respectfully hoped that they would issue me one so I wouldn't miss my seven o'clock flight. I glanced at my watch — it was three.

But first I had to pay the United States Embassy one hundred dollars, she informed me with her unflagging, cheerful equanimity.

I could only gape. Was she crazy? How could I pay a hundred dollars if I had lost all my money and credit cards?

It may have been that fatigue and shock made me sensitive, but right at that moment I perceived that, on top of all my other troubles, Pilar seemed disappointed in me. I felt that she considered it deficient in a mature woman to have had every valuable on her person and thus to have been a sitting duck for pickpockets. This

was unspoken, so I didn't get to explain that it was *strategy*, my considered plan to foil the *suitcase thieves* in Dakar.

Pilar used the tiny address book that remained in my purse to start making phone calls for me. She dialed from her desk, and whenever she made a connection, a dial-less handset on my side of the Plexiglas wall would ring. I would pick it up and talk — to Tony, to my sister in San Francisco, to my bank, a credit card company, to Air Europa and Continental Airlines. But we couldn't reach Lucy, so Pilar left a message at her school.

My sister faxed her credit card to a hotel that Pilar designated, to guarantee my room and expenses for two nights. ("*Two* nights?" I thought with alarm.) Pilar spoke directly with Tony, instructing him how to send via Western Union funds sufficient to purchase my passport and get me on my way.

I had surreal conversations with agents at Continental and Air Europa, all of whom were yawningly uninterested in my misfortune. Air Europa's agent was sure that I'd have to buy a new ticket for Dakar. Because Africans were unreliable, the airline only accepted cash.

About my luggage? There were no doubts about *that*. It was in Madrid and I could collect it tomorrow at the Continental baggage claim desk. It would arrive

in Dakar that night on the missed Air Europa flight, and it would be returned to Madrid tomorrow. It was en route to Newark, New Jersey.

Pilar did what she could to make me safe for the night, told me when to return to pursue my passport in the morning, and sent me off, penniless and weak with hunger, to the Hotel Melia Galgos, a block away, just around the corner. It was evidently the hotel of choice for the Embassy, and its staff awaited me with the same solicitousness they extended to visitors far more august than I. The desk clerk, the concièrge, the smiling little manager in his impeccable gray suit and fresh boutonnière — all knew my story: "Arrangements have been made, Madame!" I was shown to the neatest little room, just as Her Fairest and Most Excellent Representative of Columbus, Ohio might have expected.

Oh, but where *was* my luggage? I couldn't hang my anxiety in the closet. I decided that I had to investigate in person at the airport while I still had free passage on the Metro.

So I washed my face in cold water and cleaned my teeth with my finger and a dab of repellant, complimentary Spanish toothpaste. When I descended to the lobby, the manager sprang upon me like a sparrow on a starling. Even his boutonnière was bobbing. "A phone

call, Madame, a phone call!" he announced, grinning and drawing me toward the desk. With conspiratorial delight, he hissed in a stage whisper, "It is *your daughter!"*

How Lucy had reached me there was to my fagged mind a miracle. I spoke her name into the handset as a question, and what joy it was to hear my own child answer, "Mom?" with equal amazement and then burst into tears.

Lucy had suffered all day under the misapprehension that I had been mugged. I was flabbergasted. She hadn't worried about my money or government-issued documents: My daughter was agonizing over my impending death! Suddenly, wonderfully, I was going to live. Actually, for a few minutes, I had never felt better. I was an armed, uniformed, brown-eyed Spanish woman exuding reassurance and consolation for all the pain this child had suffered.

But when Lucy asked when I'd get to Dakar, I had nothing. Thinking I'd reassure her anyway, I spooled through all the irresolute and unconfirmed speculations I'd received during the day. I told her that one Air Europa voice claimed they had only the one flight weekly, and that I'd have to pay a thousand dollars at the gate for a ticket on the next one. "But don't worry, Lucy," I concluded in the chipper voice shared by the

insane and mothers, "I'll get it sorted out tomorrow. I'll get there, I promise."

*"Don't worry?"* she shouted indignantly. Then we were both in tears. We wept to each other, "I love you too!" and promised we'd talk again when I returned to the Embassy in the morning. I'm sure that her sleeve passed across her nose in Senegal at just the same moment mine did as I surrendered the handset in Spain.

Depressed and hungry, I regressed instantly to juvenile modes of thought. That nose-dive in judgment was hastened by the weight of collapsing will. My trip back to Aeropuerto de Madrid-Barajas was a fool's errand. At least I retrieved my hand luggage from the locker. But I squandered what precious little energy and judgment I had left, dragging around miles of corridors, obsessed with a doomed idea that I would find my baggage. It was too late and I had lost my identity. I was bereft of a caressing self that would kindly say, "Do get some sleep; it's time to let go, Dear."

I returned from the airport around nine-thirty and I ate an hors d'oeuvre at the hotel bar. I was starving. My last meal had been a roll and coffee on the plane. But this was my only dining option, since I could charge it to my room. The restaurant was impossibly expensive and, having no money, I couldn't go out to buy even a banana.

~

The next morning, I relaxed with a long shower. Because my hand-washed cotton panties had dried all the way through from their night on the radiator, I was inspired to optimism. Surely I would fly to Dakar that night.

As I passed through the lobby looking for the free continental breakfast, I discovered that it was snowing. Women pulling fur coats close around their necks dove through the revolving doors like Donner parties to frontier outposts secured by doormen with umbrellas. I shuddered in my blue Birkenstocks. This could not be.

But if it could not be snowing, then breakfast had to be a Rabelaisian fantasy: melons, rainbows of berries and pyramids of tropical fruits; bacon, sausages of every shape; *jamón,* a smoked ham that must have been selected from Gargantua's own herd; every kind of French and Spanish cheese; crusty breads; cream that poured like honey, yogurt that poured like cream. All this was arrayed on tables of tiered, silver platters that ringed the chandeliered room: a Prado of food. I had only one coat pocket plus my emptied red purse, but I filled them with a luxury lunch and a respectable snack.

Then it was back to the Embassy, slushy snow

sluicing between my toes. It was time to get my passport and get out of there.

Pilar was ready to expedite me. She handed me a metal slug to use in the photo booth, since I lacked any money to buy my own passport picture. I composed my photo carefully, as instructed, but managed to cut off my chin anyway. This error was significant enough for her to call in a vice-consul who concluded, after long study, that the picture could still be affixed to the identifying document that I would deliver by hand to Caja España. I wondered if the State Department had a one-slug-per-citizen policy.

The branch of Caja España at the corner of Calle de Velázquez and Calle de Jorge Juan was the single bank location in the city to accept the substandard form of identification that I carried. The bank extended this courtesy by an exclusive arrangement with the United States Embassy. All other sites of Caja España required a passport — as all other Spanish banks do — to complete a Western Union transaction for a non-national.

There are consequences, potentially grave ones, to docking the chin in an Embassy photo booth; to misconstruing the value of their free metal slug; even to wearing Birkenstocks in December when you are en route to the subtropics. Every detail in life is conse-

quential. Tiny consequences grow burdensome once the slide into misfortune accelerates. This is doubly true where you are a stranger, unable to purchase your own identity.

As I walked down Calle de Velázquez, a gracious avenue of narrow sidewalks and elegant boutiques, to collect my Western Union, I felt like a waif from a Grimm's fairy tale, a six-year-old orphan, the Little Match Girl.

But I knew I must act the Grande Dame even though the cobblestone sidewalk, treacherous with dank accumulation, froze my feet. Around me, florists filled their windows with a global spring of proteas, Irish bells, and calla lilies. Boutique grocers offered outlandishly succulent tomatoes, oranges, and papayas. At a cloistered school, fur-wrapped mothers cooed loving goodbyes to their tots. And all along the ancient, stone-paved street, doormen undaunted by the weather, saluted ladies — even this one, shivering in a loud, rumpled coat. They were gentlemen, perhaps seeing through my peculiar ensemble to my determinedly ladylike carriage.

No one had mentioned that Caja España was almost a mile from the Embassy. When I got there, it took only a minute to collect Tony's Western Union, so I had no time to warm up. As I sloshed back to the Embassy, I returned no doormen's smiles. I bowed into the wind

that blew directly against me, clasping my coat closed against the snow with ungloved hands.

At the Embassy, I paid Pilar for my passport and cheered to be done with Madrid.

But since I still hadn't secured a flight, Pilar helped me call the airlines again. Again no one wanted to deal with me. Continental didn't fly to Africa, but at Air Europa, no one knew the flight schedule, let alone who would issue the ticket or pay for it. No one stepped up to figure things out — though Continental offered to fly me back to New Jersey at no additional cost.

Before I left, Pilar dialed Lucy one last time. Since the day before, Lucy had dried her eyes and recovered her executive self. What's more, she had begun a fund-raising drive among her friends on three continents to collect a thousand dollars for an Air Europa ticket. All business now, she declared that I was *not* going home. The other young teachers at her school, a friend in Belgium, her sister in Oregon, and her father (my divorced husband) had all been tapped for pledges. Even though I was impressed by her passionate sense of mission, my pride was wounded. She cut off my protests with, "But you're my *mother!*"

Nevertheless, I was not prepared to accept cheer-leader charity. The Hotel Melia Galgos would probably

not keep me as their ward, no matter how suited for the role I felt. But I would never be the ward of Lucy and her friends, an overgrown "save this child" case.

By the end of the second day in Madrid, my only certainty was that I had to check out in the morning from the gracious Melia Galgos. I planned to stuff myself at breakfast with enough *jamón* and *mancheco* cheese to get me through another day without outright thieving. I had my passport; the Embassy had bid me *adios*. I had very little cash, no access to credit, and though Tony was wiring me more money, it would arrive in Dakar. But would I get there? I was void of all ideas. But one.

That last night, when I had my final hors d'oeuvre for dinner at the bar, I decided to enhance it with a martini, even if it meant a €10 overdraft and default on my hotel tab. To hell with it all: They'd never find me. This woman sorely needed humanitarian assistance, and a self-administered, good, stiff drink seemed to be all there was available.

Imagine, if you will, my despair to lift that icy cold glass and find that a Spanish martini is dry vermouth on ice. No gin. "Ah! Here we call that a *gin* martini, Madame," simpered the tux-clad bartender. When I got back to my room, I cried until I was limp and my head spun from lack of oxygen. My resolution to outlast the

absurd had been kicked to a pulp. In eight hours I would be on the street without a ticket to Dakar.

By this time, I had made so many fruitless telephone calls from my hotel room that my service had been disconnected twice. But I blew my impacted nose and out of despair's dumb, obstinate lack of imagination, I rang Continental Airlines yet again.

For three days I had called the same number and been connected with Spanish agents and their supervisors. Why now did that number connect me to Miami, Florida?

Penny picked up. No Spanish woman, aching with empathy, Penny was American. The line crackled with can-do, with the spirits of Rosie the Riveter, Katherine Hepburn, Sojourner Truth and Tyra Banks. I spent over an hour with her, most of it on hold, while she investigated avenues to Dakar. She listened carefully to my story then rolled up her distant sleeves. From time to time she'd interrupt Muzak with a question, evaporate for another ten minutes, reemerge to verify a detail, and leave me again to last it out with trust and Neil Diamond.

Finally, Penny confessed, "I can't figure out a thing. No one here knows what's supposed to happen." My heart dropped, but she forged ahead. "You've been through

too much already. So just go to the airport tomorrow and get on Air Europa flight number 1321, departing for Dakar at 7:35 pm. Boarding begins at gate AB at 6:50. I *promise* you, on my personal authority, that there will be a ticket and seat assignment waiting for you at the Air Europa ticket counter in the main concourse. I wish I could explain — I can't — but I promise you this will work. Now, here's how you reach me personally..." And she gave me two direct telephone numbers.

"Have a great time with Lucy," Penny offered. I managed to keep my composure until she forced a fresh gush of tears by saying, "...and have a nice flight."

～

The flight was okay. All my baggage was still missing, but I had found my way. My losses mounted up so high that they finally sank under their own weight, and the Air Europa jet lifted me away lightly, as if I awakened from a nightmare after a disagreeable dinner.

I was far too tired to sleep. Once we left Madrid five hours late, the lights became fewer and farther between until there were finally no lights at all, nor yet any clouds to disguise the unspotted blackness over which we flew those hours that we crossed the Sahara

Desert. Maybe the pilot navigated, like Saint-Exupéry, by the stars. But I prefer to think that the pulse of Lucy's heart drew the aircraft to Dakar just because I was supposed to be coming. After all, I am her *mother.* ➣

# Baggage

*by*

## BRITANY ROBINSON

⌒⁂⌒

NEW YORK CITY was drowning me in people and promises and failures and booze. I moved there because that's where writers go, but I wound up working two jobs and having no time to write. My days were spent in the office of a corporation that stood for everything I hated. At night I bartended — often going shot for shot with customers, which led to even unhappier mornings at that other job.

A road trip would be my escape, my redemption, my claim to a writerly pursuit. I would leave the shadows of tall buildings and the subways crammed with anonymous bodies; their skin pressed against mine but our eyes never meeting. And I'd find something more honest out there, on the road.

Back then, I would have told you that I was looking for adventure. I was looking to hit the highway and

discover America, like so many great writers have done before me. But really, I was looking for home. New York City was but one of a string of places to which I'd tried to feel that sense of belonging.

I didn't think about home or self-discovery or nagging unhappiness when I cleaned my windshield and filled my trunk in the driveway of my parents' Connecticut house. I did, however, check my phone to see if a boy on the other side of the country had returned my most recent text. He hadn't, and I began my drive with distracted eyes, waiting for a road trip companion who wasn't there.

### San Francisco

When I first noticed Josh, my cross-country trip was just an idea. I was visiting San Francisco for the weekend. He was standing by a pool table, peering over a full beer.

He approached without hesitation, inviting me to join him for a drink at the end of the bar. I thought it was sweet how he touched his glasses when he spoke — confident but not cocky. Maybe even a little nervous.

Our conversation quickened at the realization that we were both writers. He'd gone to school for poetry.

I, for journalism. Our language danced together then, sparring with our confidence in words. I laid my bourbon-inspired bluntness on thick. He teased me with quippy flirtations and cheesy puns.

The next night we took a whirlwind tour of his favorite bars, cramming conversations about writing, jobs, love, and life into the chilly summer night. All too quickly it was late and we found ourselves at the base of the Oakland Bay Bridge. There was no one else around and I shivered under his arm until he pulled me around and kissed me. A nosy seagull squacked in our direction, just as his mouth grazed mine. We laughed, and he kissed me again as I smiled against his lips.

Josh lived in San Francisco. I lived in New York. This was a bad idea.

But I had plans to leave New York. My epic summer road trip was just around the corner. I told him how I had no destination and no clear route. And how that would be the best way to explore and to write about it. He said he admired my sense of adventure.

When I woke up in his arms, I didn't want to leave.

It was crazy to suggest I might wind up in San Francisco. He'd run for the golden hills. So I said goodbye on his front stoop and casually mentioned that perhaps I'd see him again soon.

As soon as my cab crossed the Williamsburg Bridge, my phone lit up with his name. I was almost back to my apartment, and he offered to come visit me soon. I couldn't stop smiling as my driver honked and cursed at traffic.

## The Road

Three months later, I stood beneath the spray of Niagara Falls where I snapped selfies, hoping my phone would survive the relentless spray. Josh was thrilled to hear that I was going to ride in a helicopter later that day. He loved planes, and drones, and anything that flew high above the Earth. I was prone to motion sickness and worried that I'd be sick, but I didn't mention that. He said I should ask to steer.

The next week, I sipped cheap bourbon at a bar in Louisville, whose towering liquor wall glimmered with top shelf temptations I couldn't afford. A gentleman with a navy blue suit and a syrupy accent sat next to me and offered to buy me my next Old Fashioned, which I accepted. When my straw finally gurgled against naked glass, I excused myself and retreated to my hotel, where I hung over the side of my big hotel bed with Josh's

voice in my ear, and I told him stories about horseback riding that afternoon. Did he miss me? Yes, of course he did.

Days later, in Detroit, I met artists who made me want to purchase my own dilapidated house and create something beautiful with a few thousands bucks and recycled paint. Perhaps I could live here. I could buy a tiny piece of a city that was rising from the ashes and learn how to use a crowbar and a circular saw. I would share firewood with friends who were also heating their old houses with wood burning stoves. The artists invited me out for drinks and said, "Yes! You should move here!"

Back at my hotel, I made plans to meet Josh in Chicago.

## *Chicago*

A shift in our communication happened somewhere along the flat highways of the Midwest. His texts became distant and rare, and my phone calls often went unanswered. The boredom of the road didn't help the rising anxiety that something had changed in this relationship that really wasn't. It was the day before my

birthday when I arrived in Chicago, and Josh finally admitted that he wouldn't be coming.

In the city I called home before New York, I walked along streets I'd walked a hundred times and never thought I'd walk again. I had planned to move through Chicago quickly, lest I trip over any ghosts of my past life. But without my expected company, I sunk into the start of a slow motion depression. After just one month, I sensed the wheels slipping off. I was tired of the road. I was even more tired of being alone.

I knew this trip would be lonely. But the loneliness you feel when you're truly alone is different. It's pure. Now I was lonely with anticipation and disappointment. And that's the type of lonely that makes your heart feel hard.

So I lingered in Chicago. On my first day in the windy city, I stopped at the coffee shop I'd worked at during graduate school and discovered they could use a week or two of extra help. So, I helped. It was bizarre to see the faces of five years ago still pop in each morning with the same orders on their lips. Most of them looked at me for a few seconds too long but couldn't place my face. I was a ghost to them, too.

Two weeks went by. I was sleeping on the echoey, empty floor of a friend's apartment while her old lease

overlapped with a new one. She moved on to something bigger while I slept on an air mattress surrounded by dust bunnies, grateful to sleep anywhere that didn't come with a sticky keycard and a slippery bed cover.

This wasn't how it was supposed to be. I'd left New York City to find something new, and here I was in the place I'd last left for the same. I wasn't having an adventure. I was wallowing in a past I'd chosen to leave, and a present that felt all wrong. I thought I didn't need a destination, but with the star of San Francisco fading on my mental map, I didn't know how to move forward. Where would I go? And how would I know when I'd arrived?

When he finally called to apologize, I yelled with tears crawling up my throat. Why had he encouraged me to come to him, when he kept drifting further away?

When I hung up the phone, it was time to hit the road.

### *Westward Bound*

Sweeping up my friend's apartment and repacking my car gave me renewed energy. The skyscrapers of Chicago melted into fields of corn and I found my way to an old creamery in Iowa.

My AirBnB host was a thin man in his mid-thirties with a golden beard and stern eyes that made him look much older. He'd purchased this sprawling, barn shaped structure and transformed the interior, furnishing it with old wingback chairs, dusty books, and typewriters. It sparkled with warmth and welcome, despite the cold, concrete floors.

Was it stupid to stay with a strange man in the middle of nowhere? I wondered. Probably. But I'd drained myself of worry.

He kept a polite distance and I spread out in the attic loft like I was staying forever. This was romantic. He made breakfast from his garden each morning. And then left to visit his girlfriend in Des Moines. For several days, I had the dark, drafty old creamery all to myself. And I fell in love with the time alone. I lit candles and wrapped my body so tightly in wool blankets that the inner ache began to fade. My trip had been so quiet, but now I filled that quiet with words and I started to write.

The world passes by quickly on road trips, while the story within slows down. My stories felt sappy, but I didn't care. Sure, I wanted to write tales of adventure, like the road tripping greats: Kerouac, Thompson, Steinbeck.

One might argue that gazing inward is more indulgent or less valuable than offering commentary on the passing world. But I couldn't absorb the passing world until I understood my place within it. That's what this trip was about, and it was okay if I missed some of the beauty while grappling with inner truths. It simply had to be done.

### *Portland*

"I'd like to submit an application," I said, surprising myself.

The building manager handed me the papers.

I hadn't spoken to Josh in weeks. It felt strange to be so close to him, relative to New York City, and to say nothing of the narrowed gap. I'd like to tell you I never bothered to call him, but I did. Eventually I visited San Francisco again, and he confirmed all my fears — he didn't care the way I did.

Road trips are difficult to write about. Nobody wants to hear about the interior of your car, but that's the place where you spend a lot of time. You sit there with yourself and you try to pass the seconds, minutes, hours until your bladder feels heavy or your eyes begin

to itch and you find a truck stop gas station where you can eat or pee or rest. It isn't glamorous. It isn't romantic.

But there is a surprising amount of beauty in and around and between truck stop gas stations.

I didn't write a great travel saga from that trip. I wrote about a boy and I wrote about unrequited love. I wrote about loneliness and heartbreak and all the things I feared I was and some of the things I hoped to be; though I was still trying to figure out that last one.

I slept in that empty Portland apartment for three weeks before my furniture arrived from the East Coast. It was still lonely, but the good kind.

Last summer, I crossed the country in my car again, this time drawing a full circle that would bring me back to the new home I've made in Portland, Oregon. I still own the same crappy car with the crumbs of past adventures lost deep in the cracks between the seats, but nearly everything else about my life has changed. I have a dog now, who offers just the right amount of company on long trips like these. He reminds me to roll down the windows and feel the air on my face — feel how it changes from mountain chill to diesel-dusted heat. He reminds me to let the details seep into my pores.

There's always more to see, more to do, with a road stretched out in front of you. That's why home is such

an elusive concept. There's always another one out there that you could occupy. Another story. Another life. Another heartbreak. There's always more adventure and better stories to be told. But I can only live my own, and keep searching. ✝

# About the Authors

∽⁂∼

**DONNA STEFANO,** *Rami Levy.* Donna Stefano's career spans twenty years in the Middle East, Africa and Asia working in the fields of international development, humanitarian assistance and peace building. In 2016 she was selected as a nonfiction writer in residence with the Carey Institute for Global Good.

**HERTA B. FEELY**, *Sugar's Ride.* Writer and editor, Herta Feely is the author of the 2016 prize-winning novel, *Saving Phoebe Murrow.* In the wake of the James Frey scandal, Feely edited and published the anthology, *Confessions: Fact or Fiction?* She was awarded the James Jones First Novel Fellowship and an Artist in Literature Fellowship from the DC Commission on the Arts and Humanities for *The Trials of Serra Blue.* Feely is the co-founder of Safe Kids Worldwide, an organization

dedicated to saving children from unintentional injuries, the leading killer of children in the United States. She lives in Washington, DC.

**RUTHMARY MANGAN**, *Have Feet, Will Travel*, writes mostly for personal pleasure, filling journal after journal with musings. Several short pieces and poems have been published in "Works in Process: Women Over 50, Reflecting." A former violinist, her circuitous path has found her marching in the streets, working with almost-homeless kids, and transcribing medical reports.

**ANN STARR**, *I'll See the Prado on the Way*, is the founder and publisher of Upper Hand Press and author of *Sounding our Depths: The Music of Morgan Powell.* She has raised children, shown widely as a self-taught painter and book artist (e.g., The National Museum of Women in the Arts, Center for Book Arts), written art criticism (starr-review.blogspot.com), and lectured on art and medicine (e.g., The National Portrait Gallery, London; Yale Medical School). She founded Upper Hand Press in 2014.

**BRITANY ROBINSON,** *Baggage.* Author of the blog *travelwriteaway.com*, Britany Robinson is a freelance

writer whose many travels have been recounted in the pages and pixels of *Mashable, Salon, Hemispheres, Limbo, BBC Travel* and others. She lives in Portland, Oregon.